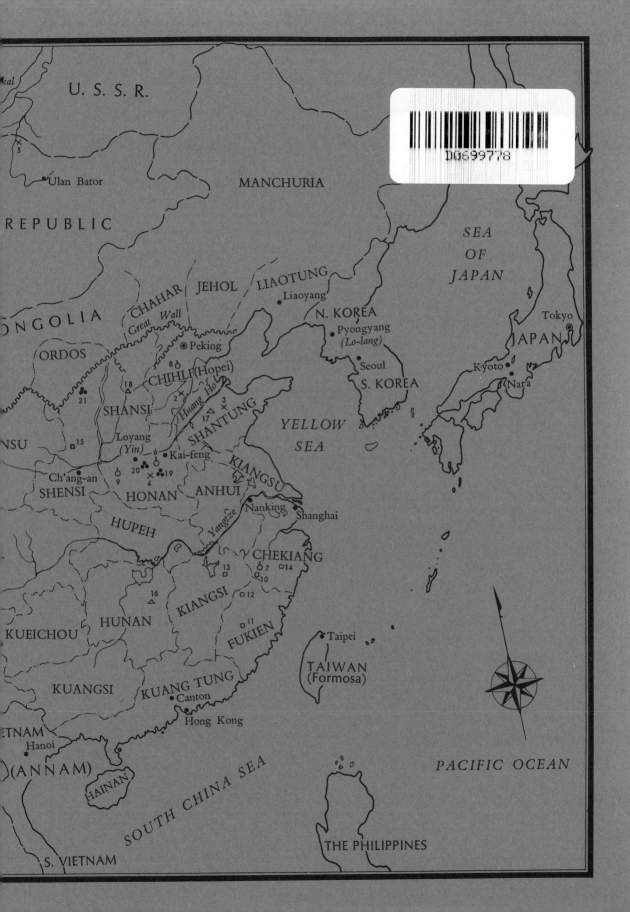

The Arts of CHINA

(*Frontispiece*.) Blue-and-white Kang Hsi porcelain jar with prunus design. Ch'ing period. Morse collection, New York.

The Arts of CHINA

by HUGO MUNSTERBERG

Charles E. Tuttle Company

RUTLAND, VERMONT & TOKYO, JAPAN

Representatives

For Continental Europe:
BOXERBOOKS, INC. *Zurich*

For the British Isles:
PRENTICE-HALL INTERNATIONAL, INC., *London*

For Australasia:
BOOK WISE (AUSTRALIA) PTY. LTD.
104-108 Sussex Street, Sydney 2000

Published by the Charles E. Tuttle Company, Inc.
of Rutland, Vermont & Tokyo, Japan
with editorial offices at
Suido 1-chome, 2-6, Bunkyo-ku, Tokyo

Library of Congress Catalog Card No. 70-188012
International Standard Book No. 0-8048-0039-1

First printing, 1972
Second printing, 1981

Book design & typography by F. Sakade
Layout of plates by S. Katakura
PRINTED IN JAPAN

To PEGGY
who has shared my interest in Chinese art
for a quarter of a century

Table of Contents

List of Illustrations

Acknowledgments

I wish to express my gratitude to colleagues of both the East and the West whose research and writings, both supplementing and complementing my own study, have made this book possible. Some are mentioned in the text and some are listed in the bibliography. Still others remain unmentioned, but to each and all I extend my thanks.

I am also grateful to those who furnished the photographs which contribute so much to this book. Especial thanks are due to Mr. Earl Morse of New York, who provided most of the color plates and a goodly number of monochromes, to Mr. and Mrs. Myron Falk, also of New York, who kindly permitted photographic reproductions of Chinese ceramics in their private collection, and to Dr. Paul Singer, of Summit, New Jersey, who graciously supplied me with photographs of objects in his collection.

The Art of

PREHISTORIC CHINA

(c. 3000 B.C.–c. 1500 B.C.)

CHINA CAN look back upon the oldest continuous artistic tradition existing in the world today. Other civilizations predated the Chinese—ancient Mesopotamia, dynastic Egypt, Minoan Crete, Jomon Japan, and those of prehistoric Iran and the Indus valley—but only in China does a current civilization extend back in unbroken continuity for well over four thousand years. Both the people and the culture descend directly from a civilization which took form during the third millennium before Christ. Many characteristics of prehistoric Chinese art persist or recur throughout these centuries in a continuity found in no other great civilization of today.

Like the legends of all cultures, those of China describe the origin of the world. In one common version, P'an Ku created the world by separating heaven and earth. During the next 400,000 years, the Twelve Emperors of Heaven and the Eleven Emperors of Earth reigned over the world. The Nine Emperors of Mankind reigned during the next 45,000 years. Then a sequence of sixteen rulers was followed by the three Great Sovereigns: Fu Hsi, Shên Nung, and Huang Ti. These last are credited with inventing the arts and crafts and founding Chinese civilization. Shên Nung taught the people to till the soil. Huang Ti, known as the Yellow Emperor, founded the imperial house of China.

The first two are usually represented with human heads and serpent bodies, suggesting a totemic concept, but Huang Ti, the Supreme Ances-

tor, is depicted as entirely human. According to legend, he and his five successors civilized the Chinese people by teaching religious concepts and rules of moral conduct. With the fifth successor, legend crosses the threshold into history, for he, Emperor Yü, founded the first historical house, the Hsia dynasty. Thus legend melds with history in the person of the fifth lineal descendant of the legendary Yellow Emperor.

Modern studies indicate that there is more truth in these myths than was formerly believed. Archaeologists have found remains of a prehistoric man which date as far back as 500,000 B.C. This creature, known as Peking man, is one of the most ancient specimens of humanity yet discovered, establishing beyond doubt that eastern Asia was actually inhabited during the same ancient period spanned in Chinese legend. The brain capacity of this early man was not quite equal to that of modern man but was double that of the gorilla and the chimpanzee. His human status is bolstered by evidence that he shaped tools and used fire. However, it is not at all certain that Peking man was the actual ancestor of the modern Chinese.

The Ice Age interfered seriously with both the growth of human settlement and the preservation of archaeological evidence; consequently, very little has been discovered about the intervening millennia of Chinese prehistory before about 20,000 B.C. Habitation by hunting and gathering cultures after this date is evident from traces found in China, Manchuria, and Mongolia. Migrants from these cultures probably crossed the land bridge, now sunken to form the Bering Strait, to people the Americas. More and more, however, the people tended to live in regular settlements. By about 5000 B.C. they appear to have domesticated the pig and begun making coarse pottery. These people were the prehistoric, but direct, ancestors of historical China.

The earliest truly artistic works discovered in China are from a neolithic pottery culture of the third millennium B.C. The Swedish archaeologist J. G. Andersson discovered the first specimens of magnificent painted ceramic vessels from this period, called Yang Shao after the modern place name. The origin and early stages of Yang Shao pottery remain obscure. Definitive answers to puzzling questions await further excavations in Central Asia and adjacent territories linking China with western Asia and the Near East. Certainly, the early pottery culture of

China owes much to that of the more ancient Mesopotamian and Iranian cultures. Highly developed by the fifth millennium B.C., these cultures used forms and decorative motifs markedly similar to those found in Yang Shao pieces of two thousand years later.

Chinese scholars, although usually reluctant to admit any Western influence upon ancient China, have acknowledged this evidence and admitted its implications. Some have taken the initiative in pursuing these threads. For instance, Li Chi, director of the Academia Sinica and author of a work on the beginnings of Chinese civilization, sees a somewhat degenerate form of the hero-and-beast motif of ancient Mesopotamia in some Chinese woodcarvings and bronze inscriptions bearing a face mask with two antithetically positioned tigers. Another similarity noted by Li Chi involves jars having phallic-shaped handles standing upright in their centers, found at Jembet Nasr in Mesopotamia, at Mohenjo-Daro in India, and at Yang Shao in China.

Andersson draws interesting comparisons between decorative motifs of Yang Shao vessels and those from Anau in Russian Turkestan and Tripolje in the Black Sea region; however, the striking similarities between designs decorating prehistoric Mesopotamian pottery and those of early China are of more significance. Beatrice Goff, in her book on symbols of prehistoric Mesopotamia, shows many figures—wavy lines, circles, spirals, triangles, dots, crosses, plants, birds, fish, and weeping human faces—each having exact equivalents in the neolithic ceramics of China. In short, little doubt remains but that the prehistoric pottery culture of China is heavily indebted to the far more ancient civilization of Mesopotamia.

The neolithic Yang Shao pottery culture spanned the millennium from about 2500 B.C. to about 1500 B.C., when Stone Age culture was generally replaced by the bronze culture of the Shang period. In outlying provincial regions such as Kansu, Sinkiang, southern Manchuria, and Yehol, however, prehistoric pottery styles persisted as late as 500 B.C.—long after these had been displaced by more advanced art forms in cultural centers such as Honan, Shensi, and Shansi.

In the earliest phase, 2500 B.C. to about 2200 B.C., the pottery was quite simple, resembling that of prehistoric Europe. Primarily a fine red ware with plain, polished surfaces, some pieces are decorated at the mouth

rim with geometric designs in a red of deeper hue. Others have incised or cord-marked patterns. Predominant shapes are bowls with both round bases and flat bases, vases with ring-shaped mouths, and an early form of the tripod-shaped vessels so characteristic of Chinese design in later times. In addition to the red ware, shards of a coarser grey ware have been found.

The middle phase of Yang Shao culture, which Andersson dates from 2200 B.C. to 1700 B.C., climaxed this early civilization with some of the masterpieces of the neolithic potter. Remains from this period have been discovered in Honan, Shansi, Shensi, and Kansu provinces. New sites are currently being discovered. Middle Yang Shao pottery appears to have flourished in these centuries throughout northern China and, at a somewhat later period, in the border regions of Yehol, southern Manchuria, and Sinkiang. Pan-po-ts'un, near Sian, was excavated during the period 1953–55 by the Chinese Academy of Sciences and has proven the most rewarding of the sites scientifically explored. Some excellent examples of this middle Yang Shao pottery have also been found at Pan-shan in the western province of Kansu.

Middle Yang Shao pottery occurs in a greater variety of shapes—bowls, basins, cups, beakers, pots, jars, jugs, and hollow-legged tripods. The forms are simple and strong. Many are painted with designs in black, red, and brown. The decorative painted designs are, in fact, their most outstanding feature, distinguishing them from neolithic ceramics of other cultures throughout the world. A notable example of the middle Yang Shao artisans' skill is the painted vessel formerly in the Chait collection in New York (Plate 1). This jar, believed to have come from a burial site at Pan-shan in Kansu, has a clean, sturdy shape in light-grey ware tinged with red. Striking decorative patterns create a sense of extraordinary vitality. The brushwork is free and vigorous. The pattern lines are nicely related to the contours of the surfaces.

The many motifs appearing on these ancient vessels are surely symbolic in nature. The symbolism probably expressed concepts of fertility magic. Certainly the wavy lines on the Chait vessel represent water, since the ancient Chinese ideograph for water used the same lines. Since rainfall was a matter of life and death, the primitive artist hoped to produce the actual phenomenon through sympathetic magic by representing it in

this manner. The lozenge-shaped forms enclosing the water symbols are another symbolic motif, sometimes said to represent the cowry shell and sometimes the female vulva. These were symbols of the related concepts of abundance and fecundity. The cowry shell was used as money in ancient China and is often found in graves, testifying to the wealth of the deceased. The third element of this design is the cross-hatched background pattern. Since the earliest vessels were made of reeds, this pattern probably represents only the woven surface of the prototype. Interestingly enough, a similar pattern occurs on prehistoric Mesopotamian pottery.

Another symbol commonly occurring on Yang Shao pottery as a main decorative motif is the spiral. Found also in later Chinese art, the spiral is known as the *lei wen,* or thunder pattern. Again, the character for thunder in archaic Chinese script resembles this spiral. Standing for thunder, storm, clouds, and rain, it also represents fertility.

Other basic, abstract figures used widely and bearing symbolic import in terms of fertility magic are the circle, which was also the early ideograph for the sun; the triangle, resembling the female pubic region and common in many primitive cultures as a symbol of the Mother Goddess; the square, appearing with a cross inside as the archaic ideograph for a tilled field; and paired dots, thought to sometimes represent the visage of a primitive deity.

A more complex pattern, consisting of red bands flanked by small triangles, has the appearance of rows of teeth. Andersson has termed this the "death pattern," since neolithic vessels bearing this design have been found in China only in burial sites. When examining the elements of the death pattern, one is struck by the consistent use of the color red for this design. Red symbolized blood—hence life—in all primitive societies and usually can be presumed to have symbolic significance. Fertility deities were commonly painted red, and traces of red ochre are often found in burial sites. Red water, representing the essence of life, was believed by primitive man to confer immortality after death. This death pattern, composed of red bands symbolizing immortality and repeated triangles symbolizing fertility, in its linear, parallel arrangement, probably was meant to invoke new life in parallel continuity with the phenomenon of death.

Portrayals of the human figure or those of animals seem to have been comparatively rare in this primitive culture; however, both have occasionally been found in neolithic remains. The most remarkable are a number of pottery idols having human heads and star-shaped bases. Tears streaming down the cheeks indicate that they represent rain deities. Wavy parallel lines, triangles, and lozenges on their bases also suggest a connection with rain and fertility. Human figures having circles for heads, and faces with large eyes have also been found. Among animals represented, snakes, fish, and frogs are the most prevalent. Since, in later Chinese art, all are connected with the concepts of water and fertility, a close relation between these animals and the neolithic dependence upon the harvest can be inferred.

The third and last phase of Yang Shao pottery culture is usually called Ma Ch'ang, after the principal site where remains have been found. Probably representing a culture in transition from ceramic to bronze crafts and proper to the period from about 1700 to 1500 B.C., pottery of this order continued to be produced in Kansu well into historical times. Apparently deriving from the Pan-shan type of middle Yang Shao pottery, the vessels are coarser and the forms and designs are less attractive. The symbols are generally the same but have lost something of the earlier expressive power. Later phases of pottery culture followed this last phase of the Yang Shao, but these are uninteresting as art works. The forms of these wares are weak. The painted designs are carelessly executed and no longer related to surface contours. Certainly by this time the superior bronze culture of the Shang dynasty had displaced neolithic ceramic culture in all but the outlying backward regions.

Less ancient than the Yang Shao painted red ware but also artistically important, a second genre of neolithic pottery was contemporary with the last phase of Yang Shao. Called Lung-shan after the site in Shantung where the first examples were found, it was first thought to be of a purely local culture. In recent years, however, discoveries in Honan and other provinces support the belief that this pottery was made throughout northern China from about 1700 B.C. until the rise of Shang culture around 1500 B.C. This pottery is most commonly a grey ware, sometimes a black ware, decorated with comb marks, incised patterns, or impressed designs instead of painted designs. Among a great variety of shapes, some antici-

pate those of later Chinese art such as the *li* tripod, the *tsun* goblet, the *tou* fruit stand, and the *ting*. The silhouettes of Lung-shan vessels are sharper and more linear than those of the Yang Shao. Above all, these wares are more technically advanced, having been formed on the fully developed potter's wheel and fired in a process involving oxidation and reduction.

Especially fine are the black wares. Thin-walled and of a lustrous, jet-black color, these vessels can be very beautiful. Here again, as in the case of the Yang Shao red ware, there are close parallels with a similar black ware made in Iran at an earlier date, around 2000 B.C. in this case.

The grey pottery has been found at the same sites as has the black and even more extensively in northern China. Chêng Tê-k'un has suggested that they represent separate cultures. Others believe the grey to be merely a more common, ordinary form from a single pottery culture.

In either case, these black and grey wares provide a direct transition between late neolithic and historical times in terms of both design and decoration, implying a direct connection between the peoples of the prehistoric and historic eras. Some scholars have equated the Lung-shan culture with the earliest historical Chinese dynasty, the Hsia, which is supposed to have immediately preceded the Shang. But, pending confirmation by further archaeological discovery, this identification can only be speculative, or tentative at best.

Although pottery was the dominant art in prehistoric China, as in other neolithic cultures, other artistic media were widely used: stone, bone, wood, and precious stones such as turquoise and jade. The jade rings, pendants, and ritual implements are most remarkable from both the aesthetic and the technical points of view. Here, again, the continuity of Chinese culture is demonstrated. Jade has continued to play an important role in Chinese art. Used from the earliest times for ritual and ceremonial purposes, it has always been treasured by the Chinese above even silver and gold. Prehistoric jade artifacts, when worked with skill, combine excellent craftsmanship with exquisite design. These, along with the neolithic ceramic masterpieces, reveal the high aesthetic concepts possessed by the Chinese people in primitive times.

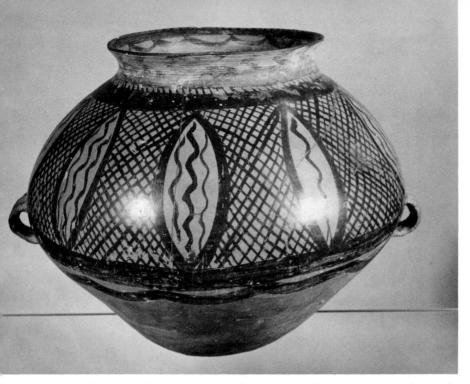

1. Neolithic painted pottery jar. Prehistoric period. Formerly in Chait collection, New York.

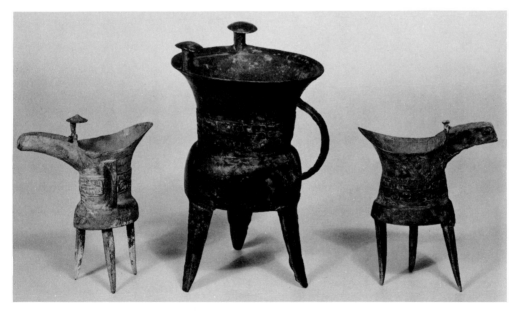

2. Bronze ceremonial vessels. Pre-Anyang period. Royal Ontario Museum, Toronto.

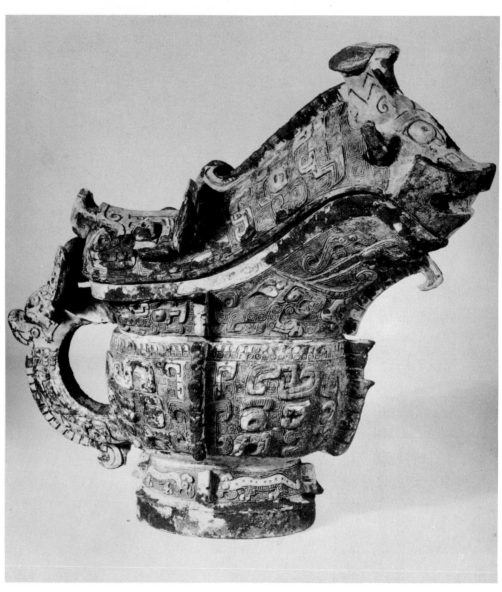

3. Bronze kuang (ritual wine vessel). Shang period. Cincinnati Art Museum.

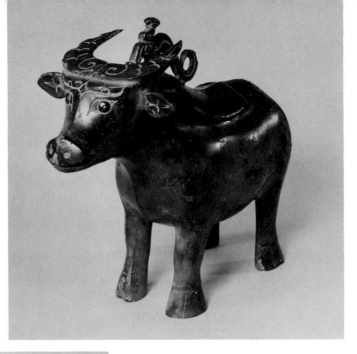

4. Bronze vessel in form
of water buffalo. Shang or
Early Chou period. Fogg
Museum of Art, Cam-
bridge, Massachusetts.

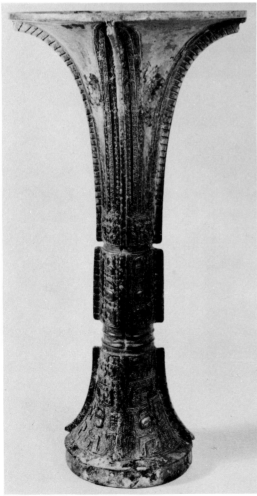

5. Bronze ku (ritual wine
vessel). Shang period. Duke
collection, New York.

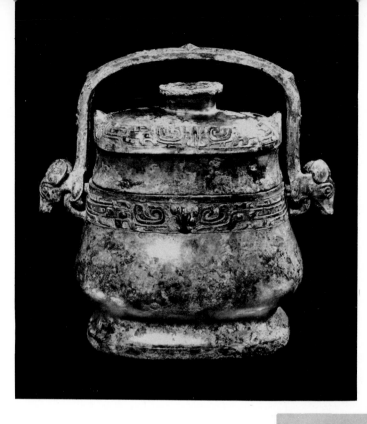

6. Bronze yu (wine pot),
Shang period. Morse col-
lection, New York.

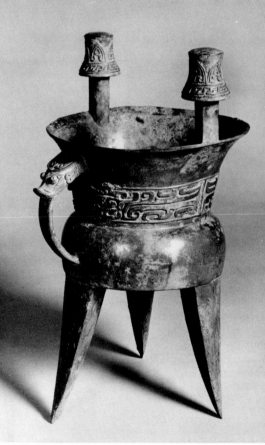

7. Bronze chia (vessel for heating
wine). Shang period. Morse col-
lection, New York.

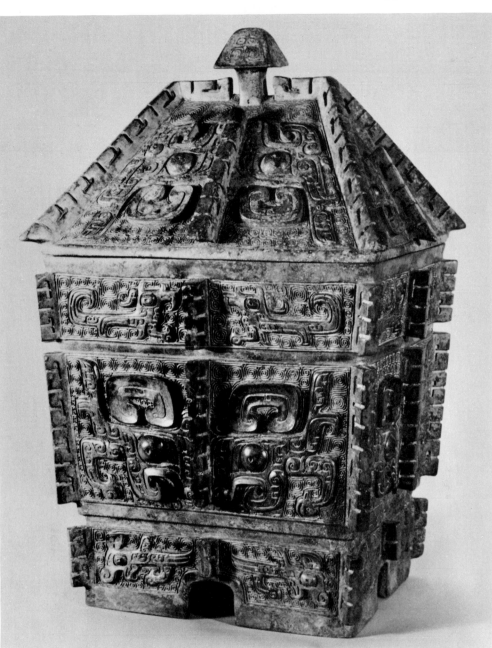

8. Bronze fang-i (food-offering container). Shang period. Fogg Museum of Art, Cambridge, Massachusetts.

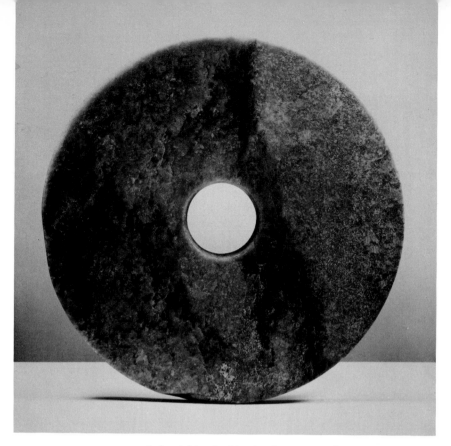

9. Jade pi (ritual object). Shang period. Singer collection.

10. Bone spatula. Shang period. Singer collection, Summit, New Jersey.

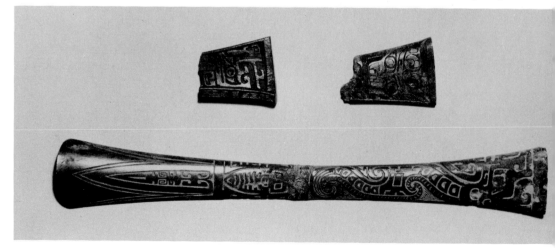

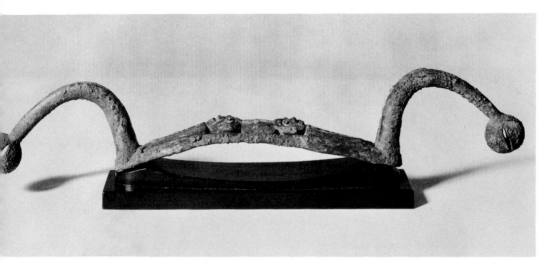

11. Bronze harness accoutrement inlaid with turquoise. Shang period. Fogg Museum of Art, Cambridge, Massachusetts.

12. Pottery li (tripod). Shang period. Chait collection, New York.

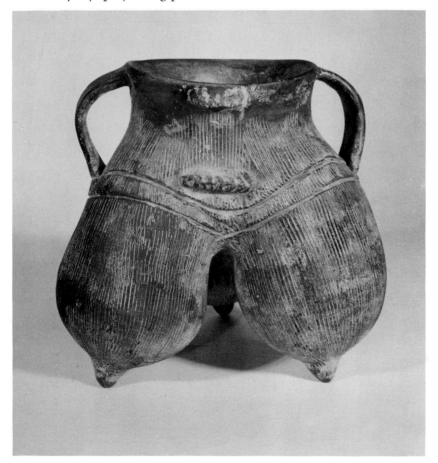

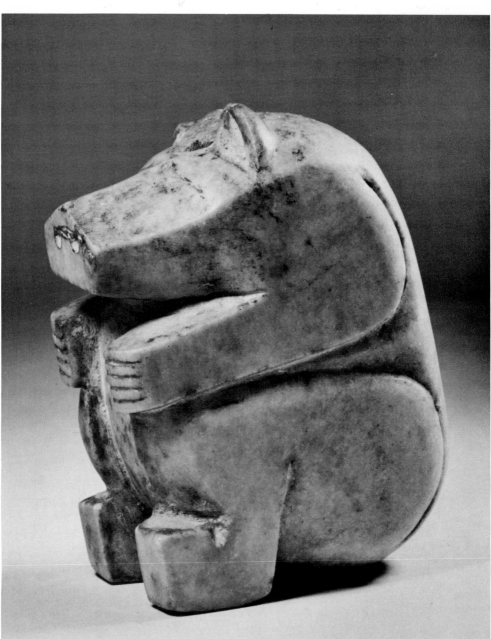

13. Marble bear. Shang period. Singer collection, Summit, New Jersey.

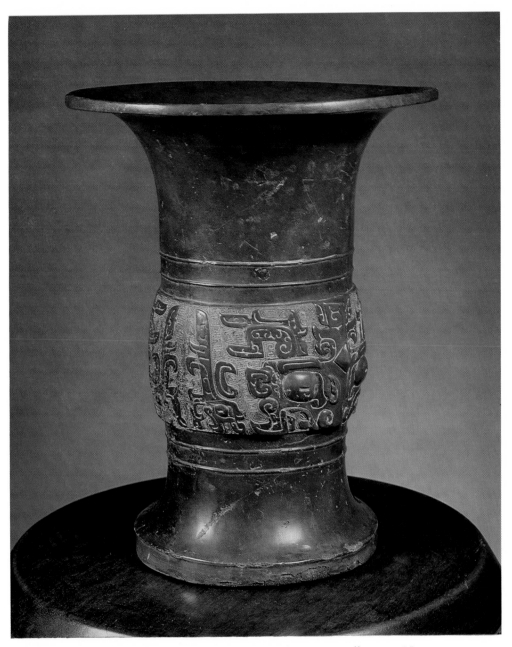

14. Bronze tsun (ritual wine vessel). Shang period. Morse collection, New York.

CHAPTER TWO

The Art of
the SHANG DYNASTY

(c. 1500 B.C.–1100 B.C.)

CHINESE ART enters its first historical period with the advent, about 1500
B.C., of the Shang dynasty. While the preceding Hsia dynasty is sometimes
termed a "historical" dynasty, none of the artifacts discovered can defi-
nitely be attributed to the Hsia period. On the other hand, much is known
about the Shang dynasty. Ssu-ma Ch'ien, a celebrated historian in the
Han period, wrote at length about the Shang rulers. More important,
through the discovery and interpretation of inscriptions on oracle bones
and sacrificial bronze vessels, modern archaeology has pieced together a
picture of the civilization in northern China at this time.

 Just as the more ancient civilizations had originated in the valleys of
great rivers—the Nile, Tigris, Euphrates, and Indus—so was the center of
Shang culture located in the great valley of the Huang Ho, the Yellow
River. Among the many Shang sites excavated, the most important is in
Honan Province at the ancient site of Anyang, the Shang capital from
about 1300 B.C. to about 1000 B.C. Known in Chinese history as Yin, this
site had been a famous source of ancient relics for centuries but was not
scientifically excavated until the twentieth century. The National Research
Institute of History and Philology, under Li Chi, undertook extensive
archaeological investigations from 1928 to 1937. The most important
among the many sites explored in more recent years has been Cheng-chou.
This is believed to have been the site of the earlier Shang capital, Ao.

 When compared to the prehistoric civilization which had flourished

during the previous one thousand years, marked innovations suggest that this dynasty fostered a fundamentally new society and culture. Outstanding features were the creation of a system of writing comprising some three thousand pictograph-based characters and forming the basis for modern Chinese script; the rise of large towns surrounded by thick walls of pounded earth; new developments in ceramics; advanced stone-carving; innovations such as chariots, chamber burials, and ritual sacrifice; and the emergence of a highly developed bronze culture in which vessels, weapons, and tools were made of metal rather than stone, clay, or wood. At the same time, the persistence of older cultures in isolated enclaves and in the border regions, the survival of the grey pottery, the continued use of Y.ng Shao and Lung-shan shapes for vessels, and of oracle bones and jade ritual artifacts all suggest a large measure of continuity between the prehistoric culture and that of Shang China.

Here again Western influence may have prevailed, since no truly primitive stages of writing or metalworking have been discovered in China. Both arts had evolved to a high level in Asia Minor some fifteen hundred years earlier. Max Loehr has suggested the northern regions as the connecting passage through which the metal culture was transmitted, but Chinese scholars, such as K. C. Chang, believe these developments to have been indigenous in origin. Recent excavations have brought to light some pre-Anyang stages of the Chinese bronze culture. Although plainer and more crude than later works, these early objects are too advanced to represent a beginning phase (Plate 2). The origin of Chinese metal culture still remains obscure.

The finest Shang bronze works are masterpieces in the area of metalwork and are the most remarkable among the various art works produced by the Shang people. Cast from molds, perhaps at times by the lost-wax process, and consisting of eight or nine parts copper to one part tin, with small quantities of other metals, these bronzes show a technical mastery which testifies to the high skill of the Shang metalworkers.

The bronze vessels served a twofold purpose: as funeral gifts to be placed in the graves of kings or nobles and as containers for food or wine in the ritual of sacrifice to ancestors or deities. They were often embellished with inscriptions, usually short but sometimes running to several hundred characters. These inscriptions sometimes commemorated a particular

occasion—for example: "On the day Kuei-tzu the King bestowed upon Hsiao Ch'en Yi ten ropes of cowry shell. So [he] dedicates to [his] Mother Kuei this sacred vessel. . . . On this occasion of the holidays for the King's sixth Grand Sacrifice, in the fourth month . . . The Yi family of the Ya nobility." But simple dedicatory inscriptions were more common, such as: "The Yi family dedicates this vessel to its Mother, Hsin, [who came from] the Chi family of the Ya nobility."

Chinese scholars through the centuries have studied these inscriptions. A dependable chronology of Shang and Chou bronzes, based upon these studies, has been compiled in modern times by the eminent Swedish sinologist Bernard Karlgren.

Sacrificial vessels were fashioned in many shapes. Several shapes derived from Lung-shan ceramic forms. The prototypes of other shapes may have been the wooden or bamboo vessels mentioned in the *Book of Songs* as being used for offerings. Offerings were beverages such as wine or water and foods such as meat or grain. These were offered as ritual sacrifice to the spirits of the dead and to deities representing the forces of nature. Among early peoples, the belief that the universe was inhabited by such spirits was widespread. When properly placated by offerings, such spirits might be well disposed; otherwise, they were certain to prove malevolent. Even in modern China, this custom is followed by all except the most sophisticated. Until deposed in 1912, the Manchu emperor of China performed the sacred rituals each year, using the ancient ceremonial vessels.

Connoting far more than mere utility, these ritual vessels were major expressions of both religion and aesthetics. Architecture, sculpture, painting, or drawing may each convey central cultural concepts. In Shang China, it was the product of the metalworker which embodied the highest ideals as well as the aesthetic concepts of the Chinese people. The magnificent design and complex symbolism displayed by the *kuang*-shaped wine vessel in the Cincinnati Art Museum (Plate 3) are typical of these ritual bronzes. The *kuang*, largest of the ritual vessels, resembles a sauce boat and was used to make offerings of black-millet wine. The most impressive feature of this bronze is the rich decoration covering every inch of the surface. The ornate patterns include symbols of magical purport.

The major symbolic motif appearing on this vessel, and many others, is the tiger. This motif is repeated four times, as a tiger mask on each side

of the vessel and in more plastic form at the front and back of the cover. Rather than a naturalistic animal, this is a magical creature. In the representations at front and rear, potency is increased by phallic horns having incised symbols for thunder and rain. The tiger masks upon the body are extremely stylized—composed of four separate features. A fang, an eye, an eyebrow, and an ear are placed one directly above another in a vertical arrangement. The hook-shaped fangs, prominent even in cases where other parts of a composite mask are derived from birds or horned animals, identify the tiger mask.

In later times the Chinese called these masks *t'ao t'ieh,* meaning glutton, and thought they were placed on these vessels to warn the user against gluttony. This proves only that, by the third century B.C., the forgotten magical symbolism had been replaced by a rationalistic concept.

Actually, the tiger had been a magical symbol since neolithic times. One of the prehistoric sites has yielded a tiger amulet. Its purpose was surely to protect the wearer from evil influences for, even today, Chinese children wear tiger caps to ward off evil spirits. Throughout Chinese history the tiger has been revered as an auspicious and sacred animal, associated with earth and mountains. He was considered the chief animal of the terrestial realm, just as the dragon was conceived of as the ruler of the sky. The west was called the "tigrine quarter" in a Chou inscription. In the art of the Han period, the tiger always symbolized the west when the four directions were represented by animals. Since, in the imperial palace, the earth deity's altar was located on the west side, it would appear that the tiger represented the earth deity, upon whom the fertility of the fields depended.

Birds are a second motif on the Cincinnati *kuang,* one appearing in back on the handle and one in front directly below the tiger's chin. They are portrayed by eyes, wings, claws, and projecting beaks. Probably they represent sun and light, in contrast to earth and darkness associated with the tiger and the western direction, in which the sun sets. An archaic pictograph consists of a bird with a radiant sun for its head. In later art the sun bird, usually called the phoenix in the West, is associated with the direction south. Known in China as the *fêng,* the phoenix became the emblem of the empress and decorated the headdresses of the Chinese household goddesses. In Shang times birds were a favorite motif on bronzes

and, being unquestionably symbolical, were portrayed in the hope of achieving magical results.

The third motif on the Cincinnati *kuang* is the dragon, which appears in various forms throughout the pattern. Appearing on practically all of these ancient bronzes, this seemingly imaginary beast may well represent a subconscious memory of the giant flying lizards in the age of reptiles. Remains of these were found in Sinkiang only a few years ago. In China the dragon is an auspicious animal still worshiped today and associated with the sky, thunder, clouds, rain, and fertility. He is also associated with the royal ancestors. According to legend, two of the early emperors were sons of dragons and the legendary emperor Yao is said to have been born of the union of a dragon and a woman. The altar of the ancestors, in the imperial palace, was located on the east side, the direction symbolized by the dragon. In later times, the dragon became associated with the emperor, whose throne was called the "dragon throne."

Although designs on these vessels commonly represent animals, the animals are seldom portrayed naturalistically. Rather of a magical nature, they are often composite in character or completely fantastic. The common domestic animals used for sacrifice—pigs, cows, and sheep—were not represented; nor were dogs. Even the horse, which played such a prominent role in Shang civilization, was seldom portrayed in Shang art. Plants were never shown in the decorative designs. On the rare occasions when human figures were used, deities were no doubt intended rather than ordinary men.

A vessel on the functional order of the *kuang,* but shaped quite differently, is the bronze in the form of a naturalistic water buffalo in the Fogg Museum (Plate 4). Even though the entire vessel forms a single, realistic animal figure, the spiral thunder symbols on the horns and the handle shaped like a phallic-horned dragon indicate something more than an ordinary beast of burden. The lunar symbolism in the single crescent formed by the two horns further denotes the magical nature of this representation. Shapes so simple and plastic with minimum decoration are extremely rare among Shang bronzes.

Among vessels used for wine offerings, the most beautiful is the *ku.* These tall, slender goblets have hollow bases, cylindrical middle sections, and upper sections which flare into wide, trumpetlike mouths. The *ku*

in the Doris Duke collection in New York is an excellent example (Plate 5). Miniature dragons and *t'ao t'ieh* masks comprising fangs, eyes, eyebrows, and ears appear in low relief on both the base and central sections. All design is executed in very flat relief, entirely subordinate to the goblet itself. Being a vessel of great elegance, the *ku* became a model for flower vases in later times.

The *tsun* is closely related to the *ku*. Broader and heavier, it is otherwise similar in both design and purpose. The Earl Morse collection in New York contains a *tsun* notable for its beautiful green patina (Plate 14). The tiger mask is the main motif. Between the two tiger masks, on both sides of the *tsun,* are two dragon figures. Executed in bold relief, these figures appear against a low relief background of repeated squared spirals, the thunder pattern called *lei wen.* The base and upper sections are plain, contrasting strongly with the animated design of the central section.

The *yu* is a covered, pot-shaped wine container with a rather bucketlike appearance. The *yu* in the Morse collection (Plate 6) has a ram's-head motif. The ends of the handle terminate in rams' heads, which also appear in relief on the decorated rim band along with stylized dragons. The precise import of the ram symbol is not known.

The *chia* and *chüeh* are vessels designed for heating wine. They stood over the fire on their three pointed legs. A typical *chia* (Plate 7), also in the Morse collection, has a decorative band similar to that on the Morse *yu* but with *t'ao t'ieh* and abstract bird designs. The handle is decorated with a water-buffalo head with protruding eyes and flattened, crescent-shaped horns. The two capped uprights standing just inside the rim, a characteristic feature, were probably used to lift the heated vessel from the fire.

The *chüeh* is smaller and more graceful than the *chia*. On one side the rim extends into a pointed beak. The other is formed into a spoutlike lip. Otherwise the *chüeh* is similar to the *chia*.

In addition to the foregoing liquid-offering vessels, others were designed to contain the various food offerings. The *hsien,* designed for steaming food; the *li,* a tripod form; and the *ting* were all ancient and ubiquitous forms whose prototypes are found among prehistoric ceramics.

The most impressive food-offering container, however, is the *fang-i,* a rectangular box-shaped container equipped with a base piece and a cover shaped like a roof with a four-way pitch. The *fang-i* in the Winthrop

collection at the Fogg Museum is a splendid example (Plate 8). The chief decorative motif is the tiger mask, very forcefully rendered in bold relief on each side of the vessel and, inverted for viewing from above, on each slope of the cover. On the vessel sides, above the masks, two stylized dragons face each other. On the sides of the base piece, two stylized birds face away from each other. Stylized dragon forms are also blended into the tiger masks. The knob at the top of the cover repeats the shape of the cover and resembles the roof of a shrine. It may well represent a miniature ancestral temple. Carl Hentze, the foremost authority on the symbolism of these ancient bronzes, believes that all aspects of the *fang-i* form represent the ancestral temple with its typical roof, projecting beam tips, and supporting base. This hypothesis seems quite supportable by the evidence. Quite probably the very shape of some vessels, in addition to their symbolic decoration, embodied religious meanings connected with specific cults. Certainly these bronzes, cast in dimensions as great as fifty-one inches, were major cult objects serving the rituals both in veneration of the spirits of the ancestors and in propitiation of the forces of nature upon which the very survival of these agricultural people depended.

Jade, called *yü* in China, ranked next in importance to bronze as a medium for the Shang artisans. However, while bronzeworking was an innovation by the Shang culture, the use of jade continued traditions stemming from prehistoric times. A stone of great hardness and of even texture, jade lends itself especially to the demands of carving on a miniature scale. While universally valued for its color and texture, jade is not only aesthetically prized in China but also venerated as an auspicious substance.

Among the many jade shapes used in sacred rites, the most important are probably the *ts'ung*, a square tube which has a round perforation running through it, and the disc-shaped *pi* with a hole in its center. According to tradition, they represent Earth and Heaven and are often found in ancient Chinese graves. The *pi*, a good example of which may be found in the Singer collection in Summit, New Jersey (Plate 9), resembles the ancient pictograph for the sun, and may have been a solar disc before becoming associated with the deity Heaven. The *ts'ung* is believed to represent the deity Earth and may have been derived from the cover for the ancestral tablet, as Dr. Karlgren has suggested. The two shapes together

certainly stand for the yang and the yin, the male forces associated with light, sun, and heaven, and the female associated with darkness and earth—the "above and below" which are mentioned in Shang inscriptions.

Shang jades also include other ceremonial objects; insignia of rank; weapons such as daggers, knives, spears, and arrowheads; utilitarian objects such as axes and hoes; and animal and human figures. Actual usage of these weapons and tools seems most unlikely, considering the time and effort required to produce such exquisite carving in a medium both precious and difficult to work. The Shang craftsmen had only primitive tools with which to deal with a medium that challenges even modern carvers. Also, the same variety in color appears in both objects of the utilitarian type and in objects of ritual art. Ranging from pure white to near black, colors include yellow, brown, green, and shades in between tending toward blue and red. The unique appeal of Shang jades lies in a combination of simple beauty of shape and subtle variation in color.

The animal figures from Shang times include sensitive portrayals of the familiar symbolical creatures: tigers, dragons, birds, water buffaloes, bulls, bears, snakes, fish, cicadas and other insects, and the *t'ao t'ieh*.

The human figures are distinctly Mongoloid, having broad noses and narrow eyes. We do not know just whom they represent nor do we know what their functions were. The late Alfred Salmony, the foremost Western authority on ancient Chinese jades, did not believe that these Shang figures represented gods or demons because of the absence of supernatural features. However, since no other element of Shang art seems other than magical in character, these most likely represent either the supreme ancestors or nature deities such as the great god Shang Ti, who presided over the Shang pantheon. Naturalistic representations of specific historical personages seem to have come only later in Han times.

Shang carvers worked also with bone, ivory, and turquoise. The spatula in the Singer collection (Plate 10) is a typical bone artifact. The carving at the spatulate end represents a dragon. The obverted D shapes repeated along the body, although dissimilar to the vulviform cowry symbols painted on the vessel in Plate 1, are probably another abstract form of these symbols of prosperity. At the handle end, the carving in its entirety represents the adult, winged cicada. Taken by itself, the forward section of this cicada figure may represent the pupal stage. Since the shrill

cries of the cicada are heard at the height of the growing season for some crops and in the season of some summer harvests, its frequent incidence in ancient Chinese art probably stems from association with fertility and abundance. Cicadas carved in jade are frequently found in graves of the Han period. Since the cicada hatches above ground, spends a long period underground, and finally emerges as if in rebirth, these burial tokens were probably intended to induce resurrection by sympathetic magic.

Ivory, rarer and more precious than bone, was infrequently available to Shang carvers. The rare pieces were apparently prized highly, since Shang ivories are most intricately carved and often inlaid with turquoise.

Turquoise was widely used by the Shang artisans for inlay work, even with bronze. The turquoise-inlaid bronze object in the Fogg Museum (Plate 11) was an article of harness used to adjust the direction of pull on the reins. The reins passed beneath the belled hooks on either side just as they are passed through rings in ordinary modern harness.

Ceramics continued to be the most widely followed craft, but no longer played the dominant role aesthetically. The most notable Shang ceramic ware is a hard, white stoneware in almost pure kaolin. The Freer Gallery, in Washington, D.C., possesses a superb specimen from the site of old Anyang. While no other whole vessel of this type has been recovered, shards have been found at widely distributed sites. This vase, decorated with symbolic designs such as those found on bronze ritual vessels, was probably used for ritual purposes. Another notable ceramic type discovered at Shang sites is one having a natural ash glaze.

The great bulk of ceramics from Shang sites, however, is an ordinary grey ware of the type common in prehistoric times. A wide distribution of shards in quantity suggests usage in the daily affairs of common people, as does the high incidence of accompanying wooden artifacts. Of the great variety of grey-ware shapes, most derive from traditional forms from the prehistoric period. Lack of originality and aesthetic quality suggests that, for the Shang people, ceramics were more of a utilitarian than an art form. The decorative designs are plain and not especially symbolic, usually impressed or incised into the surface of the clay. A rare, extremely interesting piece of Shang grey ware is in the Ralph Chait collection in New York (Plate 12). This *li* tripod, instead of conventional legs, has three mammiform lobes tipped with prominent mammillae.

In these again, the magical character of Shang art is evident. Breast and nipple shapes, most overt symbols of fecundity and abundance, are similarly found in ritual bronzes. The marked contrast between the incurving waist, the open arch of the handles, and the swelling forms of the supporting lobes renders this vessel interesting also from the formal point of view.

Painting, sculpture, and architecture, major art forms of later times, held a lesser position in the Shang culture. Michael Sullivan, in his *Introduction to Chinese Art,* is probably correct when he says that, in the house of an Anyang nobleman, ". . . we would have seen *t'ao t'ieh* and beaked dragons, cicadas and tigers, painted on the beams of his house and applied to hangings of leather and matting about his rooms, and, very probably, woven into his silk robes," but this is hardly the type of painting which would qualify as a dominant art form. Paul Pelliot reported traces of painted designs seen on Anyang woodwork which resembled designs on ritual bronzes. Only the most scanty remains of Shang painting have been discovered.

Few sculptures, either, have survived from the Shang period. Marble carvings have been found at Anyang and other sites. While some of these represent human forms, most are animal figures of the usual symbolic types. The small bear in the Singer collection (Plate 13) comprises only basic forms rather than realistic detail. Like much primitive sculpture and some of the most modern, emphasis is upon abstract, geometric shapes and planes rather than upon modeling in the round. The result is strong and aesthetically pleasing but seems lacking in technical skill when compared to bronzes and jades of the period.

The little that is known about Shang architecture comes from inspection of tombs and building foundations. Although these provide some data on methods of construction, much remains speculative. Since stone remains are generally limited to base pieces for pillars, the chief building material must have been wood. Again, since neither brick nor tile was yet known, packed earth was probably used in the walls and straw thatch in the roofs. Judging from imitative bronze forms, roofs were gabled or hipped. We have fragmentary evidence of painted woodwork and of woodwork carved and decorated with inlay. But the largest foundations excavated at the Shang capitals measure about ninety feet on a side, and

therefore the palaces and temples, compared with those of contemporary Egypt and Asia Minor, could hardly have been impressive. However, since the rural people surely lived in primitive huts and in caves, as many Chinese do to this day, the higher forms of Shang architecture would have been locally impressive.

While their prehistoric predecessors had lived in nothing larger than villages, the Shang period knew large cities with populations in the thousands and with special districts for the aristocracy, priests, and the various craft guilds such as metalworkers, potters, wood carvers, and stonemasons. The walled inner part of Ao, the first Shang capital, included 3.2 square kilometers (about 1.23 square miles). The built-up area of the later capital at Anyang comprised some 15 square kilometers (about 5.79 square miles). The Shang royal palace stood in the center of the city facing south, since the ruler was likened to the North Star. With the exception of Egypt and Mesopotamia, the Chinese civilization of this time was the most advanced in the world, and even its fragmentary remains are a living testimony to the great culture which the Shang people had evolved.

CHAPTER THREE

The Art of
the CHOU DYNASTY

(c. 1100 B.C.–221 B.C.)

AFTER SOME five centuries of rule, the deteriorating Shang dynasty was succeeded by the Chou. This change of dynasties was more political than cultural in nature. Chou was a buffer state on the western frontier in what is now Shensi Province. The ruler of Chou, in displacing the dissolute last Shang emperor, contributed primarily political and military vitality, attributes fostered by continual threat of invasion of the rich valley regions to the east of Chou by barbarians from the west. Since Chou was a frontier region, direct cultural contribution from Chou political dominance would have been doubtful in the extreme. But this rule—the longest in Chinese history, covering the eight centuries between 1100 and 221 B.C. —eventually encompassed one of the most creative epochs in Chinese art and philosophy.

In contrast to the Shang period, during which the only written records were in the form of oracle bones and inscriptions on bronze, the Chou period produced a rich and varied literature. Most of the Chinese Classics were composed during the latter part of this period. Among them are the *I Ching,* or *Book of Changes,* a manual of divination for foretelling the future; the *Shu Ching,* or *Book of History,* a collection of documents, speeches, reports, and legends concerning the early history of China; and the *Shih Ching,* or *Book of Songs,* an anthology of 311 poems. While most of these poems are of a purely lyrical nature, some have a political or legendary theme and others are sacrificial songs originally sung during

· 49

ritual dances. Arthur Waley has translated one of the latter as follows:

'With the Thing Purified, the Thing Bright,
With our bullocks for sacrifice, and our sheep
We come to honour the Earth Spirit, to honour the quarters.
For our fields have all done well,
The labourers have had luck.
We twang zitherns, beat drums
To serve Field Grandad,
To beg for sweet rain,
So that our millet may be blessed,
Our men and girls well fed.'

[*The Book of Songs* (Boston: 1937), p. 170]

The greatest Chinese philosophical works are products of the later half of the Chou period. By this time, faith in magic seems to have declined in favor of a more rational, humanistic outlook. The most influential philosopher was K'ung Fu-tse, known in the West as Confucius. Living from 551 to 479, he was contemporary with Gautama Buddha and two or three generations earlier than his Western counterpart, Socrates. His sober and conservative philosophy, emphasizing tradition, propriety, and obedience, was based on human morality and values. He did not speculate about the Beyond. He held loyalty to rulers and filial piety to be the highest virtues and the traditional way to be the way of the superior man: "Try to be loyal and faithful as your main principle." While he valued learning and knowledge as the highest accomplishments, he sought not new knowledge as did the Greek philosophers of his time, but rather the wisdom of a prior golden age as recorded in the classics.

While Confucius and his follower Mencius exemplify the traditional, humanistic side of Chinese thought, Lao-tzu and his followers, the Taoists, represented contrary aspects: the mystical and lyrical. Lao-tzu is probably a legendary figure but is supposed to have written the *Tao Tê Ching*, or *The Way and Its Power*, a text probably dating from the middle of the third century B.C. As legend has it, however, Lao-tzu was a somewhat older contemporary of Confucius. This great, mystical work teaches the Tao, at once the Way and the Ultimate Essence. The Tao is like

water: while yielding, it wears away stone. The Taoist sage acts without action, teaches without words, learns by forgetting, and grows in wisdom by becoming as simple as a child. The wise man withdraws from the world, for in losing it he finds it. Through not desiring power, he becomes powerful, and by giving away riches he becomes rich. "Tao is forever, and he that possesses it, though his body ceases, is not destroyed."

Historians divide the eight hundred years of Chou rule into two main parts according to the location of the capital. During the Western Chou period, 1100–771 B.C., the capital was maintained in the traditional home-land of the Chou people near Ch'ang-an in Shensi. The Eastern Chou period, 771–221 B.C., begins with the removal of the capital to Loyang in Honan. Traditionally, the Chinese subdivided the latter period into the Spring and Autumn period, 771–481 B.C., and the Period of the Warring States, 481–221 B.C., when the Chou emperors were weakened by the growing power of the feudal lords. From the cultural point of view, this last period was the most fruitful, producing not only the great philoso-phies but also the finest art of the Chou era.

Since artistic and political developments during these centuries are not correlative, art historians use a different division: Early, Middle, and Late Chou. Bernard Karlgren, to whom we owe much of our knowledge of the chronology of ancient bronzes, suggests the following divisions:

Early Chou: 1050–900 B.C. Continuation of Shang styles.
Middle Chou: 900–650 B.C. Decline in magical symbolization; evolu-tion of new styles.
Late Chou: 650–200 B.C. Period of unparalleled artistic and intellectual growth. Emergence of painting and sculpture as important art forms. Revival of bronze casting, with innovations in shape and design.

Artistic evolution during this period is best traced through changes in bronze ritual vessels, which played a continuing role in the ceremonies of the feudal courts. Since Early Chou styles were merely a continuation of the Shang, differentiation of particular specimens out of context is usually difficult. But with the aid of controlled excavation and the lengthy inscrip-tions which became more common during the Chou period, certain bronzes have been specifically identified as being late Shang or Early Chou.

In the Early Chou period, certain common Shang shapes become rare and others disappear altogether—notably *ku* wine goblets, *chüeh* libation cups, *chia* warming vessels, and *fang-i* food containers.

In design, a marked early development is the appearance of projecting hooks at the flanges of vessels. In decoration, another change begins in the tenth century B.C. with a gradual decline of expressive power in the magical symbols. Designs become less dramatic, dissolving into flat, linear patterns that are more playful and decorative than symbolically evocative. The *tsun* at the Minneapolis Institute of Arts (Plate 16) shows this decorative trend. The sun bird, dragon, and bull motifs are inherited from Shang, but the intent of the artisan has changed. The barbaric force with which such patterns dominated the Shang vessels is missing. The pattern is primarily decorative in an aesthetic sense. Also, in the Early Chou period, the quality of the bronzework deteriorated, suggesting a technical regression.

These tendencies, both in decoration and in metalwork, become still more marked in the Middle Chou period, surely reflecting profound changes in society and culture. As the old religion weakened, magical symbols lost power and, if not abandoned altogether, were reduced to a purely decorative function. Seemingly, the symbolic meanings were actually being progressively forgotten, a process which seems almost completed by Late Chou times. Art historians usually speak of this period as being one of decline. Certainly, from the scanty remains found in Middle Chou sites, bronze vessels appear to have become both fewer in quantity and lower in quality. But the disappearance of old forms was accompanied by the creation of some new forms. Perhaps this evidence of a new outlook deserves more stress than does the passing of the older forms.

One type of vessel which became popular in Middle Chou times was the *kuei,* a food container. The bronze specimen in the Morse collection (Plate 17) is typical. The surface of the vessel is a series of plain ridges and grooves. The only symbolic device is the *t'ao t'ieh,* and this has been reduced to an ornamental motif. While Shang and Early Chou decoration was overtly grotesque and intentionally awe-inspiring, this *kuei* is restrained and sober, surely reflecting a more rational, mundane approach toward life.

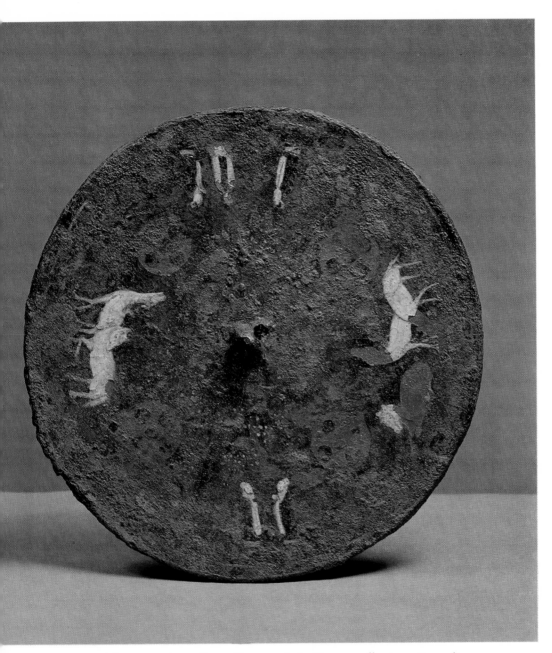

15. Painted bronze mirror. Late Chou period. Singer collection, Summit, New Jersey.

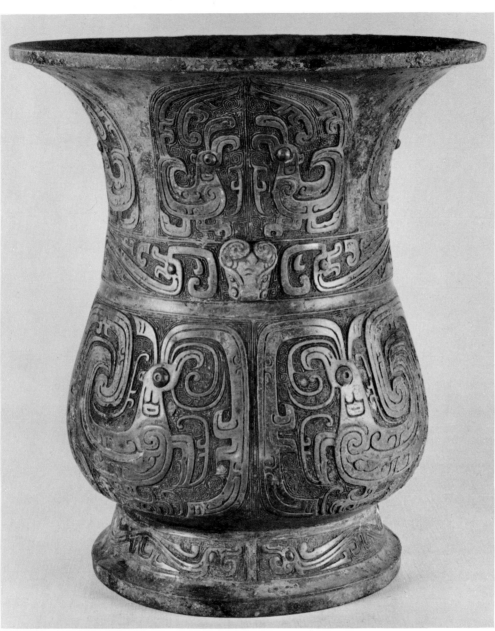

16. Bronze tsun (ritual wine vessel). Early Chou period. Minneapolis Institute of Arts.

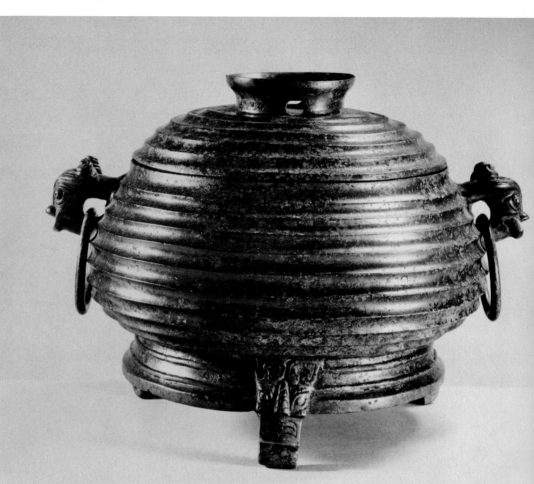

17. Bronze *kuei* (food container). Middle Chou period. Morse collection, New York.

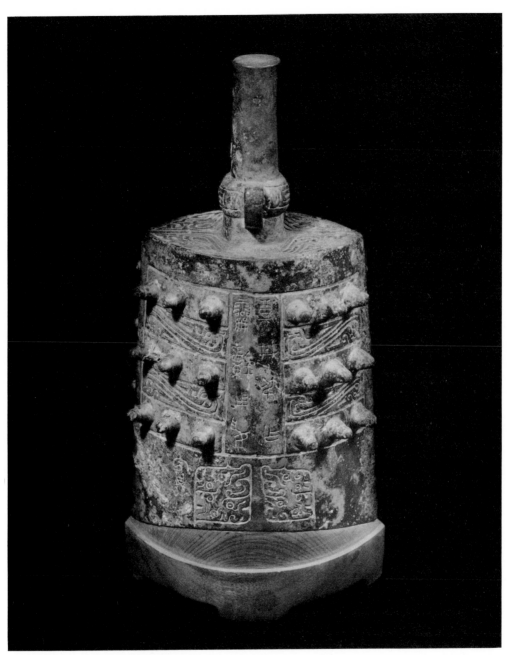

18. Bronze chung (bell). Middle Chou period. Morse collection, New York.

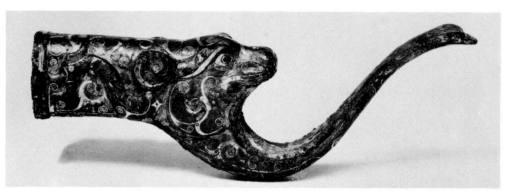

19. Bronze pole rest with gold and silver inlay. Late Chou period. Fogg Museum of Art, Cambridge, Massachusetts.

20. Bronze kuei (food container). Late Chou period. Brundage collection, De Young Museum, San Francisco.

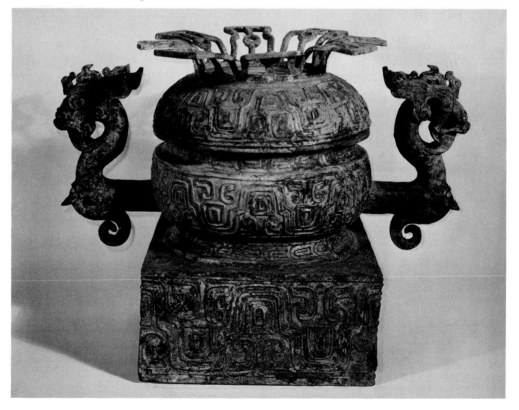

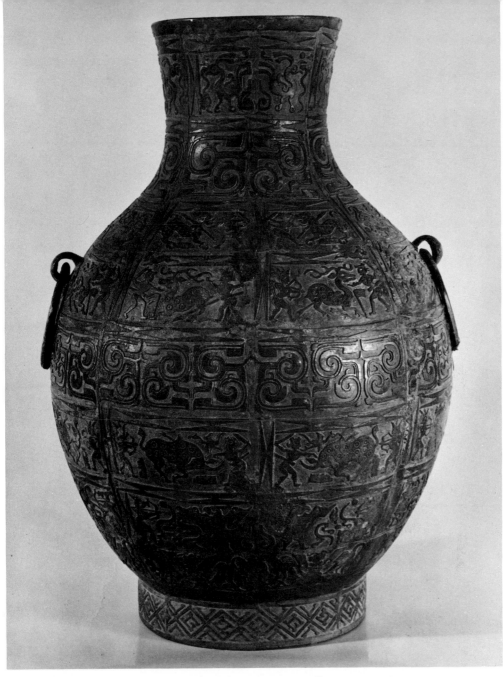

21. Bronze hu (jar). Late Chou period. Brundage collection, De Young
Museum, San Francisco.

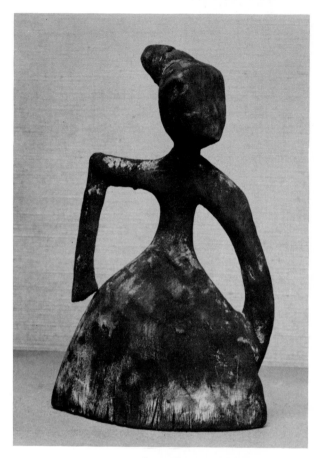

22. Wooden figure of dancing-girl. Late Chou period. Fuller collection, Seattle Art Museum.

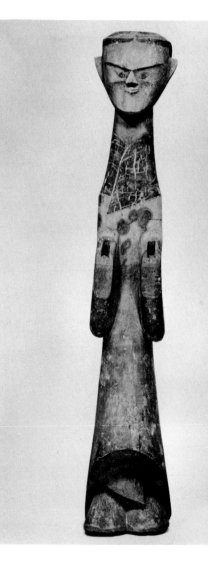

23. Wooden figure of man. Late Chou period. Fuller collection, Seattle Art Museum.

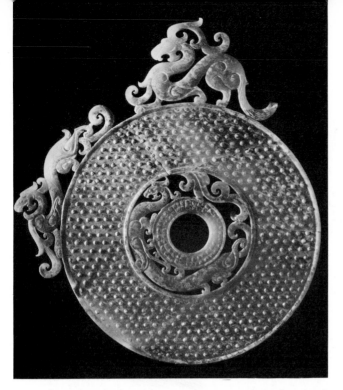

24. Jade pi (ritual object). Late Chou period. Nelson Gallery of Art, Kansas City.

25. Lacquered wooden winged cup. Late Chou period. Singer collection, Summit, New Jersey.

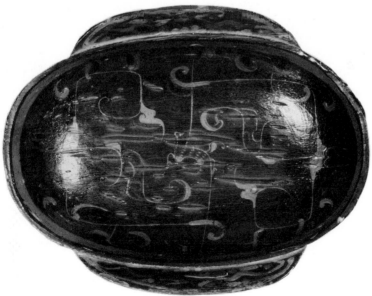

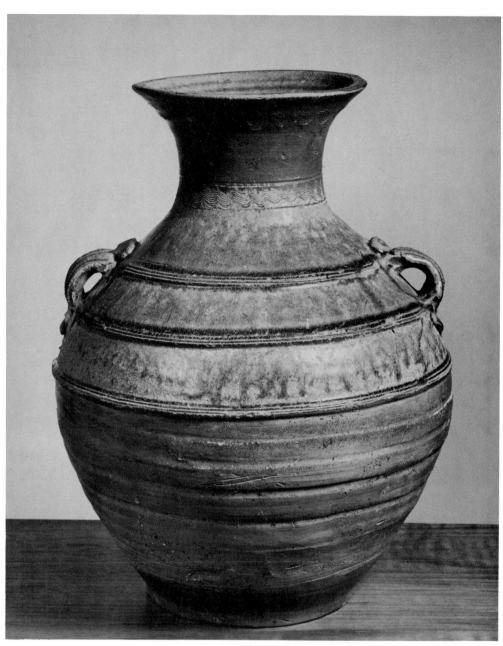

26. Glazed pottery jar. Late Chou period. Singer collection, Summit, New Jersey.

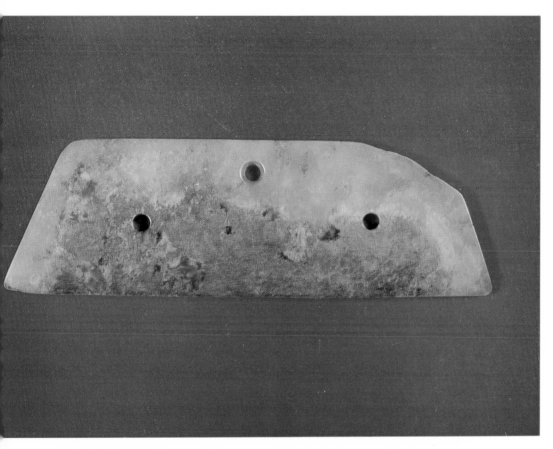

27. Jade ceremonial blade. Early Chou period. Munsterberg collection, New Paltz, New York.

Another shape then common was the *chung*, or bell, such as the one in the Morse collection (Plate 18). The form here is very severe. The incised figures of dragons and birds appear against a plain background, rather than as raised figures against a low-relief, spiral-pattern background, and bands of nipplelike projections alternate with bands of decoration. Other new shapes which appeared in Middle Chou times were the *fu*, a square dish; the *i*, a sauce-boat shape; and the spiral horn.

As is so often the case in the history of art, drawing a sharp line between the end of Middle Chou and the beginning of Late Chou is difficult. Karlgren has chosen 650 B.C. Others have suggested 600 B.C. We lack the evidence necessary for precise delineation, and the change that finally becomes apparent probably developed gradually, differing in time from region to region and from place to place within regions. Certainly chronology differs between the northern and southern regions, and, as we have seen, the more remote border regions preserved a neolithic pottery culture well into the Chou period.

The bronze *kuei* in the Brundage collection at the De Young Museum illustrates the process of transition from Middle Chou to Late Chou decorative style (Plate 20). Similarity to bronzes found at the seventh-century Hsin Cheng site serves to date this piece. Middle Chou style persists in the decorative surface patterns: abstract low reliefs on plain backgrounds. Late Chou style is forecast by the dynamism expressed in the swirling volutes composing the dragon-shaped handles and also by the intricate linear design of the projecting members on the cover. In the terminology of European art, "baroque" best describes these new aspects, in contrast to the more restrained, "classical" style of Middle Chou. By the sixth century, swirling dragon and snake forms, spirals, whorls, and projecting animal heads completely dominated Chinese art and are thus distinguishing features of Late Chou style. The unending series of interlacing and intertwining hooks, spirals, and animal forms which typically decorate the surfaces of Late Chou vessels resemble ornamental designs found in early Celtic manuscripts. A similarit ywith designs found in the art of the steppes regions to the west may well indicate their more immediate source.

Among vessels popular in Late Chou times, the important jar-shaped *hu* originated as early as the Shang period. The *kuei* and *chung* shapes

were common, as were the *tui, tou,* and *ting* shapes. The appearance of decorated bronze mirrors indicates the more worldly character of Late Chou art. These mirrors are round, polished on the front, and decorated on the back. They were suspended by a silken cord passed through a perforated knob at the back.

New techniques in the art of inlaying bronze developed in the Late Chou period. Inlay materials included gold, silver, jade, turquoise, mother-of-pearl, and even the newly invented glass. Although Shang artisans had produced inlay work long before, the striking effects achieved in Late Chou times were quite new to Chinese art. The bronze pole rest in the Fogg Museum (Plate 19), inlaid with gold and silver in intricate and lovely designs, is a good example of Late Chou inlay work.

The narrative scenes which appear on bronze *hu* of the fifth century are of particular interest. These may reflect something of contemporary painting, an art form of which few specimens have survived. Executed in low relief, the background depressions may well have been filled with lacquer or some type of paste to achieve a smooth decorated surface. The entire surface of the *hu* in the Brundage collection at the De Young Museum (Plate 21) is covered with bands of decoration. The designs in the bands at the base of the neck, at the midsection, and around the base are purely abstract and decorative. The others, however, are pictorial panels filled with lively, vigorously executed scenes of action. In the upper band, birds and snakes are shown in combat. In bands below the neck, hunters are shown killing tigers, deer, and bison. Near the bottom, bird-men are shown shooting snakes and birds. Rather than symbolical intent, as in Early Chou designs, or purely ornamental intent, as in Middle Chou decoration, these hunting scenes seem to have a pictorial, narrative purpose outweighing their possible connection with hunting magic. They represent scenes from contemporary life in fairly realistic style and, for the first time, portray human figures in action.

Sculpture, previously only a minor, sporadic art form, assumed an important role in the course of the Late Chou period. Although limited to small-scale figures, the output seems to have been large and varied. Early examples, dating from the beginning of Late Chou, tend to be crude and rigid. Bronze, wood, stone, clay, and jade were used with increasing skill, however, and quite realistic effects were achieved by the

end of this period in the portrayal of both animal and human figures.

Some of the most impressive Late Chou sculptures represent the dragon. The dragon's sinuous serpentine form, uniquely suiting the taste of the period, was an especial favorite. Other animals frequently portrayed were tigers, bears, water buffaloes, rams, phoenixes, pheasants, cranes, and owls. Toward the end of this period, horses were represented for the first time in Chinese art.

This more rational outlook is evidenced also by Late Chou sculptures of the human figure. No longer limited to representations of supernatural creatures, these portray mundane, contemporary subjects including dancers, wrestlers, and servants. The contrasting wooden sculptures discovered in tombs at Ch'ang-sha in the southern province of Hunan are especially interesting. One group comprises grotesque monsters with protruding tongues and huge insect eyes. But the other group, probably grave figures intended to accompany the dead into the realm of the spirits, are nonsymbolistic representations of men and women of the day. The naïve charm of this latter group can be seen in the unaffected, plastic treatment of two such carvings now in the Fuller collection of the Seattle Art Museum (Plates 22, 23).

Only the scantiest remnants of Late Chou painting have survived. The few paintings discovered have been found in recent years, principally in tombs of the Ch'u people at Ch'ang-sha. Most of these are paintings in lacquer on wood. At least one painting on silk, however, has been recovered. In this fourth- or third-century work, a woman is shown in side view standing in an attitude of supplication beneath phoenix and dragon figures. Since both are ancient sky symbols, the phoenix standing for the sun and the dragon for rain, the woman figure probably represents a fertility priestess of an agrarian religion. Here the skillful use of the brush and reliance upon line rather than color or shading have produced a remarkably spirited piece of art, evidence that painting was a developed art form by the end of the Late Chou period.

Another piece of silk bears decorative plant designs and creatures half human and half animal. Also, various painted designs decorate boxes, bowls, dishes, coffins, shields, mirrors, and shells excavated at Ch'ang-sha—items remarkably well preserved under water. A mirror in the Singer collection (Plate 15) is decorated on the back with a handsome composi-

tion in color. Red discs alternate with white horses and blue-robed human figures in a skillful arrangement applied with accomplished brushwork— a testimony to the level of achievement of the late Chou painters.

The spirit of the Late Chou period found its highest expression in jade carivngs. Never before or after has this substance, so precious to the Chinese, been used with greater technical skill or more aesthetic imagination. While Shang- and earlier Chou-period jades tended to austere simplicity, as seen, for example, in the Early Chou ceremonial blade in the Munsterberg collection, New Paltz, New York (Plate 27), Late Chou jades express animated motion and, although of small size, are in the highest order of art. Outstanding among the thousands of Late Chou jades extant, the exquisite *pi* found by Bishop White at Loyang and now in the Nelson Gallery of Art in Kansas City (Plate 24) is in striking contrast to the unadorned discs from the Shang period (Plate 9). The graceful elegance of this symbol of heaven would grace the art of any culture. Bold curves and spiral hooks brilliantly sustain the sense of motion immanent in the dragon forms. The regular pattern of circular bosses enhances the sense of motion.

The varied shapes of Late Chou jades include the *ts'ung,* which complemented the *pi;* discs and rings used in the cult of the dead; beads and rings for personal adornment; garment hooks and clasps; sword fittings; archers' thumb rings; and small sculptures. Among jade sculptures, animal figures outnumber the human. The itgers, dragons, bears, bulls, and birds are of a historically symbolic character, but in this period the actual intent may often have been limited to secular decoration. The beauty of these jades depends more upon abstract design than upon naturalistic portrayal. Spirals and interwoven bands, some incised and others rendered in relief, are almost always present and always exhibit the animation and dynamic energy so characteristic of the art of Late Chou.

Lacquer was an important medium for decoration of wooden objects in the Late Chou period. This lacquer, as is true of modern-age Chinese and Japanese lacquer, was a natural type made from the sap of a species of sumac. Applied in thin, successively dried coatings, it becomes hard, impervious, and durable and can be polished to a high luster. Designs may be created in the lacquered surface by use of lacquer in two or more colors, or they can be painted on the polished lacquer surface. In Late Chou times,

lacquer was used extensively on toiletry boxes, cups, and dishes and on architectural members, coffins, and tombs. The many lacquer objects found in tombs at Ch'ang-sha suggest that this southern city was a center for this art form. A fine example of Late Chou lacquer work, the oval wooden cup with elongated, flangelike handles now in the Singer collection (Plate 25), is decorated with designs created in red, black, and brown lacquer. The outlines of the small, graceful, spotted deer in the center are integrated into the equally graceful abstract pattern of extruded spirals. This sophisticated elegance suggests a work from the very end of the Late Chou period, probably from the third century.

Pottery of the Late Chou period appears to have served primarily a utilitarian purpose. The strong, simple shapes have an attractive, honest directness and exhibit considerable technical development, compared with pottery of the preceding centuries. Both glazed surfaces and painted designs reappear in this period. Even so, pottery does not seem to have been one of the major creative art media in this period—shapes are largely derived from the metal wares, and the painted designs are almost identical with those on lacquer wares. The handsome Late Chou jar in the Singer collection (Plate 26), thrown on a potter's wheel and partially glazed, is a fine piece of ceramic ware and a tribute to the skill and good taste of these artisans.

Once again, period architecture is almost an unknown feature today. Surviving remains are limited to a few tombs and the foundations of a few structures. These suffice only for vague speculation. A few minor components, such as roof tiles decorated with the *t'ao t'ieh* design, have been found. The only evidence of structural forms has been pictorial—the best illustration being a drawing engraved on a bronze bowl found in Honan province at Hui Hsien. The tile-roofed, wooden building on stone foundations pictured here, being so similar to later specimens extant today, indicates a Chinese architecture flourishing in a period much earlier than that of its earliest physical remains.

CHAPTER FOUR

The Art of

the HAN DYNASTY

(206 B.C.–A.D. 221)

THE FINAL phase of the Chou dynasty, the Period of Warring States, had been culturally and artistically productive; however, the constant internecine warfare and repeated incursions of barbarians capitalizing upon this chaotic state disintegrated the ancient feudal confederacy. The Chou rulers, from the time they moved their capital from their western homeland to the eastern city of Loyang, had become progressively more decadent. Once again, the more virile leaders of a western border people conquered the heartland and proclaimed emperorship over China. The prince of Ch'in assumed the title Shih Huang-ti, "First Emperor," in 221 B.C. This strongman re-established the institution of empire so firmly that it survived his death and the weakness of his successor in the Ch'in line, to be carried on for some four hundred years under the house of Han, from 206 B.C. to A.D. 221.

The course of the Chinese empire during these centuries was remarkably similar to that of the Roman, both in time and in character. The Han dynasty expanded the frontiers of China into Korea and Manchuria in the north, Indo-China in the south, and westward into Central Asia to the frontiers of Parthian Iran and Kushan India. Thus, the empire of China physically abutted that of Rome. In short, China was unified at home and powerful abroad, undisputed master of the East, building a tradition of empire such that Chinese in modern times call themselves "Men of Han."

This was an age of material splendor. Literary accounts describe magnificent palaces and temples decorated with wall paintings and carvings. The palace of the "first emperor," Shih Huang-ti, was said to have measured 2,500 by 500 feet and to have accommodated ten thousand people. Unfortunately these wooden structures have not survived, but their reported size does not seem unreasonable for this early period. Consider the scale of the Great Wall, which was built during this time to protect the northern and western frontiers against the inroads of the barbarian nomads. This structure is of impressive scale even by modern standards—a monument to the architectural and engineering genius of the Han builders. Certainly their art was on a grander scale than any known before in China. The capital cities of Ch'ang-an and, somewhat later, Loyang, were among the largest and most civilized in the world of that time. Little wonder that the Chinese believed the capital of the Son of Heaven to be the center of the world and other countries to be inhabited by barbarians.

Most of the surviving Han-period art has been found in tombs. This funerary art connected with the cult of the dead may well have been the most prominent of the time. To a great extent, the cult of the dead was of more importance than the immediate welfare of the living, since the welfare of the living was thought to depend ultimately upon the good offices of the spirits of the departed. At death, the animal soul descended to earth as dust, and the human soul ascended into heaven as spirit. These spirits of the ancestors were also dependent in some ways upon certain attentions by the living. Spirits which had committed crimes while living were doomed to roam about restlessly and inclined to do harm to the living. Other spirits, for whom the correct rituals were not performed or for whom the proper respect was denied by the living, would also lose place in heaven and roam restlessly. Thus rituals and signs of respect were of the utmost importance. Countless Chinese folk tales tell of such spirits appearing as ghosts, animals, or beautiful women and haunting those responsible for their plight. Even in fairly recent times fear of unsatisfied spirits could become obsessive. Hung-wu, founder of the Ming dynasty, had been an orphan, and his parents, while living, had been destitute. He instituted official ceremonies for neglected ghosts.

Well-to-do people commonly prepared their burial sites long before death. Presentation of a coffin to one's parents was a mark of true filial

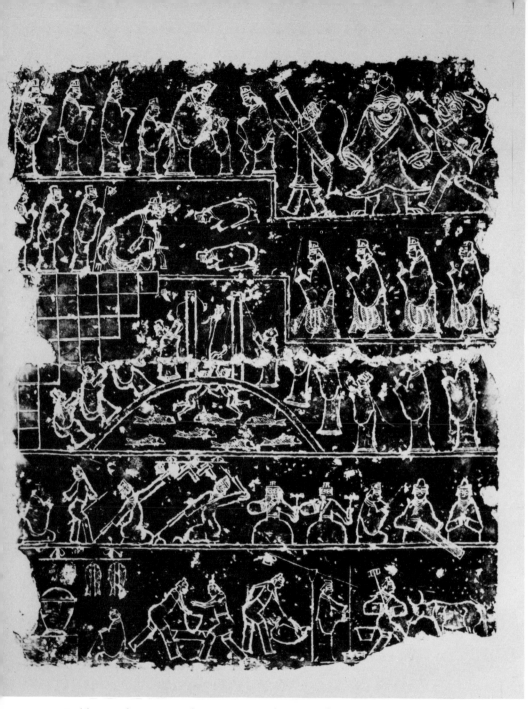

28. Rubbing of stone tomb picture at Chi-nan, Shantung Province. Han
period. Sickman collection, Kansas City.

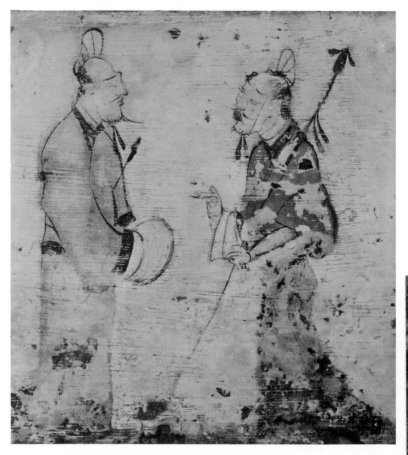

29. Painted tomb tile. Han Period. Museum of Fine Arts, Boston.

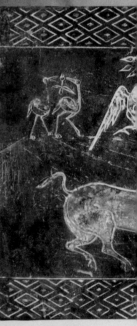

30. Impressed and painted tomb tile. Han period. Caro collection, New York.

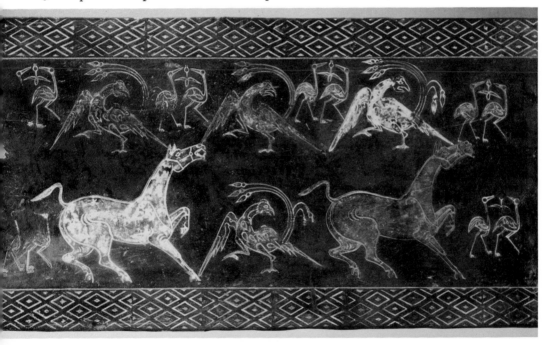

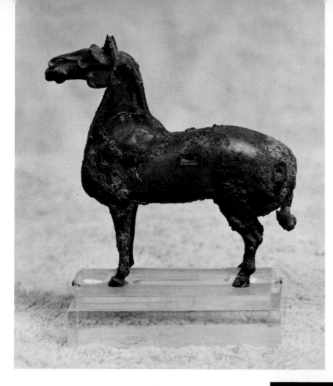

31. Bronze horse. Han period. Hart collection, New York.

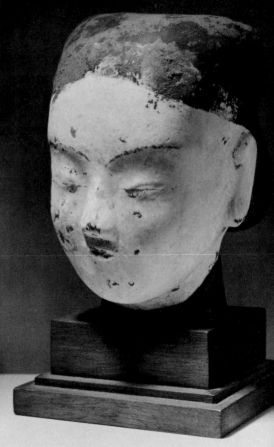

32. Head of clay tomb figure. Han period. Falk collection, New York.

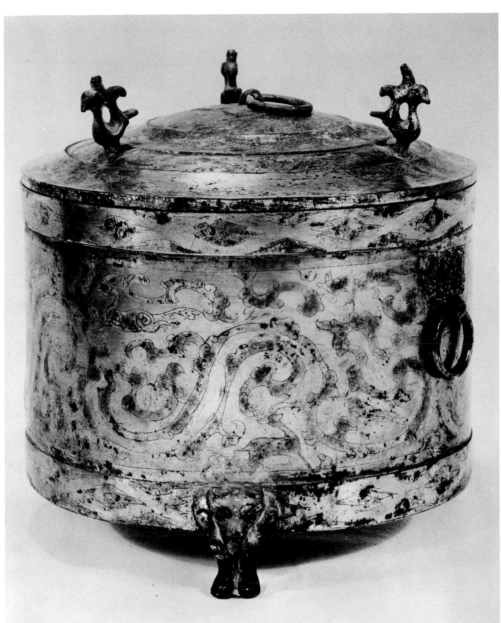

33. Bronze lien (toilet box) with gold and silver inlay. Han period. Minneapolis Institute of Arts.

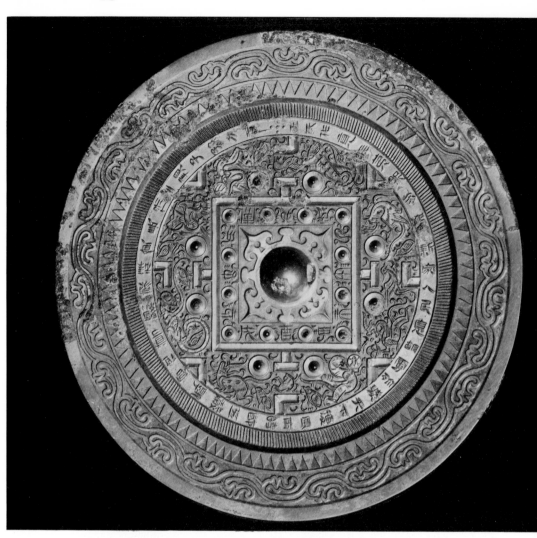

34. Bronze mirror with TVL pattern. Han period. Nelson Gallery of Art Kansas City.

35. Pottery jar with hunting scene. Han period. Hammer collection, New York.

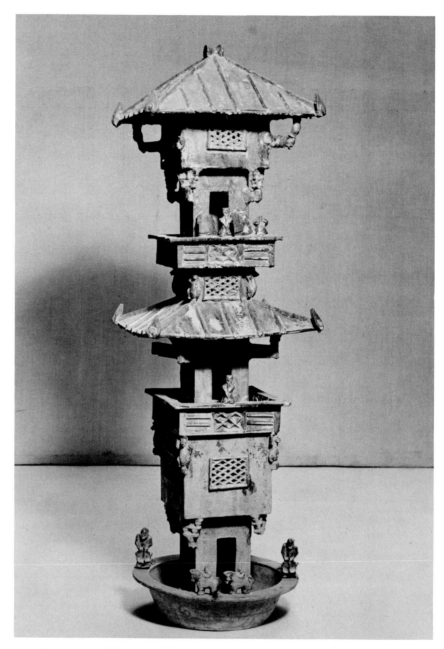

36. Pottery model of watchtower. Han period. Royal Ontario Museum, Toronto.

piety, a sign that parents could expect a worthy burial. Tombs, thought to be dwelling places of the spirits, were furnished with everything considered necessary in the life beyond. Consequently, excavation of grave sites has produced most of the surviving Han art. Many of the finest pieces have come from these "houses of the spirits."

From the Shang period through the Chou, ceremonial bronzes had been the major creative art form. Beginning with the Han period, painting and sculpture emerged as dominant forms. Both, in addition to becoming more prominent, were executed on a monumental scale. While the remains of these works are both scanty and fragmentary, literary accounts describe vast wall paintings and huge sculptures. The stylistic trend in the Han period was toward realistic portrayal of scenes having moral or social significance. The desire to recreate reality visually resulted in more sophisticated, facile techniques.

Many subjects depicted by the painters were drawn from Confucian teachings and illustrated proper moral behavior by portraying famous instances of loyalty to the emperor, filial piety, and such noble conduct as that of a wife sacrificing herself for her husband. Also on the more rational order, scenes from contemporary life showed the Han nobility engaged in feasts, official meetings, hunting expeditions, and military campaigns.

On a more mystical order, Taoist-inspired paintings showed scenes from the realm of the spirits, such as the soul of the departed driving to the palace of Hsi Wang Mu, the Mother Queen of the West, who sits on a dragon throne surrounded by worshiping spirits, or Tung Wang Kung, the King of the East, who presides over the Eastern Quarter. Other scenes showed spirits of the clouds and waters riding through the skies on dragons or fish. Still others portrayed the half-human, half-animal spirits and fairies that inhabited the Taoist heaven. The rulers and sages of antiquity were popular subjects. The legendary ancestors Fu Hsi and Nû Kua were represented with human bodies terminating in dragon tails.

The animals of the four directions were favorite motifs on the four walls of tomb chambers. These were the Red Phoenix of the South, originally a sun symbol; the White Tiger of the West; the Green Dragon of the East; and the Black Tortoise and the Snake, called the Somber Warrior, of the North. Sometimes the Yellow Dragon of the Center symbolized the Chinese concept of a fifth direction. In use since the Shang period,

when they had symbolized the powers of nature for magical purposes, these animal symbols now expressed the Chinese cosmology in accordance with astronomy, an eminent feature of Han-period intellectual culture.

One source of information about Han-period wall painting is the analogous low-relief carving found on the walls of Han tombs. Another such source is incised designs on clay tomb-tiles. Outstanding relief carvings have been discovered in Shantung Province at Wu Liang Tz'u, dating from a late Han era between A.D. 147 and 168. Similarly outstanding incised tomb-tiles have been found in Szechuan Province at Ch'êng-tu. A rubbing of a tomb picture incised in stone, taken in Shantung Province at Chi-nan, is now in the Laurence Sickman collection in Kansas City (Plate 28). A variety of human and legendary figures appears in abstract, linear style. The unrelated scenes appearing in tiers separated by horizontal lines form a balanced overall decorative pattern. The two lower panels depict a festival of Han times. In the lowest panel, cooks, bakers, and butchers prepare for the feast while, directly above in the next panel, musicians and dancers are performing. The central section portrays a famous story of an attempted recovery of an ancient bronze vessel from the lake inhabited by the dragon king. Robed dignitaries watch while the vessel is raised by ropes, an attempt frustrated at the last moment when the dragon king cuts the ropes. At the left of the uppermost section, deities of heaven are receiving spirits of the dead in audience just as nobles were received at the Han court. To the right, a weird Taoist deity holding a snake is flanked by two dancing figures. Although these funerary pictures are provincial in character and incised in stone rather than painted, they may nevertheless reflect to some extent the wall paintings of the time.

Of actual Han paintings surviving today, the most complete and best preserved are those painted on the walls of tombs in Manchuria at Liao-yang and in Hopei Province at Wang Tu. The latter, discovered in 1954, are mostly portraits of government officials shown bowing respectfully toward the occupants. The former depict horse-drawn chariots, men on horseback, and a festival scene in which musicians, jugglers, and acrobats perform in front of a tower. Although again provincial examples, and intended for the dead rather than for the great palaces and temples of the Han cities, these emphasize the human figure and depict contemporary life in the manner of the flourishing wall-painting art of the time.

Among the Han paintings in Western collections, the finest by far are on tomb tiles in the Boston Museum of Fine Arts. These originally graced the lintel and pediment of a very late Han-period tomb. The general theme is not apparent, but it consists of contemporary people conversing (Plate 29), playing, and dancing. The very accomplished style reveals an emphasis upon brushwork and calligraphic line, which became the outstanding characteristic of Chinese painting. The line is animated by varying width and intensity, while the subtle colors—reds, blues, and black, on a white slip—are of secondary importance. The result is a kind of shorthand in which the artist goes to the heart of the matter rather than seeking a surface likeness. These tiles demonstrate the Han painters' mastery of the art of portraying the essence of a scene with no attempt to recreate it in photographic detail.

Additional examples of Han painting have been found on all sorts of craft objects. Ceramic tiles upon which painting is combined with impressed or incised outlines are the most common, a typical example being the tile in the Frank Caro collection in New York (Plate 30). The horse and bird figures were probably repeated by using stamps, since the only variation seems to be in coloring and placement. Spacing is slightly irregular, and some figures are painted white while others are a reddish ochre. Yet this humble tile exhibits the same feeling for animated movement and calligraphic line so evident in the brushwork paintings. The exquisite sense of design characteristic of Han art appears especially in the figures of the phoenix and the prancing horse.

Paintings decorating lacquered objects, vases, and plates are remarkable for their brilliant brushwork. A group of lacquer pieces, apparently brought from Szechuan Province in China by a military garrison in Han times, was discovered in tombs in northern Korea at Lo-lang. The painting on these pieces is far more fluent and sophisticated than that of any extant Han wall painting, indicating that the stage of development reflected in the provincial tomb paintings may be minimally typical of the period. Again, the main subjects are human figures, notably ancient rulers, sages, filial sons, and other worthies. Dragons, also, are depicted among swirling clouds.

Similar subjects, rendered in the same free, animated style, decorate the surfaces of ceramic vessels. Although no Han-period paintings on

silk or paper have been recovered, literary records indicate that such painting flourished, and the finer paintings on such media as lacquer and ceramics may well be only a reflection of such art.

Sculpture in Shang times had been of small scale and simple design. By the end of the Chou period, it had increased in importance, but, under the Han rulers, it became monumental. The impetus for this development may well have been from the West, specifically Persia and Assyria, since Han expansion into Central Asia had brought China into close contact with the civilization of the Near East. Certainly earlier Chinese art had contained no prototypes of the large stone lions which appeared in Han art. Not the lion, but the tiger, had been considered the king of beasts. The single most famous of these large-scale Han sculptures is the stone horse trampling a barbarian which was erected at the tomb of the Han cavalry general Ho Ch'ü-ping, who had been responsible for many of the most spectacular victories over the barbarian nomads. Dated 117 B.C., it is a typical work of the early Han sculptor. The treatment of the horse shows a primitive strength as well as an emphasis upon the underlying form, suggesting the beginning stages of monumental sculpture. The gift of the Chinese for this type of art is already evident in the feeling for plastic form and linear movement, both of which are outstanding characteristics of Chinese sculpture. Literary accounts tell of large stone sculptures at an even earlier date, but it is doubtful that they ever existed.

Small sculptures continued to flourish, and it is among these that some of the finest Han work may be found. A good example is the bronze horse in the Hart collection (Plate 31), which combines natural observation with a feeling for sculptural form. Although very small, the effect of the horse is monumental, indicating the truly plastic character of the image. Another medium traditionally used for small-scale sculpture was jade, and many fine examples have survived from the Han period. While the earlier jades had usually represented fantastic beings, natural creatures like horses became popular in the Han period. Treated in a simple, rather abstract style, these jade carvings are often very beautiful and expressive.

The most common of the small sculptures are the grave figures, large numbers of which have been found in Han tombs. They are interesting not only as works of art but also from an archaeological point of view, helping to reconstruct many details of the period. A beautiful example of

a Han clay image is the head in the Falk collection in New York (Plate 32), which is typical of the finest of these grave figures. The sculptor, modeling the figure in clay with an emphasis on the rounded shape of the head, has added touches of color for the hair, eyes, eyebrows, and mouth, creating a vivid representation of the person portrayed. The grave figures show all sorts of people, male and female, Chinese and foreign, aristocrat and commoner, as well as many different domestic and wild animals, especially horses. Although produced by artisans on a mass scale, these small statues are often works of a very high order in which the sculptural style of the period finds fitting expression.

In addition to sculpture in the round, the Han artists used relief carvings with great success. Among the many Han works of this type, the finest are the reliefs decorating the pillars which flanked the roads leading to the tombs of the rulers and officials. The most famous are the ones at the grave of the Shên family in Szechuan Province. They show the symbolic animals of the four directions; the *t'ao t'ieh,* now used in a purely ornamental sense; and Taoist spirits riding on deer. Although the square pillars with their roofs and supports are marked by classical restraint and simplicity, the reliefs themselves, especially those representing the Red Phoenix of the South, show an inspired and dynamic treatment seldom equaled in Chinese sculpture.

Although painting and sculpture had become far more important in the Han period than ever before, the decorative arts continued to play a major role. Han luxury goods were outstanding both in quality and quantity. The silks of the period were highly regarded not only in China itself but also in the Near East, Egypt, India, and far-off Rome, where Chinese textiles and lacquers were much in demand. The route across Central Asia was called the Silk Road because it was traveled by caravans bringing Chinese silk to the West. It is thus not surprising that some of the best Han textiles we have were found not in China proper but in graves at Noin-ula in northern Mongolia, in Lou-lan in Chinese Turkestan, and in the Roman city of Palmyra in distant Syria. Woven in beautiful colors in a great variety of techniques, these silk fragments testify to the remarkable skill of the Chinese weavers. The designs are similar to those found in the painted decorations of the walls and in the impressed patterns on the clay tiles. Animals of all kinds are common, as

well as abstract ornaments in the shape of triangles, lozenges, and swirling cloud patterns. The most interesting are the embryo landscapes with mountains, trees, and hunting scenes or Taoist fairies. The style is flat and abstract, well suited for the two-dimensional nature of the textiles.

Equally popular were the Han lacquers, which have been found at many sites both in China proper and in the far-flung outposts of the Han empire. The most extensive group of these lacquers was found in northern Korea, but beautiful examples have also been discovered in Szechuan and at Ch'ang-sha in Hunan. Among the great variety of shapes, toilet boxes, bowls, cups, trays, and tables are particularly common. The red or black lacquer was usually applied to a wooden base and often decorated with beautiful ornamental designs in a typical Han style. Other lacquer objects were apparently inlaid with tortoise shell or gold and silver. Bronze, too, was used with lacquer, either for decoration or as handles or mounts. Few of these more elaborate lacquers have survived, but we do have literary accounts of them, and we know that they were greatly admired.

During the Han period, the bronze ritual vessels ceased to be of major importance. A few simple shapes were produced, more utilitarian in character in keeping with the more rational spirit of the age. The most popular types were the *hu*-shaped jar and the *lien,* a circular toilet box which has three feet, handles, and a lid. The finest of these had inlays of gold and silver like the handsome *lien* in the Minneapolis Institute of Arts (Plate 33). It is decorated with narrow swirling bands, suggesting hills or clouds, and various fluently rendered animals. The feet are in the shape of bears, *t'ao t'ieh* masks hold the handles, and there are three birds on the cover. The most exquisite of these inlaid bronzes are some small tubes in Japanese collections which show abstract landscapes with huntsmen and wild animals in a gold and silver inlay executed in a delicate linear design.

Another type of metal object was the bronze mirror, which had already been found in Late Chou tombs but became even more popular during the Han period. Bronze mirrors were polished in front and decorated on the back, the most common design being the one which Westerners call the TVL pattern, because it resembles the Roman form of these letters. According to Schuyler Cammann, who has made a special study of their symbolism, the design is actually a diagrammatic representation of the Han universe with the knob in the center symbolizing the dome of heaven,

the square surrounding it the earth, the four T shapes the gates facing the four directions, and the area beyond the center containing the animals of the four directions. A fine example of a mirror with the TVL pattern is the one in the Nelson Gallery in Kansas City (Plate 34). Other kinds of metalwork consisted of belt buckles, cloak hooks, and ornaments of all types worn by Han officials and nobles. Many were wrought of precious metals and inlaid with turquoise, jade, mother-of-pearl, and other substances.

While luxury articles were usually made of metal or lacquer, ceramics continued to be widely used, both in daily life and in the furnishing of graves so that the dead could enjoy all the things in the spirit world that they had been accustomed to on earth. The shapes used by the potters were often the same as those used by the metalworkers, notably the *hu* jar and the *lien* toilet box. But many other shapes were employed, the most interesting, perhaps, being the hill jars, which were supposed to represent the Taoist Isles of the Blessed. Another characteristic Han type is the tall jar with hunting scenes stamped or molded on the shoulder, as in the jar in the Hammer collection in New York (Plate 35). Han pottery is usually a reddish earthenware or stoneware, often covered with a green or yellowish lead glaze which sometimes becomes iridescent after burial.

Of the architecture, almost nothing is left, but here again the rich tomb finds are of help in giving us at least an idea of what Han architecture must have been like. Among the thousands of objects in the burial sites, there are numerous models of houses, courtyards, wells, pigpens, grain storages, and watchtowers which no doubt make use of the architectural conventions of the time. A good example is the tower in the Royal Ontario Museum in Toronto (Plate 36), which shows the kind of construction employed by the Han builders, the brackets, the tile roofs, the latticed windows, and the projecting balconies no doubt reflecting quite accurately the type of architecture current during the Han period.

The Art of

the SIX DYNASTIES PERIOD

(221–589)

THE DECLINE and disintegration of the Han empire resulted in a period of civil and foreign wars during which China was broken up into a number of smaller states and foreign barbarians conquered most of the north. The first phase of this era, when China was divided into three states, is known as the Three Kingdoms period (A.D. 221–265). The entire era (A.D. 221–589) is also referred to as the Six Dynasties period, after the six native Chinese dynasties which ruled the south of China from their capital at Nanking from A.D. 265 to 589. The most important were the Southern Sung and the Liang dynasties, which were looked upon as the legitimate successors of the Han house. The north, on the other hand, was ruled by a series of Turkic, Hun, and Tartar conquerors who established their own kingdoms, the most powerful and lasting of which was that of the Toba Wei rulers who controlled most of northern China from 386 to 556. Although of foreign origin, the Turkic Toba people adopted Chinese dress and Chinese culture. In time they became thoroughly sinicized, so that they must really be looked upon as a Chinese dynasty which played an important part in protecting northern China against other barbarian nomads and in establishing a stable and peaceful regime in the part of the country they controlled.

As this was a period of chaos and misery, it was only natural that China was ready for a new religion, especially one which promised deliverance from suffering and rebirth in a realm of eternal bliss. Buddhism, which

had already reached China during the late Han period, offered precisely these doctrines and now found the country ripe for conversion. Missionaries from India and Central Asia made the long, perilous journey across the deserts of the continent to spread the Buddhist gospel, and by the fourth century most of China had embraced the new faith. The barbarian rulers were especially favorable to the new religion, reasoning that they too were foreigners from the west and therefore had more affinity with Buddhism than with traditional Confucianist philosophy. It must not be thought that the new faith supplanted the old ones, for the Chinese continued to worship their ancestors and the forces of nature as well as to venerate the ancient sages, especially Confucius and Lao-tzu. Although at times a ruler who was a zealous follower of Confucianism or Taoism tried to suppress Buddhism as a foreign cult, it not only continued to flourish but also completely transformed Chinese culture, just as Christianity was profoundly changing the West during the same period. By the fourth century, Chinese Buddhist monks were making the arduous trip to India, the homeland of Buddhism, and bringing back sacred texts as well as statues and pictures of Buddhist deities.

In India they encountered a flourishing Buddhist church which, under the Kushan and Gupta rulers, had produced one of the great religious arts as well as a speculative philosophy of a type China had never known. The founder of Buddhism, the Indian teacher and sage Sakyamuni, had been dead for almost a thousand years, but the gospel of the Fourfold Path of overcoming desire and entering the ultimate peace of Nirvana had spread first throughout India and later throughout southern and eastern Asia. Sitting under the Tree of Wisdom at Bodh Gaya, the Blessed One had achieved Enlightenment, and in the Deer Park at Benares he had delivered his first sermon or, as the Buddhists put it, set the wheel in motion. He said, "There are two extremes, O monks, which should be avoided: there is the life of pleasure, which is base, ignoble, opposed to intelligence, unworthy, and vain; and there is the life of austerities, which is miserable, unworthy, and vain. The Perfect One, O monks, has remained far from these extremes and has discovered the way which passes in the midst, which leads to rest, to knowledge, to illumination, and Nirvana. Behold, O monks, the holy truth about pain: birth, old age, sickness, death, and separation from that which one loves—these are pain.

And behold the origin of pain: it is the thirst for pleasure, the thirst for existence, the thirst for that which is evanescent. And behold the truth about the abolition of pain: it is extinction of this craving by the annihilation of desire."

Since there had been no tradition in ancient China for representing deities in anthropomorphic form, it was only natural that pious Buddhists wishing to create religious icons would turn to Indian and Central Asian models. Not only were sacred images made of metal, wood, or clay brought back from India and the flourishing Buddhist monasteries in the oases of Central Asia, but also manuals on how to make images as well as banners showing the most celebrated Indian icons. The models of these images were believed to be supernatural, for according to Buddhist legend the sculptors actually went to the Tushita heaven in order to observe the deities and the divine palace so that they could produce faithful likenesses. It was through such bodily representations of the divine that the Buddhist artists hoped to make the spiritual manifest. As an inscription on a Buddhist stele says, "Since the divine doctrine is of subtle transcendence, it can be truly manifest only with words and images; since perfect knowledge is profoundly deep, there is no means of displaying the glorious signs of Buddhahood unless with representative figures." Or as another inscription says, "The supreme is incorporeal, but by means of images it is made manifest. . . . Thus unless the spiritual truth takes form and is discernible, how can we hope to comprehend the ways of the Buddha?"

The earliest extant Buddhist images are dated in the fourth century, and it is unlikely that more than a very few, if any, were made in China before that time. A characteristic example of an early image, dated 338 and made of bronze, is in the De Young Museum in San Francisco. It shows the Buddha seated in the yoga position with his legs crossed and his hands in the *dhyani mudra,* the gesture of meditation. He is dressed in a monk's garment, indicating that Sakyamuni, who had originally been a royal prince, had renounced the world and become a monk. On his head there is a protuberance, or *ushnisha,* which is a symbol of the Buddha's omniscience. His expression is serene, showing that he has overcome anxiety and found inner harmony in the knowledge of the Buddhist truth. Stylistically, the statue is based upon the Graeco-Buddhist images which were being produced in Gandhara; yet even in such early works,

when the Indian style was almost slavishly copied, the greater emphasis upon line and the more abstract treatment of the drapery indicate a marked Chinese influence which was gradually to transform the foreign style. The result was the emergence of a Chinese school of Buddhist sculpture which produced some of the greatest religious icons of all time. Gilded bronze was the favored medium, and metal images, some of colossal dimensions, were cast by the Buddhist sculptors of the fifth and sixth centuries. Other images were made of stone, clay, wood, lacquer, gold, silver, and precious stones. Most of the statues which have survived are stone, but this is largely because of the more durable nature of the material, since the metal images were often melted down, and many wood and lacquer statues were destroyed by fire.

Among the bronze images which have come down to us, one of the finest is the Buddha of 536 in the University Museum in Philadelphia (Plate 37). Executed under the Northern Wei dynasty during the early sixth century, it shows Six Dynasties Buddhist sculpture at its best. The once foreign style has now been perfectly adapted to native Chinese traditions. The round sensuous forms and curving lines of the Indian models have been transformed into angular shapes which give the figure a more abstract, two-dimensional character, thus bringing out the otherworldly nature of the image. The deity represented is Maitreya, the Buddha of the Future. He stands on a lotus base with a large flaming nimbus behind him. His hands are in the *abhaya* and *vara mudra,* the gestures of fearlessness and mercy, indicating that the faithful should approach him without fear, since he is filled with compassion. On his face there is a serene smile, suggesting the peace and spiritual harmony which he has attained.

Although the Buddhas were the chief deities in the Buddhist pantheon, there were many other sacred beings, the most important of which were the Buddhist saints, or Bodhisattvas, who were very prominent in Mahayana Buddhism. The most popular was Avalokitesvara, the Bodhisattva of Mercy and Compassion, known as Kuan Yin in China. He was often represented by the Chinese Buddhist sculptors, as for example in the bronze statue of 516 in the Stocklet collection in Brussels (Plate 38). In contrast to the Buddhas, who can be recognized by their monks' garments, short hair, and *ushnishas,* the Bodhisattvas are always dressed like Indian princes, with long hair, royal headdresses, and jewels and scarves decorat-

ing the otherwise bared upper part of the body. That the Brussels Bodhi-
sattva represents Kuan Yin is indicated by the attributes he holds, namely,
the bottle of heavenly nectar in one hand and the lotus, a symbol of purity
in Buddhist iconography, in the other. Instead of the flower, he is some-
times shown with a fly whisk, indicating that he is so compassionate that
he would not even hurt a fly but would brush it away with his whisk.
The style of the Brussels Kuan Yin is similar to that of the Philadelphia
Maitreya, both showing the same abstract, linear treatment characteristic
of the early sixth century.

The largest and most extensive groups of Chinese Buddhist sculptures
surviving today are found in the great Buddhist cave temples of northern
China. The earliest is in Kansu Province at Tun Huang, where excavation
was started as early as 366, but the most important, as far as sculpture is
concerned, are those at Yün Kang in Shansi and at Lung Mên in Honan,
which date from the fifth and sixth centuries, when this type of Six
Dynasties religious sculpture was at its height. At Yün Kang, which was
located near the Northern Wei capital, there are more than twenty caves,
the largest of which is seventy feet deep. The walls and ceilings of these
caves were covered with thousands of figures of Buddhas, Bodhisattvas,
holy men, and angels. The entire Buddhist pantheon was represented in
the sandstone caves, carved by pious monks and anonymous craftsmen
for the greater glory of the Buddha. The most impressive of these images
is the giant Buddha figure, made in imitation of the famous colossal
statue at Bamiyan in Afghanistan (Plate 39). Carved out of the rock of the
hillside at Ta-t'ung and flanked by two large standing figures as well as
a multitude of smaller images, it is a living testimony to the power of the
Buddhist church in the Six Dynasties period.

Even finer from an artistic point of view are the somewhat later sculp-
tures at Lung Mên, near Loyang, where the Wei rulers established their
capital in 495. Here, too, the interiors of the caves were once covered
with innumerable carvings of sacred beings dedicated by worshipers for
the benefit of their souls and those of their ancestors. Today, many of the
finest of these sculptures have been removed or wantonly destroyed, and,
as a result, the cave sites at both Yün Kang and Lung Mên are but sad
reminders of what they once were. However, China's loss was a gain for
the West, since wonderful sculptures from these sites have been acquired

by museums in America and Europe. An outstanding example, once in the Pin-yang cave at Lung Mên and now beautifully exhibited in the Nelson Gallery in Kansas City, is the relief carving of the Empress and her ladies doing homage to the Buddha (Plate 40). Here the Chinese feeling for flat, linear designs is wonderfully expressed, and the result is a panel of rare sensitivity and beauty. Another good example from Yün Kang is the Bodhisattva head in the Morse collection (Plate 41). The forms are elongated, with a tall headdress and exaggerated ears, and the expression is concentrated in the closed eyes and crescent smile.

In addition to the bronze images and the cave sculptures, the Buddhists also made many steles, which were probably derived from the memorial tablets already found in the Han period. They usually show sacred Buddhist figures, especially trinities, or scenes from Buddhist legends, as well as the donors who dedicated them. An excellent example is the stele in the Morse collection (Plate 42) which portrays Maitreya, the Buddha of the Future, in the form of a Bodhisattva flanked by two other Bodhisattvas. The Seven Buddhas of the Past, who had preceded the historical Buddha Sakyamuni, are shown in the halo of Maitreya, and on the base beneath the figures there are an earth demon and two lions, the animals being symbols of royalty. The figures are elongated and graceful, indicating that the stele dates from the early years of the sixth century, when this style was current. As in the Romanesque carvings at Vezelay and Moissac, the artist has transmuted the natural form into something abstract and two-dimensional, thus giving expression to the spiritual and metaphysical nature of the deities represented.

While the sculpture produced under the Wei dynasty during the first half of the sixth century had this highly stylized form, the sculpture made under the Northern Ch'i and Northern Chou dynasties during the second half of the century showed a more plastic style, reflecting renewed Indian influences. A good example of a Northern Ch'i image is the white marble Buddha head in the Morse collection (Plate 43). In contrast to the earlier Yün Kang head (Plate 41), this sculpture has a fuller, rounder form and a feeling of sensuous beauty. The proportions of the head are quite different, corresponding more closely to Indian standards, and the effect is one of human warmth and serenity characteristic of the Buddhist art at the end of the Six Dynasties period.

Although Buddhist painting was no doubt equally important, almost nothing of the work produced by Six Dynasties painters has survived. Executed on perishable materials, such as the walls of wooden temples or silk and paper, they had disappeared long before our time. The only exceptions are the wall paintings in the caves at Tun Huang, which, though a provincial version of contemporary Chinese work, reflect quite accurately the style and iconography of the Buddhist painting of the age. Tun Huang, at this time a great religious center, was the last Chinese town on the road to India, and thus a meeting place for Buddhist pilgrims, scholars, artists, and merchants. Here the roads which led across Chinese Turkestan started, and here the pilgrims returning from the holy sites of India reached the boundary of their native land. Naturally these travelers brought back many foreign ideas and influences, and the wall paintings at Tun Huang reflect this mixture of styles and concepts.

Among the paintings dating from the Six Dynasties period, two main styles can be distinguished. One is very similar to that of early-sixth-century Northern Wei sculpture, emphasizing linear accents and elongated forms, while the other, probably from a somewhat earlier period, is closer to Indian and Central Asian prototypes. A good example of the second kind is the paradise scene in Cave 135 (Plate 44). It shows the Buddha with Bodhisattvas, music-making angels, or *apsaras*, and row upon row of donors. The size of the figures indicates their importance in the Buddhist hierarchy, with the Buddha himself the largest, the Bodhisattvas about half as big, the angels smaller than the Bodhisattvas, and the donors, as mere humans, reduced to a tiny size. Equally interesting are the various styles employed. The donors, being Chinese, are portrayed in a typically Chinese manner, their forms two-dimensional and abstract. But the sacred figures, being Indian deities, are shown in a Central Asian version of the Indian Cupta style of Ajanta—that is, the rounded Indian forms are reduced to a more linear pattern. The shading so prominent in Indian painting is also less emphasized, although the rhythmic movement remains. The most typical paintings in the Chinese style are found among the Jataka scenes of Cave 110 in which the previous incarnations of the Buddha are represented. Their color patterns are especially beautiful, with bright decorative shades of turquoise, blue, brown, yellow, and white; and they show the earliest examples of Chinese landscape painting.

Almost nothing is left of Six Dynasties Buddhist architecture, in spite of the fact that during these centuries thousands of temples and monasteries were erected all over China. Built largely of wood, these structures have long since perished. Many were destroyed during the various Buddhist persecutions, others were lost in wars or fires, and still others fell victim to the neglect of later ages when Buddhism no longer was a living faith. The Chinese have never thought of architecture as a major art form. They looked upon it as a utilitarian activity undertaken by artisans who were not the social equals of painters and calligraphers and therefore could never produce anything of real importance. It was assumed that since their work was made of wood, it was not permanent, and as this type of construction was inexpensive, it could always be rebuilt when the need arose. More permanent materials, like stone or brick, were used primarily for bridges, walls, tombs, and, at times, pagodas, while the temples and palaces as well as the houses were almost invariably built of wood on stone foundations.

In China itself, the only authentic buildings dating from the Six Dynasties period are a few stone pagodas—that is, Buddhist memorial towers—the most remarkable being the large, twelve-sided pagoda of the Sung-yüeh Temple on Mount Sung in Honan, which dates from 523. However, in Japan and Korea there are numerous structures which reflect the Six Dynasties style. The most famous are in Japan: the wooden buildings of Horyu-ji temple in Nara, where up to a few years ago, when it was destroyed by fire, there was an authentic seventh-century temple hall (Plate 45). Called the Kondo, or Golden Hall, its chief purpose was to contain the Buddha images which stood on a dais in the central space of the sanctuary. Although the roofs have been changed, the one on the ground floor having been added later and the others modified to suit Japanese taste, this is basically the structure which was erected some thirteen hundred years ago, making it the oldest wooden building in the world. The basic design of the Kondo consists of a raised stone platform, a series of supports in the form of wooden pillars, and a huge, overhanging double roof made of clay tiles. The walls, which in Western architecture usually serve as supports, are merely partitions screening off the interior space. The dominant element in Chinese architecture is the huge roof, which is usually hipped or gabled. It is this feature that is particularly fine

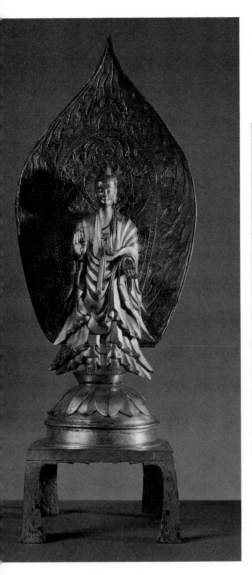

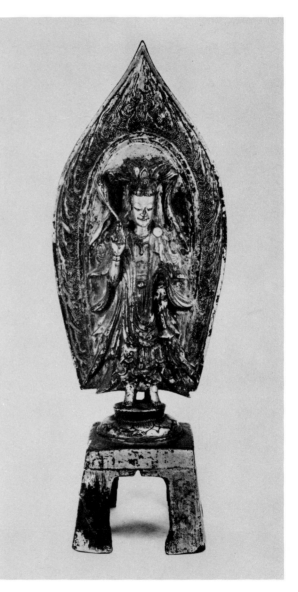

37. Bronze Buddha Maitreya. Six Dynasties period (Northern Wei). University Museum, Philadelphia.

38. Bronze Bodhisattva Avalokitesvara (Kuan Yin). Six Dynasties period. Stocklet collection, Brussels.

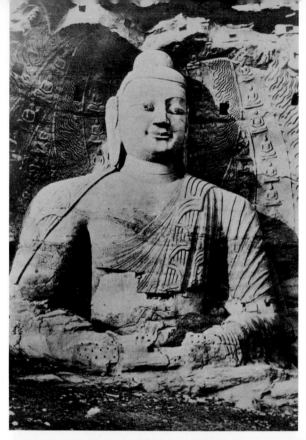

39. Stone Buddha. Six Dynasties period. Yün Kang, Ta-t'ung, Shansi Province.

40. Stone relief carving from Lung Mên. Six Dynasties period. Nelson Gallery of Art, Kansas City.

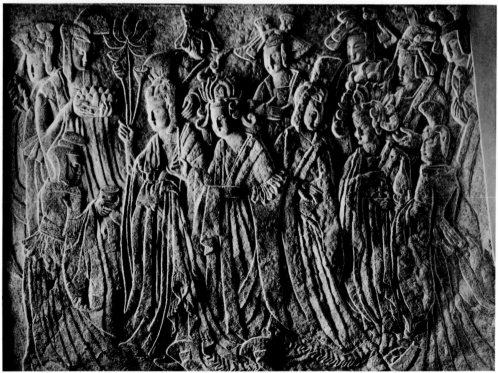

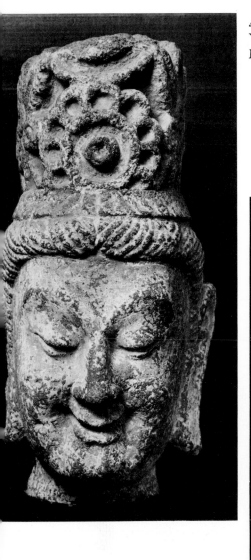

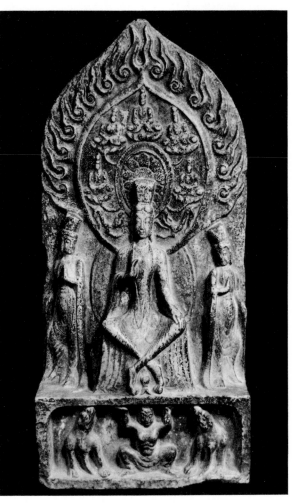

41. Stone head of Bodhisattva from Yün Kang. Six Dynasties period. Morse collection, New York.

42. Stone stele with Buddha Maitreya and two Bodhisattvas. Six Dynasties period. Morse collection, New York.

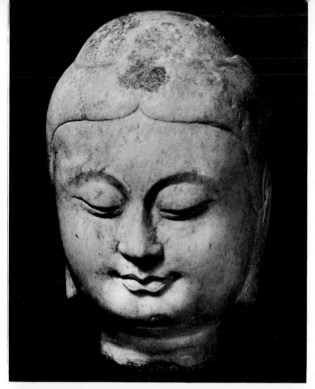

43. White marble head of Buddha. Six Dynasties period (Northern Ch'i). Morse collection, New York.

44. Wall painting of Buddhist paradise scene. Six Dynasties period. Tun Huang, Kansu Province.

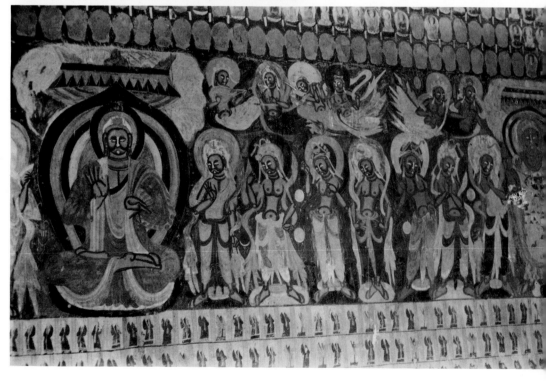

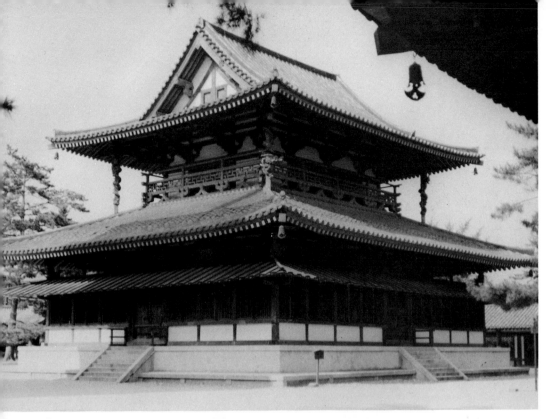

45. Kondo (Golden Hall) of the Horyu-ji. Asuka period. Nara, Japan.

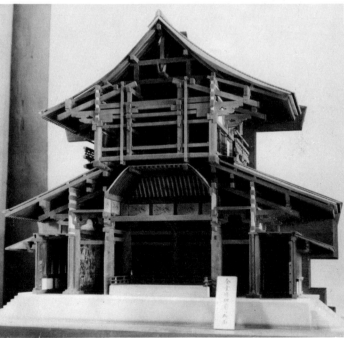

46. Model of interior of Horyu-ji Kondo. Nara, Japan.

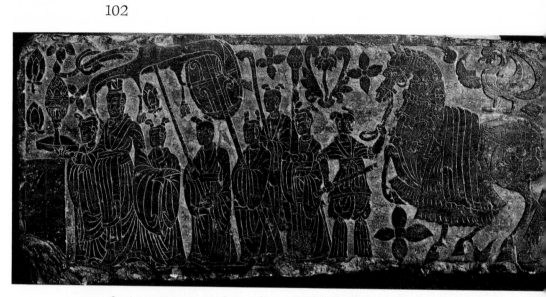

47. Stone engraving on base of Buddhist stele. Six Dynasties period. University Museum, Philadelphia.

48. Stone engraving. Six Dynasties period. Yamanaka collection, Kyoto.

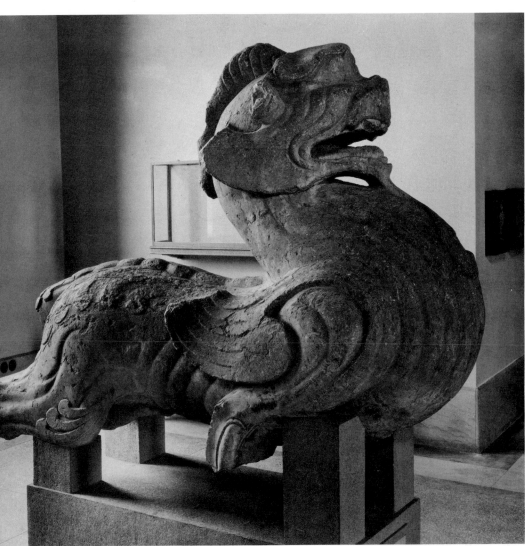

49. Stone chimera from a Liang tomb. Six Dynasties period. University Museum, Philadelphia.

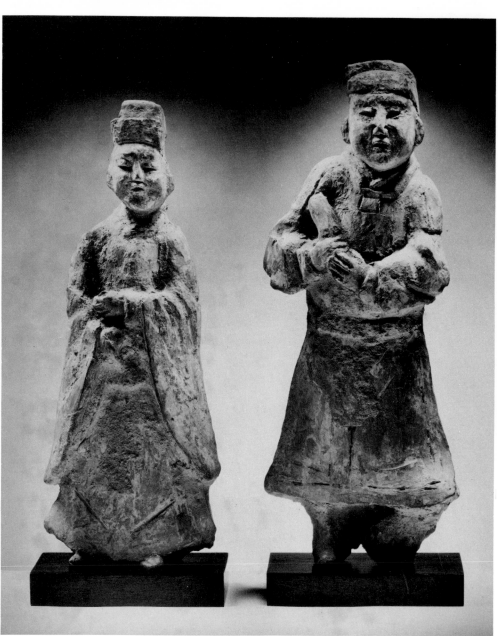

50. Clay tomb figures. Six Dynasties period. Singer collection, Summit, New Jersey.

in Far Eastern architecture, for it is the roof with its gently curving eaves, beautiful tiles, and graceful yet strong silhouette that gives these structures their distinctive appearance. The woodwork in the pillars, beams, brackets, balustrades, and lattices is also often of great beauty and was usually painted red and lacquered to protect it from parasites and decay. In the early structures, such as the Kondo, these members are simple and utilitarian, creating a pleasant design.

The interior of such a temple hall was looked upon primarily as a repository for sacred images rather than as a place for congregational services. In this respect the Buddhist temple was much like the Greek, whoes innermost sanctuary was thought of as the dwelling place of the god. A small-scale model of the interior of the Horyu-ji Kondo indicates what the inside of this structure is like (Plate 46). The central space, which is almost completely filled by the raised platform on which the images stand, is formed by three bays and surrounded by one broad bay aisle to which a kind of porch was added in later times. The ceiling over the center space is somewhat higher than that over the aisles, but compared to the height of the building itself, the ceiling is low, because the entire upper part is used for an elaborate system of wooden beams to support the heavy tile roof. Consisting of a series of horizontal beams, vertical struts, purlins, and rafters, it was an intricate system of construction which could easily be adapted to the needs of the particular plan. Once evolved, it served Chinese and Japanese architecture admirably, and was used with very little change until modern times.

Although the advent of Buddhism and the growth of a vigorous Buddhist art were the most important artistic developments in China between the end of the Han period and the beginning of the T'ang, the more traditional Taoist and Confucian art continued to flourish. Its center was the court of Nanking, where Han-period conventions still held sway. Among the arts, painting had the leading role. Literary accounts of the time tell us of schools of painters whose names were recorded and whose works were highly praised. Although many of their subjects came from Buddhist lore, the majority were traditional, such as Taoist landscapes with fairies and spirits, Confucian scenes of ancient sages or paragons of filial piety, the animals of the four directions, the constellations, and portraits of famous rulers and their ministers. These pictures were usually

painted in color on walls or in horizontal hand scrolls of silk or paper.

Very little of this painting has survived. The only artist of whose work we can form some idea is the fourth-century master Ku K'ai-chih, who worked at the Chin court in Nanking and is said to have enjoyed a great reputation in his day. Three scrolls traditionally attributed to him are still extant. Two of them are Sung-period copies of the same scroll, a representation of the fairy of the Lo River, while the third is believed to be a T'ang copy of his *Admonitions of the Instructress to the Court Ladies*. The first scroll deals with Taoist tales, while the second is clearly Confucian, with strong moral overtones. The style of these paintings reflects that of the Six Dynasties, with slender figures, flowing draperies, and an animated linear design. The emphasis in Ku K'ai-chih's work seems to have been entirely upon the human figures, for the few landscape elements which do occur, such as mountains and trees, are treated in a very primitive manner.

The best indication of what this work actually looked like is not found in China proper but in the border areas, notably Manchuria and Korea. At T'ung Kou on the Yalu River, Japanese archaeologists discovered tombs with wall paintings in a somewhat provincial sixth-century style. The scenes show huntsmen on horseback pursuing tigers and deer, dancers, wrestlers, and, most delightful of all, Taoist spirits riding through the air on cranes and dragons. The style is very free, linear, and animated, recalling Han painting. Even more closely related to Han both in subject matter and style are the paintings in the tomb at Gukenri in North Korea, not far from Pyongyang. They are of very fine quality, and they have the expressive power and excellent brushwork that is found only in the best Chinese painting. It is possible that they are actually Chinese, for it is reported that Chinese painters from Liang were sent to Korea in 535.

Another source for our knowledge of the painting of that time is the engravings on the stone slabs and steles. Outstanding among these is the set of stone engravings on the sides of the sarcophagus in the Nelson Gallery in Kansas City, which depict stories of filial piety. Dated 525, they are executed with great care in a style far in advance of that of Ku K'ai-chih, especially in the treatment of space and landscape. Other examples of such sixth-century stone engravings are found on the base of a Buddhist stele in the University Museum in Philadelphia and on a stone slab in the

Yamanaka collection in Kyoto (Plates 47, 48). The first represents a group of donors who are making offerings to the Buddha, while the second shows figures in a woodland landscape. Although only linear drawings, these engravings nevertheless clearly reflect the style of the age and give us some idea of what the painting must have looked like.

During these centuries the first books about painting were written in China, dealing both with famous artists and with aesthetic matters. The most celebrated of these writers was Hsieh Ho, whose Six Principles for judging paintings guided art criticism for centuries to come. The first and most important principle was *ch'i-yün-sheng-tung,* the meaning of which has been much debated. Alexander Soper, who has made a special study of the term, translates it as "animation through spirit consonance." Perhaps the best modern word for this concept is inspiration, for the Chinese have always esteemed the artist who was inspired and have never thought that mere technical perfection made a great artist. The other terms are easier to define. The second is concerned with the structural method of the brush; the third and fourth say that the shape and the color should conform to the object represented; the fifth deals with the proper placing of design and composition; the sixth advises transmitting designs by handing on and copying. This last principle is very important, for in China copying old masters was always encouraged, a practice which no doubt was invaluable both for training artists and for preserving the designs of old paintings. However, it is also the main reason why determining the authenticity of ancient Chinese paintings presents such perplexing problems.

Sculpture was less important than painting in the non-Buddhist art of the period. The most remarkable sculptures are the monumental stone lions and fantastic monsters which lined the approaches to the tombs of the Liang and Southern Sung rulers near Nanking. A superb example of such sculpture is the chimera in the University Museum in Philadelphia (Plate 49), a work which shows the dynamic force and animation characteristic of these creatures. They go back to the larger stone sculptures of Han times, but they have a new sense of life and inner tension which is typical of the art of the Six Dynasties period. Another type of sculpture which continues older traditions is the clay tomb figure. A good example is the pair in the Singer collection (Plate 50). In contrast to the Han figures,

which were very abstract and showed little facial expression, these late-sixth-century sculptures are far more naturalistic, with a greater sense of the individual. The decorative arts had less chance to develop during these troubled and chaotic times. Judging from the few remains, both metal and lacquer works continued to be made, but they were inferior in quantity and quality. Only in ceramics were there any significant new developments, notably the appearance of the first porcelain, which was produced by the Yüeh Chou kilns in Chekiang Province in Southern China. However, it was in Buddhist art that the genius of the age found its most creative expression.

CHAPTER SIX

The Art of

the T'ANG DYNASTY

(618–906)

AFTER CENTURIES of disunity and strife, China was once again unified under the short-lived but strong Sui dynasty, which came to power in 589. A great patron of Buddhism and Buddhist art, this house was important in cultural as well as political spheres. Contemporary records report that under Sui rule 100,000 Buddhist images in gold, bronze, stone, sandalwood, lacquer, and ivory were made, and no less than 3,792 temples erected. However, this reign barely lasted a generation, and in 618 it was succeeded by the T'ang dynasty, which continued its policy of national unity as well as its patronage of Buddhism. The T'ang period, which lasted for three centuries, is usually regarded as the most glorious in Chinese history, for the country was more powerful and prosperous than ever before. China expanded her influence to adjoining regions, such as Central Asia, Korea, Indo-China and Tibet, and established closer trade and cultural relations with Japan. The population of China numbered fifty-two million, and the capital city of Ch'ang-an had no less than two million, making it one of the largest cities in the world. It was also one of the most cosmopolitan, and in its streets one could see Greek and Arab traders, Indian and Central Asian monks, Persian refugees from the Sassanian court, and even Nestorian Christians and Jews. All were permitted to build their own places of worship, whether Mohammedan mosques, Christian churches, or Zoroastrian temples.

During the earlier part of the T'ang period, Buddhism continued to

flourish, and Chinese pilgrims made the long journey to the holy sites of Buddhism. The greatest and most famous of these pilgrims was Hsüan Tsang, who went to Central Asia and India to study the sacred teachings in the homeland of the faith. The account of his travels is one of the most valuable sources for our knowledge of seventh-century Indian Buddhism, which was already in decline when Hsüan Tsang visited India. New Buddhist teachings became popular, some promi.ing salvation through faith in the Buddha Amitabha, and others stressing the secret, esoteric teachings of the Indian Tantric sects, and it was during this period that Ch'an Buddhism first appeared. Yet by the end of the T'ang era, Chinese Buddhism had also begun to decline, and after the great Buddhist persecution of 845 it never recovered its former position.

Taoism and Confucianism continued to flourish along with Buddhism, and emperors often supported all three religions simultaneously. Confucianism was particularly important in the political realm, where the civil-service examinations were based entirely upon Confucian classics, while the influence of Taoism was prevalent in literature. This was the age of the Taoist-inspired friends, Li Po and Tu Fu, who are still considered the greatest poets China has produced. And this was also an age of great painters and sculptors, for T'ang China was outstanding in all cultural endeavors, in this way comparable to Italy of the Renaissance.

The greatest patron of the arts continued to be the Buddhist church, and the most significant surviving monuments, certainly in sculpture and architecture, and also to a large extent in painting, were inspired by the Buddhist faith. Sui and T'ang Buddhist art showed a distinct Indian flavor as a result of the renewed contact with India, which, under Gupta rulers, had experienced one of its greatest periods of art. A good example of a Sui sculpture is the stone image of the Bodhisattva Kuan Yin in the Nelson Gallery in Kansas City (Plate 51), which, in contrast to the flat, linear style of the Wei images, is marked by a strong plastic feeling clearly reflecting Gupta influences. The forms are treated in a simple, geometric manner, with the linear accents of the jewels and scarves breaking up what might otherwise be a monotonous design. The feeling expressed in the image is that of deep spirituality, with the partially closed eyes and beatific smile mirroring the compassion of the sacred being.

This tendency toward full plastic form is even more marked in the

statues of the T'ang period. An example is the image of a Bodhisattva, originally from the caves of T'ien Lung-shan and now in the Boston Museum of Fine Arts (Plate 52). Again, the deity is Kuan Yin, the Lord of Mercy and Compassion, who can be recognized by the small image, in his headdress, of Amitabha, his spiritual counterpart. Since he is a Bodhisattva rather than a Buddha, he is portrayed as an Indian prince with jewels, diadem, and bare upper body. He stands in a dancelike position, with a swaying body and his hips thrust to the side. The forms are very full, even sensuous, showing how profoundly the Indian ideals of beauty have influenced the art of the time. In contrast to the abstract, spiritual style current during the early sixth century, these seventh-century carvings seem more worldly and naturalistic, and it is not surprising that a T'ang critic accused the Buddhist artists of making Bodhisattvas look like dancing-girls.

The most famous of T'ang Buddhist sculptures are found in the great caves at Lung Mên, which during the Six Dynasties period had already been a center of artistic activity. Here pious monks and humble stonemasons carved thousands of sacred images out of the living rock of the hillside. The most impressive is the giant image of the Buddha Vairocana, the great Cosmic Buddha, who was thought of as the foremost of the Dhyani Buddhas, the spiritual essence of Sakyamuni himself. In imitation of the great Buddha at Yün Kang, Vairocana is represented in the seated position. He is flanked by two huge images of Bodhisattvas; two monks, Ananda and Kasyapa; and four guardians, or *lokapalas,* originally the four heavenly kings of Hindu mythology. These guardians, who are almost five times life size, are among the most remarkable of all T'ang sculptures, and they show that the artists who could convey feelings of serenity and spiritual harmony were just as capable of rendering drama and power. A close-up view of one of the guardian figures at Lung Mên (Plate 53) shows this type of image at its best. The muscular body and fierce expression are typical of the guardians, whose function was to protect holy places by warding off evil spirits.

This feeling of an almost baroque sense of drama is particularly marked in the sculptures of the late T'ang period, an example of which is the marble lion in the Nelson Gallery (Plate 54), which has the finest and most representative collection of Chinese sculptures in the world. Although the

style is typically Chinese, the subject comes from Buddhist India. In traditional Chinese art, it was the tiger which was thought of as the king of the beasts and the guardian of the west, but in Buddhist art the lion was more often represented, for the lion was the emblem of the Sakya clan, to which Sakyamuni belonged, and the voice of the great teacher was likened to the roar of a lion. Usually two lions are seen flanking the throne, an idea no doubt derived from ancient Persia, where the ruler was called a lion among men, and the animal was looked upon as an emblem of power. This feeling of majestic strength is beautifully portrayed in the Nelson Gallery sculpture, which shows the lion with jaws opened so that you can almost hear the mighty roar. The head is exaggerated in a very forceful way, and the body, with its straining muscles and twisted back, adds to the feeling of dynamic power. Certainly a carving like this shows that the best Chinese sculpture is as fine as any in the world, even if the Chinese themselves did not consider their sculptors the equals of the great painters and calligraphers.

Although the bulk of existing T'ang sculptures are made of stone, there can be no doubt that many other materials, such as bronze, wood, lacquer, clay, ivory, gold, and silver were also used. Naturally the less durable images were more likely to be destroyed over the centuries, but enough have survived to form some notion of the rich output in media other than stone. In Japan, where much survives which has been lost on the mainland, there are still large bronze and lacquer statues from the T'ang period. Next to stone, the most popular material was bronze, which was usually gilded, giving expression to the concept of the Golden Buddha, who radiated light. Unfortunately all the large bronze images were melted down during later persecutions of the Buddhist church, but there are numerous small T'ang Buddhist bronzes in Japan and in the West. Two images, both in private Japanese collections, are good examples of the T'ang style. One shows the Buddha in a seated position, his legs crossed and the soles of his feet turned up (Plate 55). He is dressed in the monk's garment, with one shoulder bared, and his head has the *ushnisha,* or protuberance, and the large ears indicating supernatural powers. One hand rests on the left leg, while the other is raised in the *vitarka mudra,* the gesture of the exposition of the law, which is often used when the Buddha is shown addressing the assembly of the faithful. The

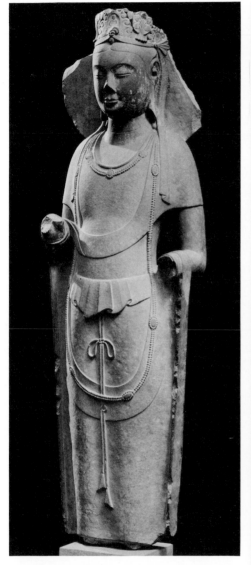

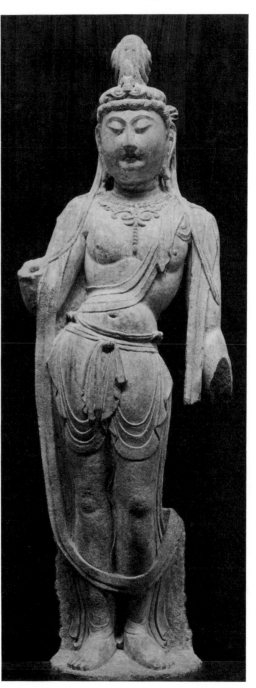

51. Stone Bodhisattva Avalokitesvara (Kuan Yin). Sui period. Nelson Gallery of Art, Kansas City.

52. Stone Bodhisattva Avalokitesvara (Kuan Yin) from T'ien Lung-shan. T'ang period. Museum of Fine Arts, Boston.

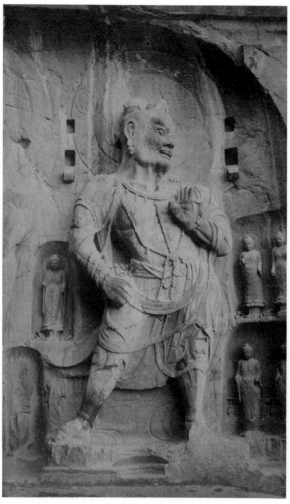

53. Stone guardian figure. T'ang period. Lung Mên Caves, Loyang, Honan Province.

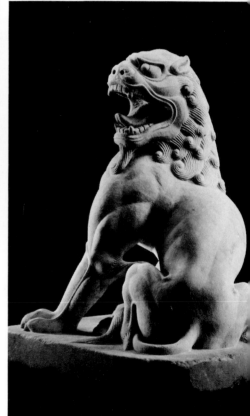

54. Marble lion. T'ang period. Nelson Gallery of Art, Kansas City.

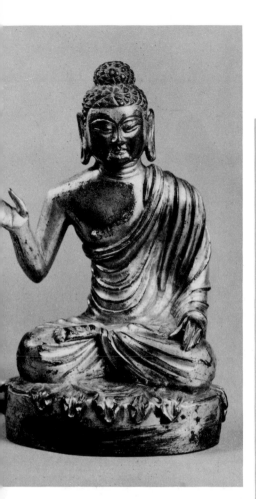

55. Bronze seated Buddha. T'ang
period. Private collection, Japan.

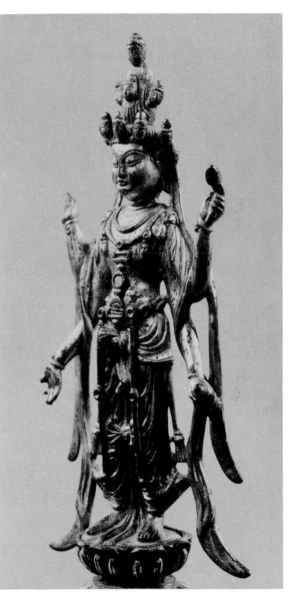

56. Bronze eleven-headed Avaloki-
tesvara (Kuan Yin). T'ang period.
Private collection, Japan.

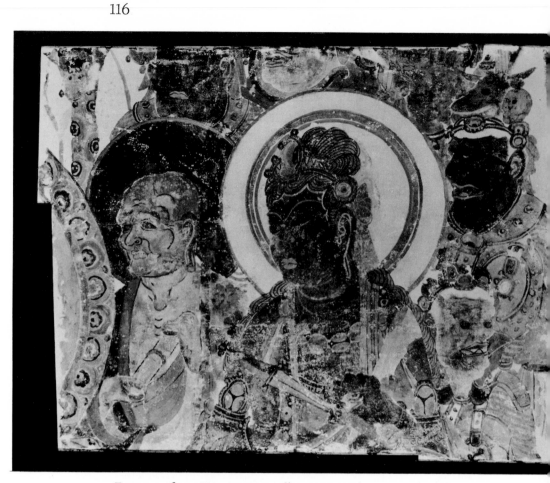

57. Fragment from Tun Huang wall painting. T'ang period. Fogg Museum of Art, Cambridge, Massachusetts.

58 (*Facing page, above*). Stone engraving of temple. T'ang period. Pagoda of Tz'u-en Temple, Ch'ang-an (Sian), Shensi Province.

59 (*Facing page, below*). Brick pagoda. T'ang period. Tz'u-en Temple, Ch'ang-an (Sian), Shensi Province.

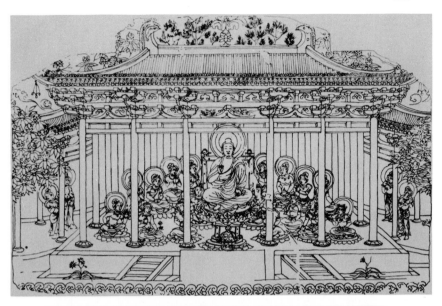

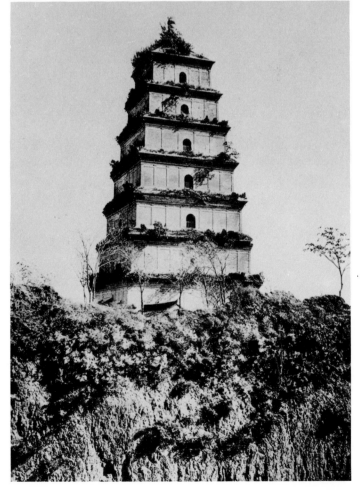

118

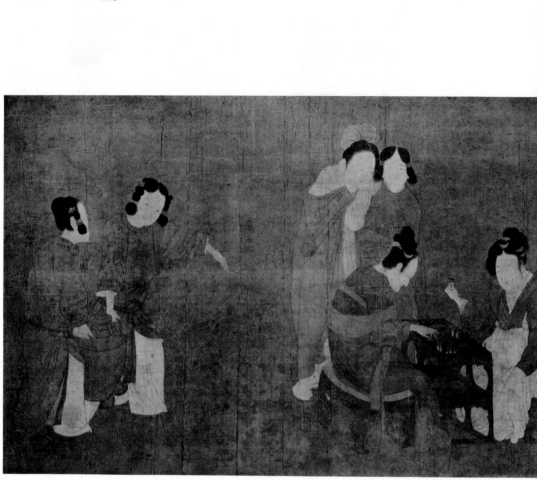

60. Chou Fang: *Ladies Playing Double Sixes*. Sung-period copy of T'ang-period original. Freer Gallery of Art, Washington.

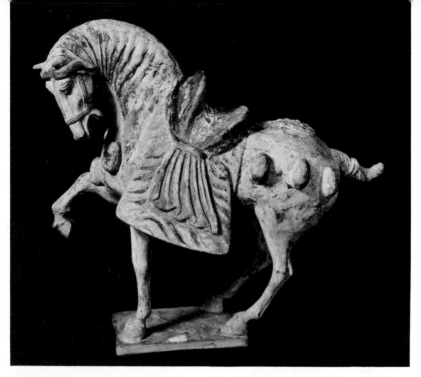

61. Clay tomb figure of horse. T'ang period. Alsdorf collection, Winnetka, Illinois.

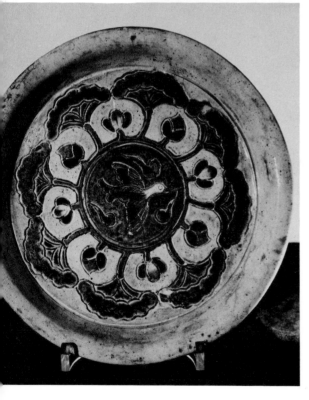

62. Plate with bird-and-flower design. T'ang period. Falk collection, New York.

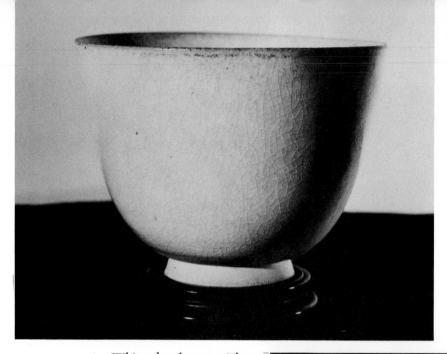

63. White-glazed cup. T'ang period. Falk collection, New York.

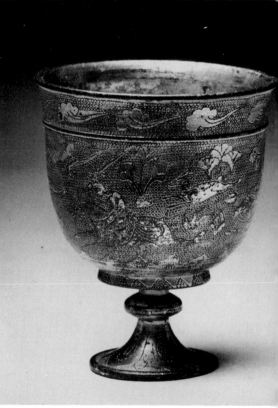

64. Silver stem cup with incised hunting scene. T'ang period. Singer collection, Summit, New Jersey.

other image (Plate 56) shows a new form of the Bodhisattva Kuan Yin, namely, the eleven-headed Avalokitesvara. Here again, the Indian influence is evident, for the multiplication of arms and heads, which is typical of Indian art, is completely alien to native Chinese conventions. The idea, of course, is to show that the deity can look in all directions at once, seeing those in need and coming to their rescue, while the four arms, each showing a different *mudra* or holding a different attribute, symbolize the various qualities of the lord.

Judging from contemporary accounts, Buddhist painting had a vital role in the religious art of the time, and some of the most celebrated painters of the T'ang period are said to have executed Buddhist scenes on the walls of the great temples. Unfortunately almost nothing of this has survived, and again we must turn to Tun Huang to form some idea of T'ang Buddhist painting. Although provincial in character and done by monks rather than by professional artists of the capital, the extensive wall paintings and banners undoubtedly reflect the kind of work produced at Ch'ang-an and other important cultural centers. At the same time, Indian and Central Asian influences are also found among the numerous paintings, so that it is a rich and varied output that confronts us. The dominant style is a rather plastic Indian one which uses shading, even lines, and rich colors, but there is also a Chinese style which is flatter and more linear and which is most common in the purely Chinese figures, such as donors, in contrast to the more foreign style used to represent the Indian Buddhist deities. The most impressive are the large paradise scenes showing the Buddha Amitabha in the Land of Eternal Bliss surrounded by a multitude of sacred beings, such as Bodhisattvas and Arhats as well as the souls of the blessed. These scenes give expression to the religious concepts of popular Buddhism, for they portray, not the ascetic practices of the original faith, but the joys of paradise and the splendors of the celestial realm with its palaces and jeweled canopies. Of particular interest is the treatment of space, which follows Western ideas of linear perspective, with the lines receding toward a common point on the horizon rather than the parallel diagonals characteristic of the Chinese tradition. A good idea of the style and quality of these Tun Huang paintings can be gathered from the fragments which the late Langdon Warner brought to America and which are now in the collection of the Fogg Museum (Plate

57). Although the colors have undergone certain chemical changes, the paintings are well preserved and suggest what T'ang Buddhist painting must have been like. The central figure in the fragment reproduced is that of a Bodhisattva rendered with the full face and sensuous forms characteristic of the T'ang period. To the left of the Bodhisattva is an Arhat holding a sacred scroll, his face modeled in terms of light and shade. To the right are two guardian figures who are represented as fierce warriors. The dominant colors are dark brown, bright red, and turquoise green, but other colors, notably all kinds of blues, greens, yellows, browns, and white, are also used in the wall paintings.

Of T'ang Buddhist architecture, almost nothing remains. Of the thousands of wooden buildings erected during the three centuries of T'ang rule, only one has been preserved, and this is a late provincial structure: the main hall of the Fo-kuang temple at Tou Ts'un, near Mount Wu-t'ai in Shansi, which was built in 857. Here again, the Nara-period temples in Japan, like the Todai-ji and the Toshodai-ji, give a far better idea of T'ang Buddhist architecture than the scanty remains in China. However, there are numerous representations of T'ang temples in the wall paintings at Tun Huang and in stone engravings such as the one found at the pagoda of the Tz'u-en Temple at Ch'ang-an, which was erected in 704 (Plate 58). It shows a paradise scene with the Buddha surrounded by seated Bodhisattvas. The assembly is taking place in a typical T'ang Buddhist hall, the front walls of which have been removed. The raised platform with steps leading up to it, the series of vertical supports in the form of columns connected with beams, and the bracketing system supporting the overhanging tile roof are all features found in contemporary Japanese temples, indicating that the ones at Nara were little more than provincial copies of the great temples of T'ang China.

The most impressive T'ang structure still extant in China is the great brick pagoda of the Tz'u-en Temple, where the stone engraving of the paradise scene was found (Plate 59). In this building the derivation of the pagoda from the Sumerian myth of Mount Meru is clearly apparent, for the seven stories are derived from the astronomical symbolism of ancient Mesopotamia, and the shape resembles the ziggurat. The square base is a symbol of the earth, while each story represents one of the steps leading to the heaven where the gods dwell. Pagodas often had a mast running

through the entire structure. This was thought of as the world axis uniting heaven and earth, and the spire was usually decorated with a series of umbrellas and crowned with a flaming jewel symbolizing the universal rule of the Buddha and his law. The openings in the walls of the pagoda face the four directions and originally contained Buddhist images, while the center, which had no utilitarian function, held some sacred relic. Although the shape and building material of the pagodas varied widely, depending upon the location, date, and use of the building, the spiritual and symbolical ideas were the same, and all the pagodas served as landmarks indicating that the place where they stood was a sacred site at which the Lord Sakyamuni was worshiped.

Chinese critics commenting upon the art of the T'ang period would no doubt have stressed the painting above everything else, for this was the period of two of the most celebrated Chinese painters, Wu Tao-tzu and Wang Wei. Wu Tao-tzu was famous for the freedom and boldness of his brushwork and the solidity of his figures which, as a Sung critic said, recalled sculptures. He lived during the eighth century, and it is said that he painted no less than three hundred murals for the great Buddhist temples of Ch'ang-an and Loyang, as well as producing numerous scrolls representing non-Buddhist subjects. By the eleventh century, the painter and critic Mi Fei was already complaining that he had only seen three or four genuine works by Wu Tao-tzu, and today nothing exists but later imitations which have nothing of the inspiration and expressive power that his paintings are said to have possessed. In fact a distinct disservice is done to Wu Tao-tzu by linking his name with this mediocre hack work produced centuries after his death.

The situation is almost as unsatisfactory when it comes to Wang Wei, the other famous eighth-century master, who was celebrated not only as a painter but also as a calligrapher, a poet, a scholar, and a musician. His poetry is still read, but nothing is left of his painting. His chief contribution seems to have been in landscape painting, although he is known to have painted Buddhist subjects as well. His most famous work was a scroll portraying the country retreat called Wang Ch'üan. The original perished centuries ago, but a stone engraving made after a copy may give some idea of the general theme and style of the picture. Wang Wei was also famous for his winter scenes, and several paintings of this type are tradi-

tionally attributed to him, but none is likely to be more than a poor copy. Wang Wei was the prototype of the gentleman painter who was a scholar as well as an artist, and for this reason he has always been greatly admired by Chinese critics, who look upon him as the founder of the Southern school of painting and the first to paint landscapes in monochrome ink.

Besides these two great masters, there were many other well-known painters. Of these the most notable were the seventh-century artist Li Ssu-hsün and his son Li Chao-tao, both of whom were later considered the founders of the Northern school of painting in contrast with the Southern school of Wang Wei. The difference between the two was not determined by geography but by the style in which the painters worked, for while Wang Wei and the artists of the Southern school employed a loose and spirited ink style, the Northern school was characterized by a more detailed and meticulous manner, often using gold outlines and bright colors, especially green and blue. Chinese art critics, under the influence of the scholars who had a great bias in favor of the Southern school, have always tended to praise it at the expense of the more academic Northern school, but some of the best Chinese painters, especially during the T'ang and Ming periods, have been followers of Li Ssu-hsün.

The only existing painting that can be connected with some degree of conviction with the two Lis is a beautiful colored landscape in the National Palace Museum in Taiwan. It shows travelers in a mountain setting, probably representing the emperor Ming Huang's journey to Shu. The style is very detailed, resembling that of landscapes found in the background of Buddhist paintings at Tun Huang. There can be little doubt that this painting is either an eighth-century original or a very close copy of one. The emphasis is still upon the human figure and the narrative detail, but the landscape setting, which had been a mere backdrop in Six Dynasties painting, is now quite prominent, and the figures not only exist in space but also move through the landscape, which extends into depth. The mountains towering above the travelers are one of the chief elements of the picture, suggesting the theme that was to be so important in Sung painting—that is, the insignificance of man against the grandeur of nature. Other features that foreshadow later developments in landscape painting are the white clouds that obscure parts of the mountains and the view through the pass that leads the eye into the distance beyond the mountains.

On the other hand, the detailed drawing, the sharp outlines, and the brilliant colors are typical of T'ang painting, especially that associated with the Northern school, and thus it is quite possible that the painting described here is a work by Li Chao-tao, the artist to whom it has been traditionally ascribed.

In addition to the famous landscape painters, there were artists who were best known for their genre scenes, figures, horses, or birds and flowers. Among the figure painters the eighth-century master Chou Fang was the most celebrated. Several surviving works are traditionally attributed to him, the best of which is the *Ladies Playing Double Sixes* in the Freer Gallery in Washington (Plate 60). Two typical T'ang beauties with plump faces and full figures are shown seated over a game, while two others watch and two servant girls bring in refreshments. Painted on silk with clear, even outlines and subtle colors, it is a work of great beauty and may well be by the artist to whom it is attributed. Among the T'ang portraits, the finest in America is the *Thirteen Emperors* scroll in the Boston Museum of Fine Arts, which is traditionally ascribed to, and may well be by, the famous early T'ang court painter Yen Li-pên. It represents the more academic, Confucian strain, showing the detailed, realistic style typical of T'ang official art. Other examples of T'ang painting are in the National Palace Museum in Formosa and in the Peking Museum, but there are only a handful of pictures which can be attributed to the famous T'ang painters with any degree of certainty, and even these are mostly Sung copies of lost T'ang originals.

Most of the non-Buddhist sculpture of this period was connected with the cult of the dead. It was still the custom to line the approaches to the grave monuments with carvings of animal and human figures, and many fine sculptures of this type were found at the T'ang imperial tombs. The most famous are the six reliefs representing the favorite chargers of the Emperor T'ai Tsung which he ordered to be placed at the entrance gallery of his tomb. It is believed that they were based on designs by Yen Li-pên, one of the various T'ang painters who were well known for their representation of horses. This animal, which has always been a favorite of Chinese artists, is often found among the clay grave figures of the T'ang period. A beautiful example is the prancing horse in the Alsdorf collection, Winnetka, Illinois (Plate 61). Although the grave figures were small and

were frequently made from molds, they are often real works of art, suggesting the high level of craftsmanship and taste which prevailed at this time. Thousands of figures, most of them representing human beings or animals, have been found in T'ang graves, where they were placed to accompany the dead into the spirit world. They give us a vivid picture of the ideals of beauty and the fashions of T'ang society, the different racial types encountered in the cosmopolitan cities, and the various animals known in China. Most of them are plain or painted earthenware, but some are also decorated with colored glazes, like the charming figure of an elegant lady in the Alsdorf collection, which combines a vivid feeling of life with beauty of color and form.

During the T'ang period, ceramics, metalwork, lacquer ware, textiles, glass, and all types of woodwork were produced in large quantities and usually in excellent quality, reflecting both the wealth and the high standards of craftsmanship. Strangely enough, the best place to study T'ang decorative arts is not China but Japan, where in 756 the widow of the Japanese Emperor Shomu deposited his belongings in the Shoso-in treasure repository at the great Nara temple of Todai-ji. For more than a millennium, these thousands of objects have been kept in the Shoso-in, so that the collection is not only complete but unquestionably authentic. Imported from China or made in Japan in imitation of Chinese models, these objects represent the highest level of T'ang decorative arts both in workmanship and design.

Among the crafts, the most important, and the one in which the most significant developments took place, was ceramics. In fact there are specialists, notably the English scholar William Willetts, who see this period as the finest and most creative in the history of Chinese ceramics. Although this estimate may be exaggerated, there is no question that the T'ang wares were outstanding. They may be divided into three types: earthenware, usually decorated with lead glazes; stoneware; and true porcelain. The shapes are usually sturdy and vigorous. Many are traditional ones which had been used in earlier periods, but others are new, foreign importations, notably the classical amphora and oenochoe as well as the Persian rhyton and bird-necked ewer. The glazes are extremely beautiful, the chief colors being green, blue, yellow, brown, and white. The stoneware is usually covered with an olive green or a dark-brown

glaze of the Yüeh type, while the porcelain, for the most part, is a pure white ware of great beauty which was not only admired in China but also imported to the Near East and Japan. Two outstanding examples of T'ang ceramics are in the Falk collection in New York, one a plate with a bird-and-flower design executed in a colored lead glaze after Sassanian models (Plate 62) and the other a simple but extremely sophisticated cup covered with a white glaze of extraordinary purity (Plate 63). These are only two examples of the immensely rich and varied output of the T'ang potters, whose work showed both technical skill and artistic sensibility.

Next to pottery, the most distinguished of the decorative arts was the metalwork. Mirrors continued to be made both in bronze and precious metals, many of them very beautiful in design and execution. The mirrors were decorated with traditional motifs, such as the animals of the four directions as well as the Western inspired lion-and-grape design, which was very popular during this period. The influence of Sassanian Persia was particularly strong in T'ang silverwork, as may be seen in the lovely stem cup with an incised hunting scene in the Singer collection (Plate 64). Gold was also used with splendid effects. The cosmopolitan character of the T'ang civilization is evident in many of these objects which reflect the Indian, Central Asian, Persian, and Hellenistic influences that reached China through the merchants and travelers. The splendor of these products is a lasting memorial to the wealth and brilliance of the age.

CHAPTER SEVEN

The Art of

the SUNG DYNASTY

(960–1280)

THE ABDICATION of the last T'ang Emperor in 906 was followed by a period of chaos and war. The country was divided into a number of small kingdoms, many of which were ruled by barbarians. Chinese historians call this the Five Dynasties period after the five short-lived ruling houses which briefly controlled the northern part of the country. After five decades of disunity and strife, the Chinese were ready for a leader who could bring peace and unity to the country. The man who succeeded was a general named Chao Kuang-yin, who became the first emperor of the Sung dynasty, which ruled China from 960 to 1280.

Later Chinese historians have tended to belittle the Sung rulers because they did not continue the imperialist conquests of the Han and T'ang emperors but pursued a pacifist policy, trying to buy off the northern nomads. Nevertheless, this was a period of great cultural achievement. Chinese civilization attained a refinement and sophistication which was never again equaled, and the emperors, as C. P. Fitzgerald says, were the most enlightened sovereigns who ever ruled China: "tolerant, humane, artistic and intellectual, free from the vices which have so often disgraced Oriental monarchs." More dedicated to the arts of peace than to the pursuits of war, they were no match for the barbarian tribes which menaced the northern frontiers. First the Kitan, a people of Tartar stock, established the Liao kingdom in Manchuria, Jehol, and Inner Mongolia and were only prevented from further conquests by being paid a large annual tribute. In

1124 the related Kin tribe overthrew the Liao and conquered most of northern China. The Sung Emperor Hui Tsung was defeated, and the rulers were forced to flee to the south. The second part of the Sung era, during which the capital was at Hangchow, is known as the Southern Sung period. This division of China into two states lasted until 1280, when the country was united by the Mongol conquerors.

Sung China, with a population of one hundred million people, was no doubt the most civilized country in the world. The pride which the Chinese felt is best expressed in a saying attributed to Shao Yung: "I am happy because I am . . . a Chinese, and not a barbarian; and because I live in Loyang, the most wonderful city in all the world." Despite the military weakness of the Sung rulers, or perhaps because the energies of the nation were not channeled into war, it was a period of great intellectual and artistic ferment. In philosophy the most important development was the neo-Confucianist school of Chu Hsi, whose thinking has dominated all later orthodox teaching. Poetry rivaled that of the T'ang period, and painting and ceramics reached a golden age which has never been surpassed. Ch'an Buddhism flourished and had a profound influence upon intellectual life. Buddhism in general, however, continued to decline, and the traditional schools degenerated more and more into popular faiths for the common people.

The finest embodiment of the Sung genius was its painting. In fact, it is the landscape painting of the Sung period which in the eyes of most critics is the supreme achievement of Chinese art. In these works, the uniquely Chinese relationship to nature finds profound expression, and it is of Sung ink painting that most Westerners and Japanese think when they speak of the greatness and philosophical depth of Chinese painting. In recent years there has been a tendency on the part of some scholars to praise Yüan and early Ch'ing painting at the expense of Sung, but there can be little doubt that Sung painting represents the climax of the Chinese pictorial tradition and that the period between the tenth and thirteenth centuries saw some of the greatest artists China ever produced.

Many of the painters were also poets and scholars, and some of them wrote about what they were trying to express in their pictures. The most famous of these essays is attributed to the eleventh-century landscape painter Kuo Hsi. His work, called "The Great Message of Forests and

Streams," has been translated into English by Shio Sakanishi under the title *An Essay on Landscape Painting* (London: 1936). In it Kuo Hsi sets forth both his manner of working and the ideals and themes of his art. How he went about painting is told by his son, who was also a painter and recorded some of his father's remarks. "On a day when he was to paint he would seat himself by a bright window, put his desk in order, burn incense to his right and left, and place good brushes and excellent ink beside him; then he would wash his hands and rinse his ink-well, as if to receive an important guest, thereby calming his spirit and composing his thoughts. Not until then did he begin to paint. Does this not illustrate what he meant by not daring to face one's work thoughtlessly? Having drawn a picture, he would retouch it here and add there; augment and adorn it. If once would have been sufficient, he would go back to it for a second time. If twice would have been enough, he would go back to it a third time. Every circle he drew, he went over again to make it perfect."

The Sung artist wished to create works which would contain the very essence of the landscape. Deeply imbued with Taoist philosophy, the painters tried to give expression to the grandeur and mystery of nature against which man seemed but a tiny part. They were not content to paint merely the outward appearance, an aim which satisfied the realists and impressionists of nineteenth-century Europe. Instead, they wanted to penetrate to the very heart of the landscape or, as the Chinese would have put it, to give expression to the Tao of nature. In order to do this, the painter, as Kuo Hsi says in another passage, must identify himself with mountains and streams, trees and rocks. Only in this way can he hope to render their very being and lose himself in the vastness of the cosmos. Western man saw himself as the lord and master of nature, which, according to the Bible, was created for his use and enjoyment, but the Chinese artist looked upon himself as a minute part of nature, basically no different from the other elements which make up the awe-inspiring spectacle.

A favorite theme was that of a small figure alone in a landscape—a sage dwarfed by towering mountains, a fisherman in his boat surrounded by an empty expanse of water—for by confronting man with the overwhelming grandeur of nature, the artist expresses his world feeling. Speaking of the forms of nature, Kuo Hsi said, "Indeed their unique forms and divine beauty are inexhaustible. Let one who wishes to portray these

masterpieces of creation first be captivated by their charm; then let him study them with great diligence; let him wander among them; let him satiate his eyes with them; let him arrange these impressions clearly in his mind. Then with eyes unconscious of silk and hands unconscious of brush and ink, he will paint this marvelous scene with utter freshness and courage and make it his own."

The purpose of this painting is closely related to Taoist philosophy, and the virtuous man found solace and inspiration in these imaginary landscapes. The viewer was asked to become one with the figure of the sage wandering through the landscape, and thus experience union with the all-pervading Tao. As Kuo Hsi put it, "The sight of such pictured mountains arouses in man exactly corresponding moods. It is as if he were actually in these mountains. They exist as if they are real and not painted. The blue haze and white path arouse a longing to walk there, the sunset on a quiet stream arouses a longing to gaze upon it, the sight of hermits and ascetics arouses a longing to dwell with them; rocks and streams arouse a longing to saunter among them; the contemplation of good painting nourishes this longing. The places become real, and the meaning of these pictures is wonderful."

The subjects painted by the Sung artists are in keeping with these ideals. The most common are the ones related to the four seasons. For spring Kuo Hsi recommends themes like the clouds of early spring, clearing weather after spring rain, and sunrise over the spring mountains. For summer he suggests such scenes as a mountain ramble in summer rain, trees and forests on summer hills, and a summer mountain retreat. Suitable for autumn scenes are the early-fall landscape after rain, a cloud descending over the autumn hills, autumn mists rising out of a valley, and autumn winds bringing rain. For winter he recommends various snow scenes such as a fisherman's hut in the snow and a snow-covered pine beside a deserted stream.

The subjects are often derived from poetry. Some of the poems that Kuo Hsi's son says his father often recited show the close relationship between the two art forms. Using such themes as a visit to a mountain retreat, fishing among the reeds, or watching the geese flying across the sky, these poems no doubt inspired many a Sung landscape and, in later periods, are often inscribed on the scroll itself. The modern Westerner

distrusts literary painting, but the Chinese artist, who was frequently a scholar and writer rather than a professional painter, felt that painting and calligraphy and poetry were intimately related and that a gentleman should be at home with all three and give expression to his view of reality by using all of them together.

Typical of this kind of verse is a poem by Ch'ang-sun Tso-fui, translated by Shio Sakanishi in *An Essay on Landscape Painting*:

> Alone I set out to visit a mountain retreat, now stopping,
> now proceeding again.
> Thatched cottages are linked behind the pine branches.
> Though the host hears my voice, the gate is not yet open;
> By the fence over the wild lettuce flutters a yellow butterfly.

The mood of the poet contemplating the landscape is rendered even more concisely in the following poems from the same translation:

> Clouds wait brooding for snow and hang
> heavily over the earth;
> The wail of autumn is uninterrupted
> as the wild geese sweep over the sky.
> —*Ch'ien Wei-yen*

> Heavy with rain the spring flood rushes
> rapidly through the night;
> Not a soul on the bank; a solitary ferry lies
> aslant the water.
> —*Wei Ting-wu*

> Together we gazed on distant waters;
> Alone I sit in a lone boat.
> —*Chang Ku*

Unlike the T'ang artists, who usually worked with bright colors in a detailed realistic style, the Sung masters preferred monochrome ink painting, depending upon subtle gradations of ink for their tonal effects. Their

brushwork was usually free and vigorous, and the forms, especially during the later Sung period, tended to be simplified and suggestive rather than detailed and explicit. Even when a picture is supposed to portray some well-known site, it did not represent a real scene so much as an ideal view which would embody the quintessence of all landscapes. Working with the simplest means, usually only ink and silk or paper, the painter used a kind of shorthand to suggest the scene rather than to reproduce it literally as it actually existed.

According to literary accounts, artists like Kuo Hsi painted some of their most celebrated works on walls or on screens, but none of these has survived. The bulk of Sung painting was probably in the form of scrolls and album leaves. The former consisted of two types, either the horizontal hand scrolls, which were unrolled from right to left, or the vertical hanging scrolls, which were derived from Buddhist banners and became the most popular pictorial form. They were usually kept in storage and only displayed for an honored guest or a special occasion. Both types vary greatly in size. Some hand scrolls were just a few inches long, while others had a length of many feet, and the hanging scrolls varied from a small rectangular picture to a very long, very broad scroll. The album leaves were fan-shaped or rectangular and were usually displayed in sets of ten in picture albums which were viewed close up like illustrated books.

While almost no originals by T'ang masters have come down to us, there are numerous extant scrolls ascribed to celebrated Sung painters. How many are actually by the artists they are attributed to, and how many are more or less accurate imitations of their style is a matter of scholarly debate. However, it is generally agreed that at least several hundred of the thousands of supposed Sung paintings were either executed by the artists to whom they are attributed or are originals by Sung painters. Some of the best-documented Sung pictures are in the National Palace Museum in Taiwan, the Peking Palace Museum, and certain Japanese temples, some of which have owned the paintings ever since they were brought from China in the fourteenth and fifteenth centuries. In the West the most remarkable collections are in the Boston Museum of Fine Arts and the Freer Gallery in Washington. Other museums, especially the Nelson Gallery in Kansas City, the Cleveland Museum, the Metropolitan

Museum in New York, the Chicago Art Institute, and the British Museum, have some outstanding examples.

Our knowledge of Sung painting is still in its early stage. The famous Swedish scholar Oswald Sirén, in his monumental study of Chinese painting, and many other experts in both the East and the West have made invaluable contributions, so that we are gradually gaining a picture both of the material which has survived and of the oeuvre of the various Sung masters. The greatest remaining problem is that of the authenticity of individual paintings, for if there is no well-established body of unquestioned work, it is extremely difficult to be certain just which works are by the artists to whom they have been traditionally ascribed and whose seal and signature they often carry. The Chinese have always made copies of works they admired and have painted pictures in the style of old masters. In fact, outright forgeries have been produced from Sung times down to the present day. Studies of the silks, papers, inks, and pigments used by Sung artists can help to determine what is a Sung original and what must be looked upon as a Ming or Ch'ing copy or a modern forgery, but even this can be inconclusive if the forgers use old materials or put false labels on pictures which are Sung originals but which had either no signature or that of a minor or unknown artist. The Chinese and Japanese tend to judge authenticity by inscriptions and seals, but since these are far easier to forge than the paintings themselves, they are by no means infallible criteria. Much has also been made of the study of old catalogues of famous collections, which supposedly prove that a given painting existed in Sung or Ming times and was considered authentic by the connoisseurs of that period. But since forgers can also study the literature, this does not prove beyond doubt that the scroll in question is the one discussed in the catalogue. For that matter, the work may not be what the catalogue claims, for Chinese critics were certainly not infallible. The most trustworthy criterion is the quality and style of the painting. Certainly it can be assumed that the masterworks by the great Sung painters would be superior to the copies and imitations of later periods, and it is almost inevitable that even the most skillful copyist or forger would betray certain stylistic traits of his own period.

Among the surviving Sung landscapes, some of the most impressive can be attributed to the great landscape painters of the Five Dynasties and

the Northern Sung periods—painters whose works helped to establish this kind of painting as the dominant art in all later periods. In the tenth century, Ching Hao and Li Ch'êng are looked upon as the originators of the early Sung style, with its towering mountain landscapes, gnarled pines, and misty atmosphere. Several works traditionally attributed to them have survived, but it is not until the eleventh century that we have works attributed to famous painters which we can be certain are authentic. Outstanding among these is the scroll entitled *An Autumn Day in the Valley of the Yellow River* by Kuo Hsi, which is in the collection of the Freer Gallery (Plate 66). It represents the mountain scenery along the Huang Ho as it would look if you were traveling down the river by boat. The style is typical of the early Sung period, with emphasis on the towering mountains, picturesque trees, and massive rocks. The minute figures— in the section shown here, two sages standing under a tree, and a traveler on horseback preceded by a servant—are hardly visible. The viewer is supposed to identify himself with them, moving through the landscape and sensing his own insignificance before the grandeur of the mountain scenery. Using different gradations of ink, the artist creates an illusion both of aerial perspective and receding space, evoking the misty atmosphere of an autumn day.

The other outstanding eleventh-century landscape painter is Mi Fei, born a generation later than Kuo Hsi and famous not only as an artist but also as a scholar, a critic, a calligrapher, and an official. His opinions as a connoisseur who owned a celebrated collection of paintings are still quoted today. Mi Fei's work was associated with a loose, free ink style using soft contours and creating subtle atmospheric effects. Several scrolls are traditionally ascribed to him, but it is doubtful if any are by his hand. However, there are some works attributed to his son Mi Yu-jên which can be accepted as authentic, and as the son painted in a similar manner, they show something of the style of the father. The best is a hand scroll in the Freer Gallery which is very typical of the Mi style (Plate 67). Using paper and strongly diluted ink, Mi Yu-jên creates a misty river landscape with the rounded forms of the mountains barely emerging from the haze. An empty pavilion in the section of the scroll reproduced suggests the presence of man, but it is of little importance, forming merely a small part of the mystery and beauty of the landscape.

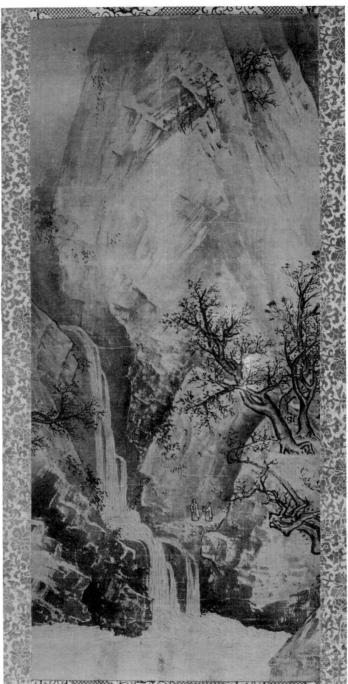

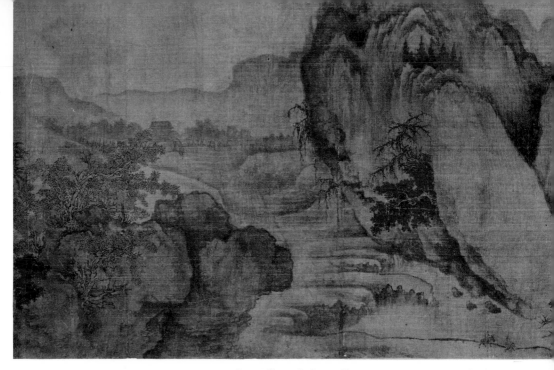

66. Kuo Hsi: *Autumn in the Valley of the Yellow River.* Sung period. Freer
Gallery of Art, Washington.

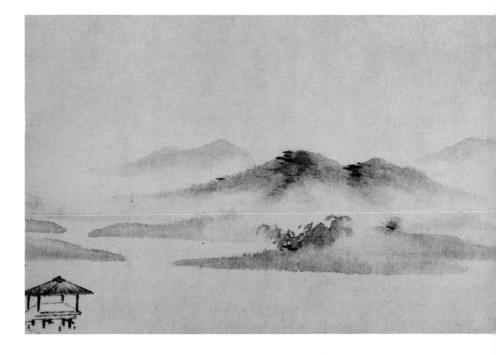

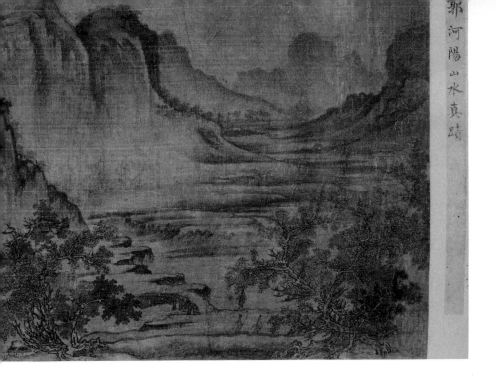

67. Mi Yu-jên: *River Landscape* (section of scroll). Sung period. Freer Gallery of Art, Washington.

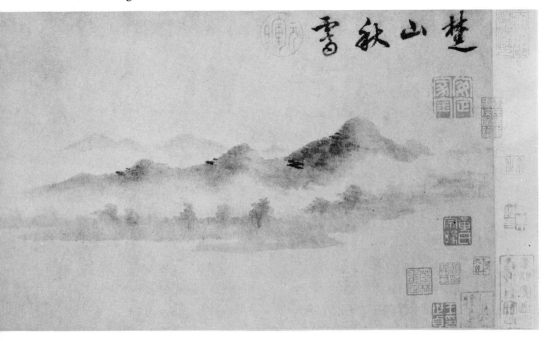

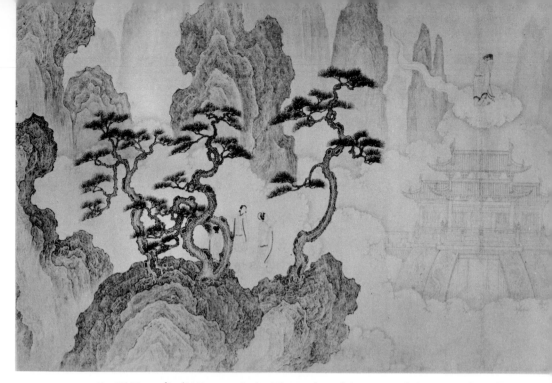

68. Li Kung-lin (Li Lung-mien): *The Realms of the Immortals* (section of scroll).
Sung period. Freer Gallery of Art, Washington.

69. Ma Yüan: *Fisherman in Boat*. Sung period. Tokyo National Museum.

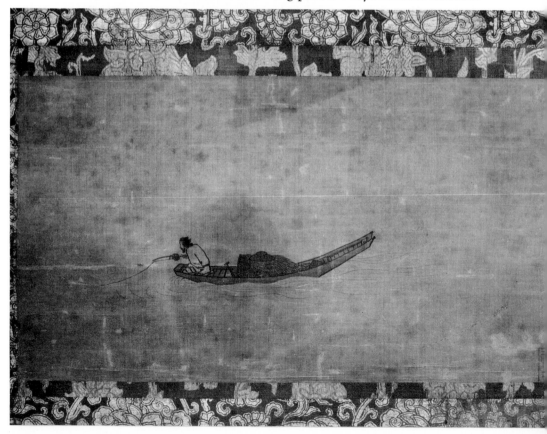

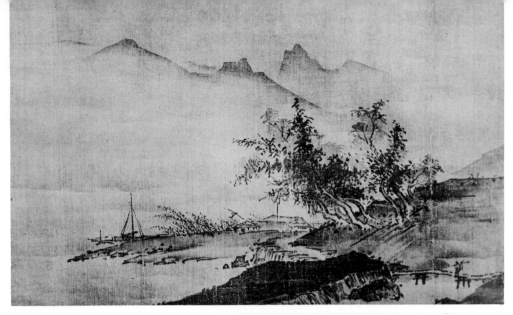

70. Hsia Kuei: *Summer Land-scape*. Sung period. Iwasaki collection, Tokyo.

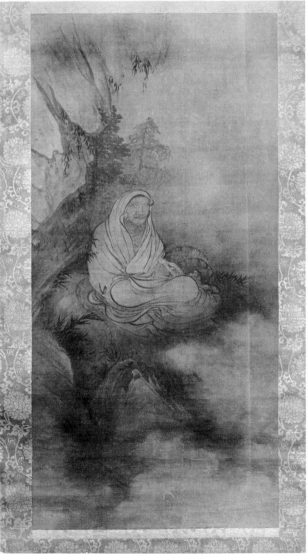

71. Mu Ch'i: *Bodhidharma in Meditation*. Sung period. Seikado collection, Tokyo.

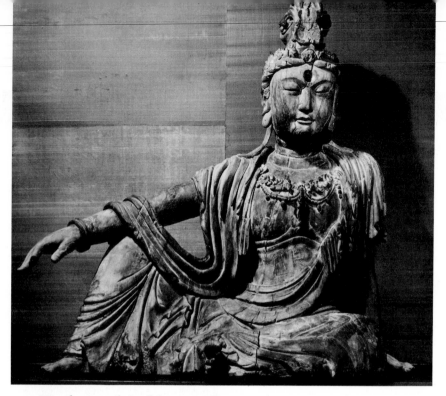

72. Wooden seated Avalokitesvara (Kuan Yin). Sung period. Morse collection, New York.

73. Kuan Yin Hall. Tu-lo Temple. Sung period. Chi-hsian, Hopei Province.

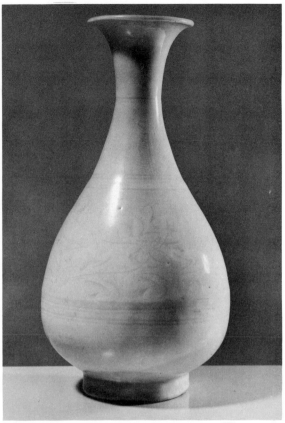

74. Ting-yao porcelain dish. Sung period. Falk collection, New York.

75. Ying-ch'ing porcelain bottle. Sung period. Falk collection, New York.

76. Chün-yao flower bowl. Sung period. Stimson memorial collection, Seattle Art Museum.

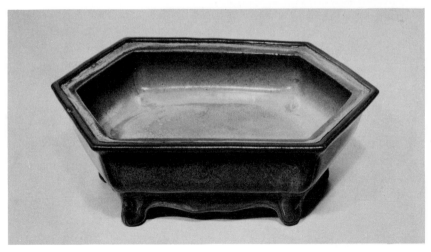

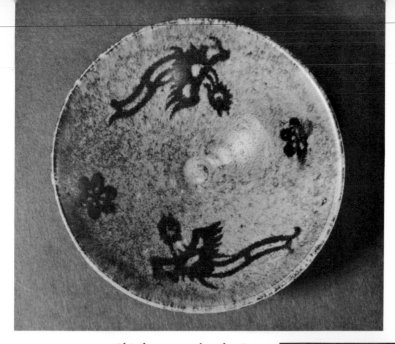

77. Chi-chou tea bowl. Sung
period. Falk collection, New
York.

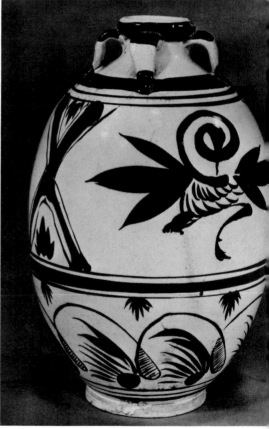

78. Tz'u-chou jar. Sung period.
Gift of Mr. and Mrs. Herbert
Brier, Seattle Art Museum.

The transitional figure who sums up the achievements of the Northern Sung period and at the same time leads to the Southern Sung, when the capital after the loss of the north was moved from Kai-fêng to Hangchow, was Li T'ang, who served at the imperial court and was considered the leading painter of his day. Among the numerous pictures attributed to him are a pair of hanging scrolls in the Koto-in in Kyoto which are master-works of Sung landscape painting. One of them, probably intended to represent winter, shows two tiny figures standing near a plunging cascade beneath the towering precipice of a mountain (Plate 65). The vigorous brushwork in the trees and rocks, the wonderful tonal effects in the mountain, and the vivid feeling of the water gushing from the heights all indicate that this is an original work by one of the great Chinese painters. The mood of the season is evoked in the bare silhouettes of the trees and the austerity of the rocks and mountains.

Not all Northern Sung painters devoted themselves primarily to landscape. Artists such as Li Lung-mien, also known as Li Kung-lin, specialized in figure painting, which continued to be important although it never regained the position it had enjoyed during earlier periods. Li Lung-mien was also famous for his Buddhist and Taoist pictures, a type of painting which continued to enjoy a great deal of popularity. Of the many pictures attributed to him, most of them with little reason, one of the finest is a hand scroll in the Freer Gallery entitled *The Realms of the Immortals* (Plate 68). It represents a typical Taoist scene of a celestial region with a heavenly palace, a Taoist sage floating on a cloud, and a group of immortals standing among gnarled pines and picturesque rocks. Here again the superb quality of the brushwork, which varies from the exquisite delicacy of the palace to the bold strokes used for the pine needles and rocks, reveals the presence of a master, although it is not at all certain that the artist was actually Li Lung-mien. However, regardless of who the painter was, it is undoubtedly a Northern Sung original and suggests that the Sung artists were outstanding in this type of painting.

Next to landscape, the most popular genre was bird-and-flower painting, which usually took the form of small album leaves, although both hanging scrolls and hand scrolls of bird-and-flower subjects also exist. This type of painting traces its origin to the T'ang period, but it was not until the tenth century that it emerged as an important subject in Chinese

painting. The most famous bird-and-flower painter of the Sung period was Hui Tsung, the last of the Northern Sung emperors, who was also celebrated as a poet, a calligrapher, and a collector. His collection of paintings, bronzes and objets d'art was the finest ever assembled in China. The paintings alone comprised no fewer than 6,396 scrolls. They were divided into ten groups, among which the largest was the bird-and-flower paintings, with about one-third of the entire collection belonging to this category. Several paintings from Hui Tsung's collection have been preserved, and their high quality is a good indication of the discriminating taste of the emperor.

Numerous bird-and-flower paintings are attributed to Hui Tsung, but most of them were probably not painted by the emperor himself. What is more likely is that they were executed by members of the Imperial Academy of Painting, which Hui Tsung patronized. Among the extant pictures, the most famous is the one in the Boston Museum representing a five-colored parakeet. Painted in color in a detailed, realistic manner, it is characteristic of Sung bird-and-flower painting. Yet the intention of the artist in such works is not to reproduce a specific bird at a given time, as a Western realistic painter might do, but to portray the general species of the bird against an abstract space. Here again the Chinese painter does not give a subjective impression of visual reality, but a generalized picture of the essential traits.

Although the reign of Hui Tsung ended in disaster, with the Tartars conquering and sacking K'ai-fêng and the emperor dying in captivity, this had surprisingly little effect on the culture of the period, for the Imperial Art Academy was soon re-established in the new capital at Hang-chow, and the second half of the Sung period was, if anything, even more refined and sophisticated than the first. It would be impossible to mention the many outstanding Southern Sung painters (among whom were established artists like Li T'ang) who had moved with the imperial court, as well as many new artists who emerged in the south, which now became the center of Chinese culture. The most famous and, in the eyes of Japanese critics especially, perhaps the greatest painters China ever produced, were Ma Yüan and Hsia Kuei. They were both active during the late twelfth and early thirteenth centuries and exercised a profound influence not only on the artists of their own time but also on those of Ming China

as well as Muromachi Japan. In their work the Taoist-inspired ink painting of the Sung period finds its culmination, and most Western critics think of this type of work when they talk of the profundity of Chinese painting and its economy of means.

There are a great number of scrolls attributed to Ma Yüan and Hsia Kuei, but here again the question of their authenticity is a difficult one. The most outstanding group by the Ma-Hsia school, as it is called, is in Japan, which acquired the paintings during the Muromachi period, when they were highly regarded by the Japanese but neglected in the country of their origin. There are other excellent examples in China and also in America, notably in Boston and Kansas City.

It is difficult to choose among the many outstanding paintings attributed to Ma Yüan and Hsia Kuei, but if a choice had to be made, this critic would select the Ma Yüan painting in the Tokyo National Museum showing a solitary fisherman in his boat on the empty water (Plate 69) and the summer landscape by Hsia Kuei in the Iwasaki collection in Tokyo (Plate 70). In these two works, the Chinese conception of the relationship between man and nature finds its most profound and beautiful expression. Using the simplest of means, the artists produce the greatest of effects. In the Ma Yüan, everything is concentrated on the fisherman in his boat. A few lines on the silk indicate the broad expanse of water, and yet with this simple subject, the artist creates a feeling of quiet intimacy between man and nature. Even more typical of the best of this type of painting is the Hsia Kuei, which shows the tiny figure of a fisherman crossing a bridge in the right foreground. There is a fisherman's hut beneath the trees and, to the left, a boat drawn up to a point of land. Beyond is a misty expanse of water with mountain peaks just visible above the haze. Using gradations of ink instead of color, the artist achieves subtle and varied tonal effects ranging from the dark land in the foreground to the shadowy contours of the distant mountains. Here again the viewer is supposed to identify himself with the tiny figure, become one with the vastness and harmony of nature, and, as Kuo Hsi said, "without leaving the room, travel among streams and ravines" and "hear the cries of the birds and monkeys and share the life of the fishermen and woodcutters."

There is one more school to be considered, and that is Ch'an painting, which flourished during the late thirteenth century at the very end of the

Sung period. Ch'an was a Buddhist sect which had emerged during the T'ang period, but it was not until late Sung times that its influence was felt on Chinese art. Believing that true insight came like a flash of lightning and could never be achieved by studying sacred scriptures or performing meritorious works, the Ch'an painters used an inspired shorthand which in a few abstract strokes gave expression to their mystic insights into the nature of reality. A typical Ch'an painting, both in theme and style, is the scroll by Liang K'ai showing a Ch'an monk tearing up the sutras, indicating that the Buddha can never be found in the texts but must be looked for in one's own heart. Rendered with a few slashing strokes, the scene exemplifies both the typical Ch'an attitude and the spiritual fervor of the Ch'an faith. Traditional Buddhist painting had become meaningless to the members of the Ch'an sect, and their spontaneous ink style stands in striking contast to the careful, detailed brushwork of the academic painters. It is no wonder that they were attacked for not working "in accordance with the ancient rules and in a refined manner." Yet the best of their works are among the greatest and most inspired ink paintings produced in China. Their work has always been admired in Japan, where Ch'an Buddhism—or Zen, as it is called in Japanese—has continued to flourish and, over the centuries, has had an incalculable influence on Japanese culture.

Few authentic Ch'an paintings have survived in China. In Japan, however, where the Ch'an masters have always been venerated, their finest works have been preserved as icons in Zen temples. The most famous is the painting of the six persimmons by Mu Ch'i, who with Liang K'ai was the most celebrated of the Ch'an masters. Although the painting shows nothing but the persimmons against an empty space, the artist gives expression to the Ch'an sense of reality, for it is not their outward appearance he portrays, but what the Ch'an writers would call their Buddha nature. As a Ch'an proverb says, grasses and bamboos proclaim the gospel of the Buddha. There are numerous other works attributed to Mu Ch'i in Japan, among them a picture believed to represent Bodhidharma, the founder of Ch'an Buddhism, which is now in the Seikado collection in Tokyo (Plate 71). The saint is meditating so deeply that he does not notice the dragon coiled around him with its gaping mouth in his lap. A few rocks and shrubs are sketched in with a loose ink wash, suggesting the setting in which the scene takes place. The chief emphasis is upon Bodhi-

dharma, wrapped in his monk's robe, his gaze inward and his body motionless in the mystical trance characteristic of Ch'an Buddhism. The forms are simple and the brushwork free, in keeping with the teachings which inspired the artist.

In addition to these major groups of Sung painting, there were also other types. Among the ten categories listed in the Hui Tsung catalogue, Buddhist and Taoist paintings were the most numerous next to bird-and-flower paintings. Other subjects were bamboos, fruits and vegetables, narcissi, fish, dragons, horses, and a great variety of other animals. Particularly interesting for the student of Chinese architecture are the scrolls representing palaces and temples, pictures which are invaluable today, since almost nothing of Sung architecture has survived. Equally interesting are the genre scenes, such as the scroll in the Boston Museum showing the return of Lady Wên-chi to China, with its lively vignettes of the teeming streets of the Sung cities, and the spring-festival scroll in the Peking Museum, with its vivid portrayal of the life of the river. Other paintings show the domestic life of the palaces and still others the homes of the common people.

There can be no question that even this large body of surviving work represents only a fraction of the vast output of paintings produced during the Sung period. Yet this random selection, which probably does not include any authentic work of several of the most famous Sung artists, indicates what rich and varied painting was produced in China under the Sung dynasty. In fact, it is no exaggeration to say that Sung painting was the most sophisticated and accomplished in the world at that time.

Sculpture was not as important during the Sung period as it had been during the Six Dynasties and T'ang. This was largely because of the decline of Buddhism, which had been the chief patron of this art. Ch'an, the most vital and influential Buddhist sect as far as art was concerned, dispensed with sculptured images because it believed they were completely irrelevant to true religious feeling. Such Buddhist sculptures as were produced were made largely of wood, which lent itself better to the softer and more painterly Sung style. Bronze ceased to be important, and stone also declined. The only significant group of Sung stone sculptures are those at Yûn Kang, which were made in an archaic style under the patronage of the barbarian Liao dynasty. Clay and lacquer were also used dur-

ing the Sung period, usually to represent Lohans, or Buddhist holy men.

An outstanding example of a Sung-period sculpture is the seated Kuan Yin in the Morse collection in New York (Plate 72). Carved of wood and originally colored in bright polychrome, it is characteristic of the Buddhist sculpture of that time. Instead of the abstract forms of the Wei images or the plastic ones of the T'ang, this statue shows the flowing lines and soft, rounded forms typical of Sung. Not only the style but also the subject is typical, for Kuan Yin, the Bodhisattva of Mercy and Compassion, now often shown as a female figure, had the greatest appeal of all the Buddhist deities in this age of refinement and sophistication.

All the evidence suggests that Sung-period architecture was magnificent. Literary descriptions of the Southern Sung capital of Hangchow tell of unprecedented elegance and beauty, some of which is reflected in the Japanese structures built in what is basically a provincial Sung style. Although almost nothing of this has survived, the numerous representations in scrolls and illustrated books, notably the *Yingtsao Fa Shih* of 1103, give us a fairly good idea of what these structures must have looked like with their grand scale, graceful forms, and brilliant yet subtle coloring.

The oldest and best-preserved Sung building is the Kuan Yin Hall of the Tu-lo Temple at Chi-hsian in Hopei Province, which was erected under the Liao dynasty in 984 (Plate 73). It is a three-story structure, seventy-three feet high and sixty-six by fifty feet in area. The most striking features are the two large curved roofs which project some fourteen feet beyond the columns. The bracket system is far more complex, and the construction is lighter and more open; otherwise, the type of construction is very similar to that used by the T'ang builders. Chinese architecture is different from European in that it did not drastically change its style in every period but only modified the details. The interior of the temple hall is again conceived of primarily as a repository for the sacred images, in this case a huge, fifty-foot-high statue of Kuan Yin, the patron deity of the temple. The woodwork was colored throughout, and the total effect of the temples must have been one of elegance and splendor.

The Sung period is generally regarded as the golden age of Chinese ceramics. In fact, many critics, Eastern and Western alike, think that Sung ceramics have no equal in any other pottery. Combining simple, abstract shapes with subtle colors, they are the very essence of what good pottery

should be. Other periods have produced more perfect porcelains or purer and more brilliant colors, but the Sung potters achieved a classical perfection that has never been surpassed. The forms are utilitarian and yet filled with aesthetic sensibility, vital and yet unpretentious and harmonious. To paraphrase the line about a Chinese jar in T. S. Eliot's "Burnt Norton," they move perpetually in their stillness.

In contrast to T'ang pottery, which for the most part was earthenware and much of which was intended for the graves of the rulers and officials, the best Sung work was usually stoneware or true porcelain and was largely produced for the court and the nobility. The shapes were more elegant than those of the T'ang era, reflecting the greater sophistication of the Sung period. The colors were usually monochromes, and decorative designs, if used at all, were very abstract in character and beautifully fitted both to the surface and to the general form of the vessel. The spirit of Sung ceramics might best be described as subdued elegance. If it lacked some of the strength of T'ang ware and the technical virtuosity of Ming and Ch'ing ceramics, it combined simplicity with beauty of execution and design, as well as elegance with vitality.

Of the wealth of ceramics which have survived from the Sung period, six types of wares stand out as the most important and the most characteristic. The first was an imperial ware produced for the court in both the north and the south. It was a fine white porcelain called Ting-yao after the site in Chihli Province where much of the best Ting ware was made. It is outstanding for its pure white body and the delicate impressed designs, usually of birds and flowers, which decorate its surfaces. A fine example of Ting ware is the dish in the Falk collection in New York (Plate 74).

More common, and well known in the West, where it is called celadon, is a grey-green ware which is rather heavy in body and can be either porcelain or a porcelaneous stoneware. It is related to the Yüeh pottery of earlier times and was made at many sites in both North and South China, the most important site being Lung-ch'uan in Chekiang Province. Its thick green glaze resembles the colors of certain jades, and it was highly regarded not only in China but also in Japan, the Near East, and the West. Although the finest celadons were produced during the Sung period, they continued to be manufactured during the Yüan, Ming, and Ch'ing periods and were imitated in Japan and Korea. The shapes are varied, and the

pieces are often decorated with carved, molded, or incised designs, as in the example in the Seattle Art Museum (Plate 79).

A third type of Sung porcelain is called Ying-ch'ing or Ch'ing-pai, a thinly potted ware with a pale blue glaze. Its body consists of a cream-white porcelain which is sometimes impressed with delicate designs, as in the lovely Ying-ch'ing bottle in the Falk collection (Plate 75).

Outstanding for the beauty of its color is the Sung ware known as Chün-yao after the Chün-chou kiln sites in Honan. Its body varies from pure porcelain to a coarse stoneware, and many of the pieces were made as flowerpots and bulb bowls for the imperial court. The glaze is thick and usually leaves part of the foot exposed. Its color ranges from an exquisite sky blue to deep purple, sometimes with reddish spots. A fine example of Chün ware is the flower bowl in the Seattle Art Museum (Plate 76).

Much admired by Japanese tea masters is a stoneware which was made in the Chien district of Fukien Province and called Chien ware, better known by its Japanese name, Temmoku. These wares are usually tea bowls covered with a thick blackish brown glaze which may be streaked with lighter tones, may have silvery markings called oil spots or, like the tea bowls of the closely related Chi-chou kiln, may be decorated with bird-and-flower designs on a lighter ground (Plate 77).

The only Sung ware which used painted designs to any extent came from Tz'u-chou in Chihli, not far from Ting-chou. It is a rather coarse, crude stoneware with a buff-grey body coated with a white slip and covered with a translucent glaze on which beautifully executed designs were painted, carved, or incised. Many different techniques and designs were used, some in black on a white ground, some in brown on a black ground, others in green on brown, and still others in bright red and green. In contrast to the porcelains, Tz'u-chou was an ordinary ware used by the common people and thus was not particularly valued by the Chinese, but its rugged strength and its beauty of design appeal to modern Western taste. A fine example of a Tz'u-chou jar with a bold painted design is a jar in the Seattle Art Museum (Plate 78) which shows the strong shape and the vigorous brushwork characteristic of the best Tz'u-chou pots. Although several other wares could be mentioned, notably those made for the court, these six types are a good representation of what the Sung potters produced during the golden age of Chinese ceramics.

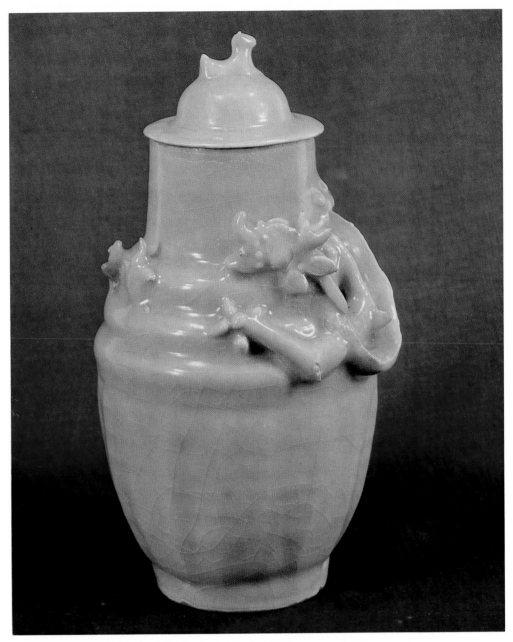

79. Celadon jar. Sung period. Fuller memorial collection, Seattle Art Museum.

The Art of
the YÜAN DYNASTY

(1280–1368)

DURING the Southern Sung period, only the south was under native Chinese rule while the north was controlled by the Chin Tartars, who took over Chinese customs and became great patrons of Chinese art and learning. In the thirteenth century, however, a far more formidable enemy appeared—namely, the Mongols, who, under the brilliant but ruthless Genghis Khan, had established the largest empire the world had ever known. The Mongols conquered the north, overthrowing the Chin dynasty, and then, under Genghis Khan's son, Kublai Khan, who had grown up in China, the south fell to the barbarians and Hangchow was forced to capitulate in 1279. China was once again united, this time under a foreign dynasty which called itself Yüan and made its capital in the north at a city they named Khanbalic, the later Peking. China became the leading state in a vast empire extending from the Danube in the west to Korea in the east and from Annam in the south to the borders of Siberia in the north. Trade was carried on among the different parts of the empire, and China attracted missionaries, merchants, officials, and adventurers from all over the known world. The most famous was the Venetian, Marco Polo, whose account of his travels and life in Cathay is still read today. Serving the Khan as a government official, Marco Polo had the opportunity to see a great deal of the country. He described the Chinese civilization as the finest in the world and observed that Hangchow deserved its name, the Celestial City, because of its pre-eminence over all

other cities in grandeur and beauty and because of its "abundant delights, which might lead an inhabitant to imagine himself in paradise."

Although the Mongol rule was hated by the Chinese, the Mongols were by no means unfriendly to Chinese civilization. Both Buddhism and Confucianism enjoyed the support of the Yüan rulers, and some of the Chinese scholars who were willing to serve the foreigners were given important positions. Having no advanced culture of their own, the Mongols adopted much of the traditional Chinese culture. Literature flourished, and the novel and the drama, written in vernacular Chinese, emerged as important art forms. The Mongols were especially interested in architecture, since they wished to build an impressive new capital, and they favored the Tibetan lamas, who were encouraged to build Buddhist temples and monasteries. At the same time, especially in the south, where the Sung heritage was strongest, much of the traditional art continued to flourish. Certainly there is no sudden break between late Sung and Yüan art, for the older Yüan artists were men who had grown up under the Sung dynasty and continued to work in much the same manner; and since the Yüan rule only lasted for about ninety years, it was never able to impress its own image on Chinese culture.

The most important creative achievement of the Yüan period was its painting, although the rulers themselves had little interest in this art. In fact most of the outstanding Yüan artists withdrew from public life and carried on a sort of passive resistance to the hated foreign government. They became recluses, often of a Buddhist or Taoist kind, or scholars who retired from official life and lived for their art, and thus they were able to carry on their creative work without interference. The only prominent Yüan artist who served the Mongols in an official capacity was Chao Mêng-fu (1254–1322), who became secretary to the Board of War, director of the Han-lin College and governor of Kiangsi and Chekiang provinces. However, in spite of the fact that he was an outstanding painter, calligrapher, and scholar, the Chinese never forgave him for having served the foreign conquerors.

The kind of painting which the Mongol rulers are said to have favored most was the portrayal of horses, perhaps because they themselves were great horsemen. Many such pictures, executed in a very detailed manner and traditionally ascribed to the Yüan period, are preserved in both Chi-

nese and Western collections. They are usually attributed either to Chao Mêng-fu or Jên Jên-fa, both of whom were famous for their pictures of horses. A good example is the scroll of horses and grooms attributed to Jên Jên-fa, now in the Fogg Museum in Cambridge, Massachusetts. (A detail appears in Plate 80). Painted in a straightforward, realistic manner, it is the kind of picture that was very popular at the Yüan court.

Another type which the rulers favored was Buddhist painting, for while the western Mongols had become Moslems, the Mongols in China had embraced Buddhism. The most impressive of the Yüan Buddhist remains are a series of huge wall paintings dating from the second quarter of the fourteenth century. Originally located in the Kuang-shêng Temple in Shansi, they are now scattered among various American museums, notably in New York, Philadelphia, and Kansas City. Although large in scale and well preserved, these wall paintings are disappointing from an artistic as well as a religious point of view, suggesting that the inspiration and high level of craftsmanship which had once prevailed in Buddhist art had been lost by this time.

More satisfactory are the hanging scrolls representing Arhats which were very common during this period. A good example is the scroll in the Hammer collection (Plate 81) which is one of a set of Arhat paintings. The style is realistic, with an emphasis upon clearly delineated lines and colors. The Yüan artist tries to imbue the holy man with marked individuality and at the same time to convey his deeply religious nature. But the brushwork is rather hard and dry, lacking the inspired quality of the best of Sung religious pictures, especially those of the Ch'an sect.

Among the artists who owed their prominence to the Sung rulers and who remained faithful to the old ideals, the most famous was Ch'ien Hsûan. Unlike Chao Mêng-fu, he refused to have anything to do with the Yüan government. Instead, he lived the life of a hermit, writing poems, painting pictures, and drowning his sorrows in wine. He produced all the traditional types of Chinese painting—figure, animal, landscape, and Buddhist—but he was best known for his bird-and-flower paintings in the style of Hui Tsung. In fact, so famous was Ch'ien Hsüan for pictures of this type that his name is attached to dozens of bird-and-flower paintings regardless of their quality or authorship. The best known is the beautiful hand scroll in the collection of the Detroit Institute of Fine Arts, which

shows insects and frogs among grasses and lotus plants. Although an exquisite work and one of the masterpieces of Chinese bird-and-flower painting, the best opinion today is that it was actually painted during the Ming period. A number of other pictures, largely album leaves in Chinese and American collections, can be assigned with more certainty to Ch'ien Hsüan. Among the best is the charming scroll in the Cincinnati Art Museum showing doves on a flowering pear branch (Plate 82). Painted in a carefully detailed, naturalistic manner, the picture combines a vivid portrayal of doves with a beautiful abstract design. Although the artist is always listed as a Yüan painter, since he died during this period, he really carried on the Sung style, and he is far closer to Hui Tsung than to the more typical Yüan painters.

In the eyes of later Chinese critics, the painters who made the most important contribution to the art of this time were the so-called Four Great Masters of the Yüan period, who were active during the second half of the Mongol reign. They were gentlemen painters who devoted their lives to literary pursuits, poetry, painting, calligraphy, and scholarship. They were amateurs in the sense that they did not sell their work but kept it for their own enjoyment or presented it to their friends. To the critics of the Ming and Ch'ing period, these literati became the ideal of what a true artist should be: someone who painted for his own pleasure, lived in retirement among mountains and streams, and above all was not a professional painter. No doubt the idealization of the gentleman painter had a good deal of social snobbishness in it, for in China as elsewhere many of the greatest artists were professionals who painted for a living and were not above accepting commissions.

Stylistically, these artists looked back to the masters of the Five Dynasties and the early Sung period, especially to Tung Yüan and Chü-jan, whom they tried to emulate in their own work. Like these masters, they were assigned to the Southern school, which, in the eyes of such Ming critics as Tung Ch'i-ch'ang, was the only really excellent school—a prejudice which has colored Chinese art criticism to this day. Many later painters who followed the traditions of the Southern school based their styles upon the Four Great Masters, who thus had a profound influence upon the painters of the Ming and Ch'ing periods.

In contrast to the poetic and philosophical spirit which had permeated

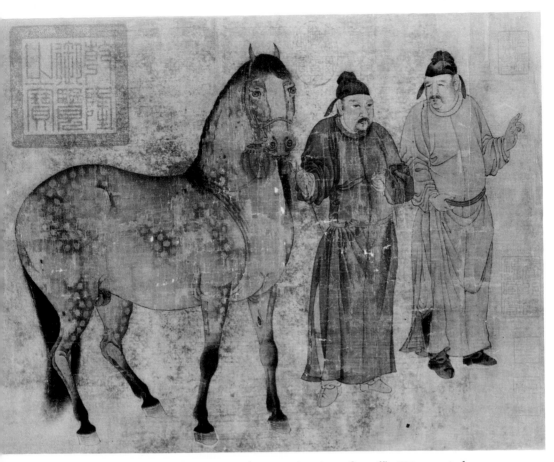

80. Jên Jên-fa (attributed): *Horses and Grooms* (section of scroll). Yüan period.
Fogg Museum of Art, Cambridge, Massachusetts.

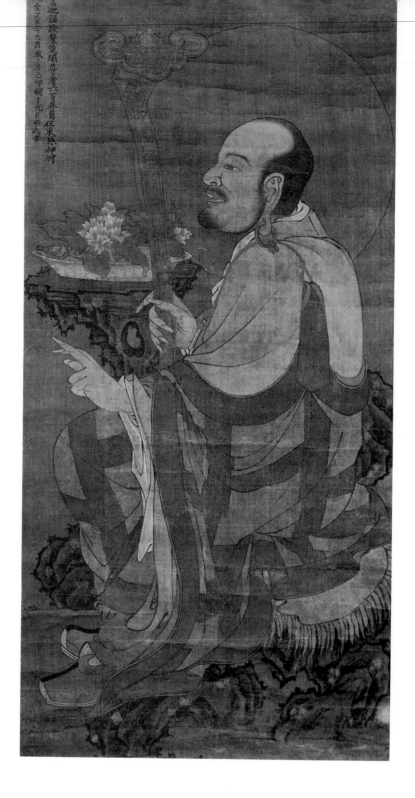

81 (*Facing page*). Arhat (one of a set of paintings). Yüan period. Hammer collection, New York.

82. Ch'ien Hsüan: *Doves and Pear Blossoms*. Yüan period. Cincinnati Art Museum.

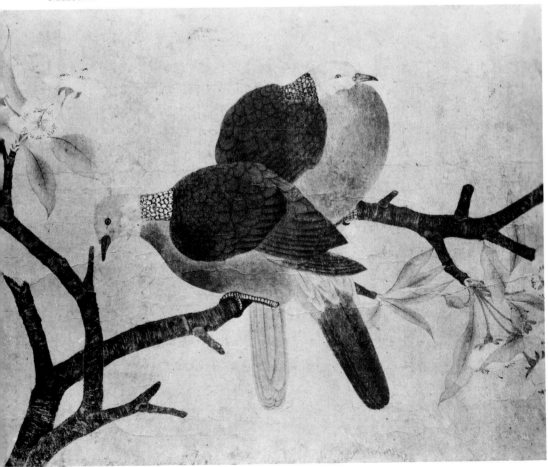

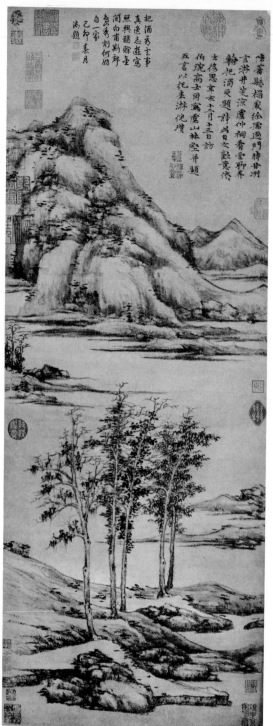

83. Ni Tsan: *Autumn Landscape*. Yüan period. C. C. Wang collection, New York.

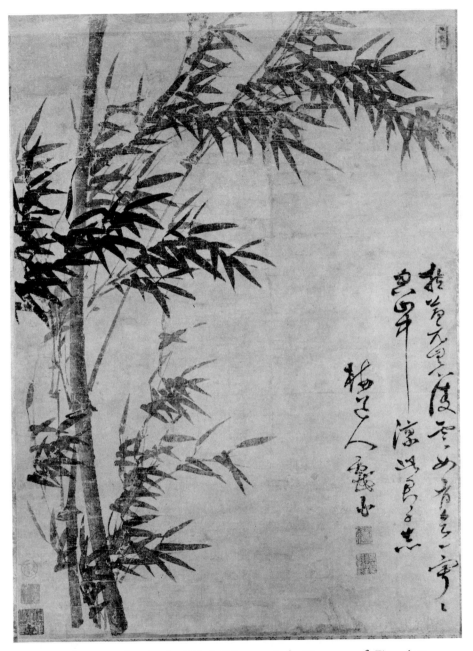

84. Wu Chên: *Bamboo in the Wind*. Yüan period. Museum of Fine Arts, Boston.

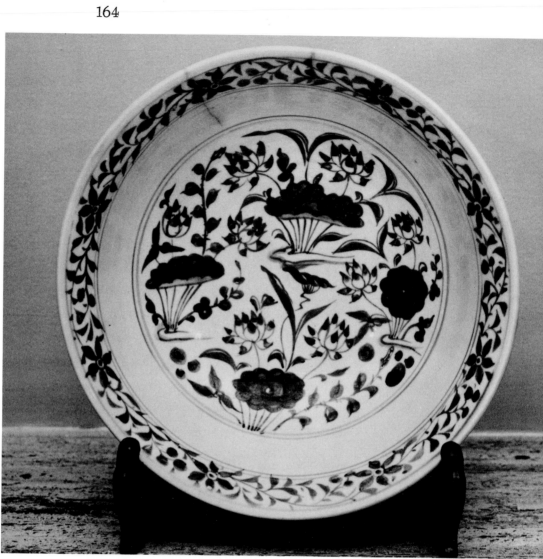

85. Blue-and-white porcelain dish with lotus-flower design. Yüan period. Falk collection, New York.

86. Tz'u-chou stoneware jar. Yüan period. Fogg Museum of Art, Cambridge, Massachusetts.

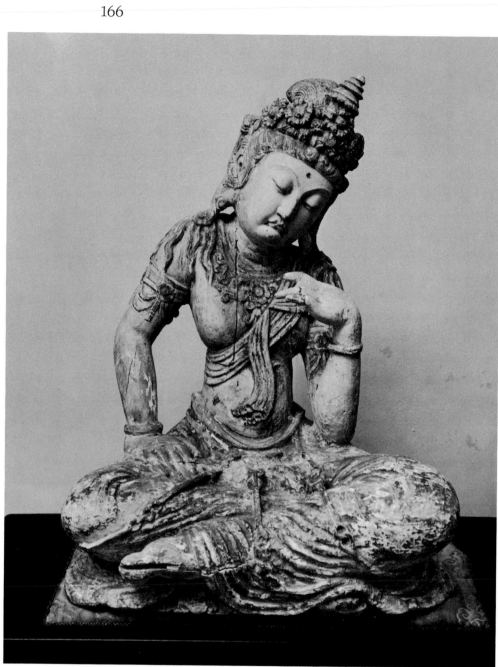

87. Wooden seated Avalokitesvara (Kuan Yin). Yüan period. Meltzer collection, New York.

the landscapes of the Southern Sung artists, the scrolls of the Yüan masters
are dry and abstract, giving expression to the temperament of the artist
rather than portraying the Taoist view of nature. Instead of the misty
atmosphere and the vast expanses of space characteristic of the Ma-Hsia
school, the landscapes are primarily formal constructs in which the excel-
lence of the brushwork and the abstract design are more important than
the romantic vision of nature. Man, who had played an essential part in
Southern Sung painting, is either omitted altogether or relegated to an
insignificant place, for it is the formal structure of the mountains and trees
which is the major interest of the Yüan artists.

The most outstanding of the Four Great Masters was undoubtedly Huang
Kung-wang, who was born in 1259 and lived until 1354. Most of his life
he spent as a recluse wandering through the mountains and staying at
Buddhist and Taoist temples. His most famous painting is a hand scroll
entitled *Dwelling in the Fu-chun Mountains,* which is in the National Palace
Museum in Taiwan. Painted in a restrained manner with great economy of
means, it shows Huang Kung-wang's style at its very best. Using dark and
light tones and vigorous brush strokes, the picture has an expressive power
characteristic of this master. His work has been unjustly neglected in the
West, perhaps because there are no first-rate examples of his painting in
any Western collection. Only recently, through the influence of modern
Western art which is closer to the abstract, subjective spirit of such work,
has this type of Yüan painting received some recognition.

The most typical Yüan artist both in his personal life and in his manner
of painting was Ni Tsan, who was born in 1301 and died in 1374. Working
in what the Chinese call a dry-brush style, and painting the same motif, an
austere autumn landscape, over and over again, he is the very essence of a
Southern school artist who paints to express his personality rather than to
please the public. There are numerous paintings ascribed to him both in
Chinese and Western collections, some of them no doubt originals but
others merely reflections of his style, since Ming and Ch'ing painters were
fond of imitating his work. A good example of a Ni Tsan painting is the
landscape scroll in the collection of C. C. Wang (Plate 83). The forms of
the picture are very simple—mountains, a body of water suggested by
the paper, a few trees—but through them Ni Tsan expresses in a moving
way the loneliness and melancholy of autumn.

The two others of the Four Great Masters were Wêng Mêng and Wu Chên. The former is celebrated for his paintings of towering mountains and weird rock formations. In contrast to the sparseness and economy of Ni Tsan's manner, Wêng Mêng's style is complex and fantastic, and the picture space is filled with elaborately rendered mountains, trees, and rocks. Wu Chên is also famous as a landscape painter, but even finer are his pictures of bamboo, a subject which enjoyed great popularity, for the bamboo was looked upon as a symbol of the Confucian gentleman scholar who bows with the storms but rises once the storm has abated— an apt symbol during an age of foreign oppression. An excellent example of Wu Chên's work is a scroll in the Boston Museum (Plate 84) which combines a beautifully painted bamboo with a fine example of the artist's equally famous calligraphy.

Another field in which the Yüan period excelled was ceramics. As John Pope has conclusively demonstrated in his studies of Chinese porcelains, it was at this time that the blue-and-white wares so highly regarded in the Ming and Ch'ing periods were first developed. Stimulated by the Near Eastern wares which became known in China through the close trade relationships among the various parts of the Mongol empire, the Chinese potters developed a pure white porcelain with decorations painted in cobalt blue under the glaze. A good example is the dish with the lotus-flower design in the Falk collection (Plate 85). Using a highly decorative floral pattern painted in bold strokes in dark blue on a pure white ground, this type of ware established a new category which was to have a far-reaching effect not only on Chinese porcelain but on that of Europe as well. In addition to the blue-and-white, traditional wares such as celadon, Chün-yao, and Ting-yao continued to be made. The finest are the Tz'u-chou stonewares like the jar in the Fogg Museum (Plate 86), which combines a strong shape with a simple yet striking design.

The textiles of the Yüan period were justly famous. Numerous fragments are preserved in Europe, where Chinese materials, especially those using gold thread, have been highly valued ever since medieval times. The oldest of the fabrics preserved in Europe is the burial garment of Pope Benedict XI, who died in 1304 in Perugia. Other remnants of these precious materials may be seen in Regensburg, Danzig, and Stralsund, indicating the great prestige that Yüan textiles enjoyed throughout Eu-

rope. Many of them were made for the Islamic market and have Near Eastern designs, while others are decorated with traditional Chinese ornaments like lotus flowers, dragons, and cloud designs. All are of the finest quality silk, demonstrating the proficiency of the Yüan weavers and reflecting the high material culture of the Mongol reign.

Almost nothing remains of the great building complexes that Marco Polo described. Yet there can be little doubt that the Mongol rulers built magnificent palaces and temples, especially in their capital city. The few minor structures which still stand suggest that by and large the Yüan builders followed their Sung predecessors, adding little that was really new. A nomadic people prior to their conquests, they had no architecture of their own, and so they had to rely upon Chinese traditions for their own structures. In sculpture, too, the Yüan artists followed the style of the Sung period. However, the tendency toward greater realism and a softer, more painterly treatment is carried even further. A characteristic example of a Yüan-period wooden sculpture is the seated Kuan Yin in the Meltzer collection in New York (Plate 87). The deity, portrayed as a female, as in most later Chinese art, is seated in meditation, her eyes almost closed and her left hand gracefully poised above her breast. The forms are soft and relaxed, and the inclined head accentuates the flowing movement of the image. Yet basically this style, too, is nothing but a continuation of that of the Sung period.

CHAPTER NINE

The Art of

the MING DYNASTY

(1368–1644)

RESISTANCE to the oppressive foreign rulers had continued throughout the Mongol reign, and by the middle of the fourteenth century rebel armies had captured much of China. The leader of the rebellion was Chu Yüan-chang, the son of poor peasants; once a monk, then a beggar, and then a bandit, he became the first emperor of the new native house, which he named the Brilliant, or Ming, dynasty. His ambition was to rival the glories of the T'ang period, and he reconquered most of the old empire, extending Chinese power north into Siberia and southwest into Yün-nan Province. At its most powerful, the Ming empire was larger than that of the Han or T'ang rulers. The first capital of the new dynasty was at Nanking, in the south, but under the third Ming emperor, Yung Lo, it was moved to Peking, where a magnificent palace was erected.

Outwardly the Ming period, which lasted almost three centuries, from 1368 to 1644, was certainly a brilliant one. China, once again her own master, was the major power in eastern Asia. Although the end of the Ming reign saw peasant uprisings and disturbances, most of the period was a time of peace and prosperity. Central Asia was no longer so important to China, for instead of using the old Silk Road across the deserts, Chinese traders chose the sea lanes to the south and reached not only Indonesia and Southeast Asia but even the coast of Africa. At the end of the Ming period Western adventurers and merchants, at first Portuguese, then Dutch and English, began to arrive at Chinese ports. Soon the first missionaries

· 171

reached the Ming empire and the contact with the West, which was to bring about such revolutionary changes, began to make itself felt.

The Ming period was not as creative culturally as the Sung, in spite of the latter's political and military weakness. The dominant philosophy was Neo-Confucianism. Buddhism continued to decline, degenerating more and more into a popular religion with little to offer the educated classes. Ming scholars devoted themselves to vast encyclopedias and endless commentaries on Confucian classics, in contrast to Europe, where this period was an age of discovery and scientific inquiry. Preserving traditional institutions and values seemed to be more important than creating anything new, for it was the ambition of the Ming period to recapture the glories of the T'ang.

Art and literature were the only fields in which vital contributions were made. This was especially true of the novel and the drama, creative forms which had emerged during the Yüan period and now had their greatest florescence. Novels like *San Kuo Chih Yen-i* (translated by C. H. Brewitt-Taylor as *The Romance of the Three Kingdoms*) and *Shui Hu Chuan* (translated by Pearl S. Buck as *All Men Are Brothers*) are looked upon to this day as Chinese classics. Written in the vernacular, often by anonymous authors, the Ming novels and plays reflect the vigor and realism of the period. Once considered merely popular, they have been re-evaluated in modern times after their true worth had been recognized.

Chinese critics consider painting the most important of the Ming-period arts. A tremendous number of paintings were produced, and a great number of them have survived, so that we have many scrolls that can be attributed to the Ming masters, as well as thousands more by lesser artists—an altogether different situation from that of the T'ang period, from which virtually no works by famous artists have survived, and that of the Sung period, from which at best a few paintings can be ascribed with certainty to well-known artists. For the first time, it is possible to reconstruct the career and work of major artists, as Richard Edwards has done with Shên Chou. There is also an extensive variety in the types of paintings, both in subject and in style. In fact, if there is one general statement which can be made about the Ming painters, it is that they were catholic in taste. All the old styles, such as the Southern school of the literati painters, the Southern Sung school of Ma Yüan and Hsia Kuei,

narrative, decorative, portrait, and even Buddhist and Taoist painting, existed side by side, with excellent work being done in all styles.

Here again the tendency was to go back to the T'ang traditions, or to what the Ming critics thought were T'ang traditions, a more detailed and realistic approach replacing the philosophical and lyrical outlook of the Sung period and the more formal and abstract one of the Yüan.

The most famous Ming painter was Shên Chou (1427–1509), a particular favorite of the literati, since he was a poet-painter who lived as a hermit and belonged to the so-called Southern school of gentlemen painters. Numerous works are attributed to him, many of which are no doubt originals. His style is derived from Northern Sung painters like Tung Yüan and Mi Fei, and the Four Great Masters of the Yüan period, particularly Ni Tsan and Huang Kung-wang. A typical example of his work is the hand scroll in the Freer Gallery called *A Scholar in His Study Awaiting a Guest,* the left section of which is reproduced (Plate 90). The strong yet subtle brushwork is characteristic of Shên Chou, and so is the economy of the style. The treatment of the mountains is reminiscent of the Northern Sung masters whom Shên Chou admired, but the emphasis upon the narrative as well as the greater realism in the detail are typical of Ming paintings, as is the importance attached to the inscriptions and the seals. The majority of Shên Chou's works are landscapes done as scrolls or sets of album leaves, but other paintings attributed to him depict rocks, bamboos, or birds and flowers.

Only slightly less famous was Tai Chin, who followed the tradition of Hsia Kuei and Ma Yüan. As with Shên Chou, Tai Chin's work is by no means merely an eclectic repetition of what had gone before, but it is a vital expression of his period. His finest paintings are two hand scrolls in the Freer Gallery which represent the life of the fishermen in an animated and realistic way. He is not interested in the fisherman as a symbol of the Taoist identification with nature, for to him the narrative and descriptive qualities are paramount. This more realistic and less philosophical approach is also evident in a scroll by Kuo Hsü in the Detroit Institute of Arts (Plate 89) in which the poem inscription asks who among the rich sitting at banquets with good food and merry wine thinks of the fisherman. Although Kuo Hsü is not ranked among the great Ming painters, his vigorous brushwork shows what real quality can be found in Ming paint-

ing, once it is understood that Kuo Hsü, in representing a fisherman in a straw rain cape pulling in a net, had a very different aim from that of Ma Yüan when he painted his solitary angler surrounded by empty water.

The narrative and realistic elements found in much of Ming art are best illustrated in the work of Chiu Ying, a prolific sixteenth-century painter who worked in the academic style. Popular with the general public rather than the literati, his name is falsely attached to a great many pictures which are often nothing but weak reflections of his style. His most charming work is called *The Garden Feast of Li Po,* a picture which shows the T'ang poet and his friends celebrating under the trees, with servants bringing wine and other refreshments.

In addition to the narrative element, Ming painting shows a strong tendency toward the decorative. This is most apparent in the numerous bird-and-flower paintings attributed to Lü Chi and his followers. A good example is the picture in the Morse collection showing birds in a snow-covered flowering prunus tree (Plate 91). Painted in bright colors with pinks, reds, blues, and lavender as well as whit and brown, it expresses the brilliant, sometimes gaudy spirit of the Ming period. Although not corresponding to the taste of the scholar-painters and done by professionals rather than amateurs, these decorative bird-and-flower scenes can be of very high quality, and at their best they represent an important contribution of the Ming period.

Another type of painting which flourished at this time was the portrait. The numerous ancestor portraits showing Ming officials and their wives dressed in formal robes are often very beautiful both in color and in design, with the reds and blues of the gowns standing in striking contrast to the meticulous linear detail of the faces. A fine Ming portrait is the one of the Korean gentleman in the collection of the Fogg Museum (Plate 92). The face, which is drawn with the most delicate detail, projects a feeling for the personality of the sitter. The pale blue robe is simply rendered, with nothing to distract from the face, and the whole effect is dignified and serene, as would befit a Confucian gentleman. This genre was never taken seriously by Chinese critics, because the portraits were painted by professionals who worked on commissions, but, in view of the fine work which often resulted, the neglect of these pictures seems completely unjustified.

Closely related to the Ming paintings were the woodcut prints of the period. The medium was a very old one, for woodcuts had been used in T'ang times for religious charms as well as for illustrations in Buddhist texts. However, the T'ang and Sung prints had usually been printed in black and white or at most in one color, while during the Ming period a multicolor process was employed. The necessity of using a different block for each color made the task more difficult and time-consuming but enabled the artists to work with many different colors. At first the prints were used for book illustrations and greeting cards, but later whole series of prints were produced, as in the work called *Pictures of the Ten Bamboo Hall,* which was issued in 1643.

The author of this work was Hu Chêng, but since he based his designs on those of contemporary artists, the series reflects the entire range of Ming bird-and-flower painting. The work has sixteen volumes containing one hundred and eighty-six pictures and one hundred and forty poems. The subjects are flowers, birds, fruits, blossoming branches, bamboo, and rocks, all rendered in a simple, suggestive style. The colors are subtle, resembling those used in the paintings of the period. Some of the volumes are meant to be manuals of instruction, while others are composed of beautiful designs executed by skillful artists. Although such works never rival the achievements of the Japanese ukiyoe, the Chinese did produce some sensitive and beautiful prints.

During the Ming period, monumental sculpture suffered a further decline. We have numerous examples of Ming Buddhist carvings in wood, clay, bronze, and lacquer, but none has the spiritual intensity and artistic expressiveness that characterized the best Six Dynasties and T'ang Buddhist sculpture. The large stone statues of officials and animals lining the avenues to the Ming tombs outside Nanking and Peking show the same lessening of vitality and technical skill, indicating that this art form, so closely linked to the rise of Buddhism, had ceased to play an important role. Only in the small-scale works did the sculptures preserve something of their former power. A beautiful example is the jade horse in the Morse collection (Plate 88). The skillfully worked jade shows a fine feeling for the plastic form of the figure. Except for the delicate lines cut into the mane and tail, the sculpture is handled with marked simplicity, creating an effect of quiet strength. Other media used for small sculptures were

ivory and porcelain. The ivories are frequently miniatures, but the medium is often handled with a great deal of expressiveness, as in the figure of an Arhat in the Singer collection (Plate 93). Many of the small sculptures were also made of clay, both as decorative elements for buildings and as independent works of art. The most delicate and technically the most finished were the white porcelain figures manufactured in Fukien Province and called Blanc-de-Chine by Western collectors. A good example of a Fukien figure is the Kuan Yin in the Morse collection (Plate 94). The stone and earthenware statues were usually more coarsely made. Brightly colored with enamels, they represented all kinds of deities, human figures, and animals.

Although the architecture of earlier periods, especially T'ang and Sung, was undoubtedly greater and more original than that of Ming, it is to the latter we must turn for any assessment of Chinese architecture, because most of the important buildings that have survived are from the Ming period, although some were added to in later times. The most impressive are the Imperial Palace and the Temple of Heaven in Peking, which, although much rebuilt in later periods, go back to the reign of the Ming emperor Yung Lo, who moved the capital from Nanking, in the south, to Peking, the northern capital first established by the Yüan rulers. Here, where according to Marco Polo the Great Khan had "the most extensive palace that has ever yet been known," Yung Lo built his own palace, one of the most grandiose ever constructed. Even today, when the buildings are neglected and there are no gorgeously dressed courtiers moving in the elaborate ceremonies of the court, one is struck by the grandeur and beauty of the old capital.

Following ancient Chinese custom, the whole area consists of a series of structures built around rectangular courtyards surrounded by walls. The complex is organized along a north-south axis which leads from the outer gate through a long series of courts to the Purple, or Forbidden, City, where the Son of Heaven had his palace and received the officials and foreign emissaries who came to do him homage. The grand sweep of this axis and the orderly and rational nature of the design give expression to the Confucianist view of the world in which the emperor, like the North Star, had a fixed place in the universe, with all other beings in dependent positions. The four gates of the imperial city facing the four

directions are also symbolical, for they indicate that the peoples of the four quarters of the universe came to the imperial throne. The layout of the building complex, with its series of large gates, its spacious courtyards and marble staircases, is also meaningful in terms of the hierarchy of Chinese society, and European ambassadors told of the overwhelming impression made upon them by the vast distances and spacious rooms of the Imperial Palace. At the end of the axis, beyond the official reception halls, are courtyards that contained the private apartments of the emperor, the empress, the imperial concubines, and the various members of the imperial family, and behind these structures is a large garden with an artificial hill. The total effect must have been quite overwhelming, comparable to the kind of palace which Louis XIV built for himself at Versailles.

The style used was a traditional one that can be traced back to the very beginnings of Chinese architecture. The dominant elements are the red-lacquered pillars and the huge carved roofs made of golden-yellow tiles. The red pillars and yellow roofs, combined with the white marble stairs and balustrades and the blue, green, and white designs painted on the beams and brackets, created a very colorful, even gaudy effect that is characteristic of much of Chinese architecture. A typical example of such a structure is the Wu Mêng, the Sublime Portal of the Imperial Palace (Plate 95), which combines the heavy fortresslike masonry of the first floor with the majestic architecture of the large palace halls in its upper stories, which were used for housing government offices and the military guarding the gate. Although the general view of these buildings is very impressive, the architectural detail tends to be of inferior quality, no doubt in part because of later repairs and reconstructions.

South of the Imperial Palace, in what at one time was a suburb of Peking, is the other famous building complex, the Temple of Heaven, where the emperor performed sacrifices and sacred rituals and offered prayers for an abundant harvest. The outstanding structure at this site is the Hall of Annual Prayers (Plate 96), which was built by the emperor Yung Lo in 1420. It has been reconstructed several times, most recently in 1890 after a disastrous fire, but it has probably preserved much of its original design. Set on a circular platform on three terraces enclosed by white marble balustrades and staircases, it is a tall, round building with a

threefold roof of blue tiles crowned by a golden ball. The pillars were painted bright red, and the panels and brackets were red, blue, green, and gold. It was here that the emperor, dressed in blue, the color of heaven, and using blue porcelain vessels, prayed each spring for a rich harvest. The design of the building gives perfect expression to the Confucian ideals, for it combines simplicity with dignity and rational order with harmony. Not far from the Hall of Annual Prayers, and part of the same temple complex, is the Altar of Heaven, a circular platform on a three-step terrace with marble balustrades, the whole surrounded by a square enclosure with four gates representing the four directions. This structure symbolizes the Chinese ideas of the cosmos, for the round altar stands for heaven, while the square enclosure is a symbol of the earth, and the emperor, the Son of Heaven, standing at the very center and performing the sacred rituals, represented the link between the forces of nature and the people of the Middle Kingdom.

Of all the Ming arts, the one most familiar to the West is that of ceramics, especially as expressed in the porcelains, which are world-famous. Superbly made, vigorous in form, and colorful in decoration, they give expression to the vitality of the Ming civilization. Although they lack some of the refinement of the Sung wares, they are among the masterpieces of the Chinese potters. While Sung ceramics were usually monochromes, painted decorations being rare and, when used, of an abstract and simple kind, Ming ceramics often have bold and ornate decorations executed in cobalt blue or rich enamel colors. Many of the finest Sung pieces were stoneware, but almost all the outstanding works of the Ming kilns were porcelain. The center of porcelain manufacture was the famous pottery town of Ching-tê-chên in Kiangsi Province, not far from Nanking, and it became the chief supplier of ceramics to the imperial court.

The finest of these wares were the blue-and-white porcelains, which represent the culmination of a development that had begun during the Yüan period. The bodies were usually a very pure white porcelain, consisting of kaolin and petuntse, both of which were found in large quantities near Ching-tê-chên. The decoration was painted in bright cobalt blue under the glaze. Coarser pieces with heavy impure bodies and greyish blue designs were also made, especially for export. These were also produced by provincial kilns. The best of the Ming porcelains

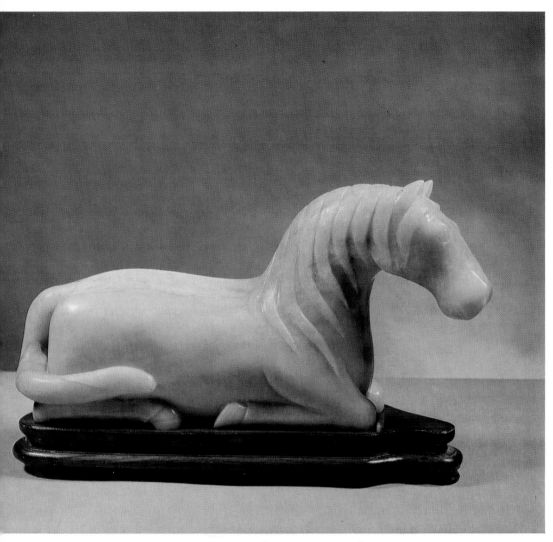

88. Jade horse. Ming period. Morse collection, New York.

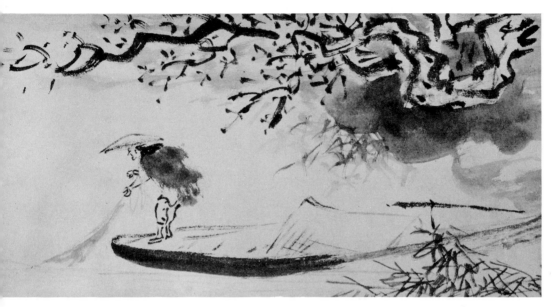

89. Kuo Hsü: *Fisherman* (section of scroll). Ming period. Detroit Institute of Arts.

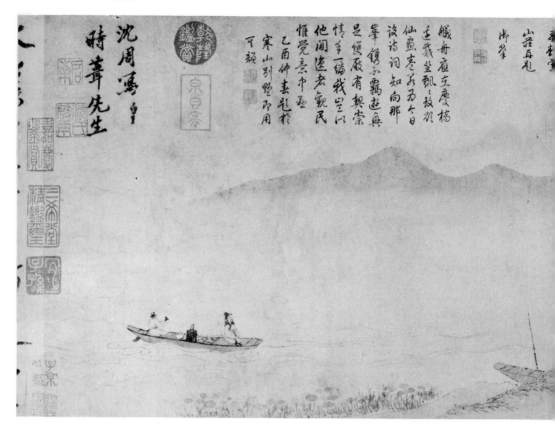

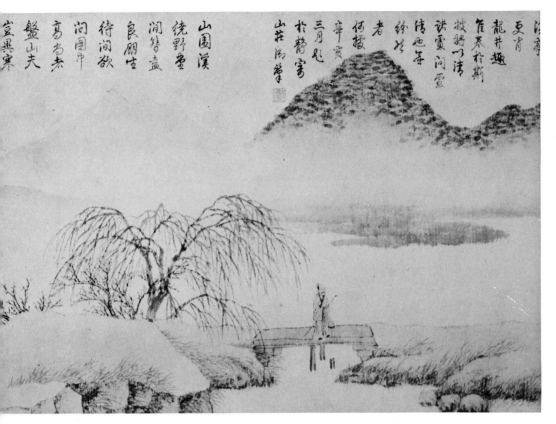

90. Shên Chou: section from scroll entitled *A Scholar in His Study Awaiting a Guest*. Ming period. Freer Gallery of Art, Washington.

184

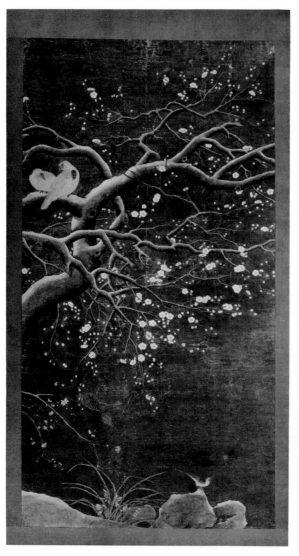

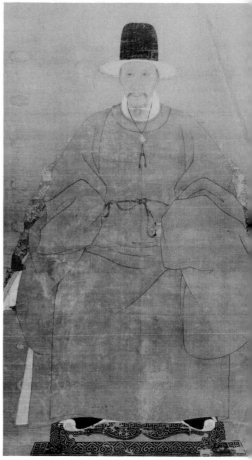

91. Lü Chi: *Birds on a Flowering Tree.*
Ming period. Morse collection, New
York.

92. Portrait of a Korean gentleman.
Ming period. Fogg Museum of Art,
Cambridge, Massachusetts.

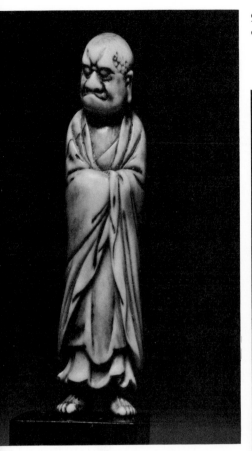

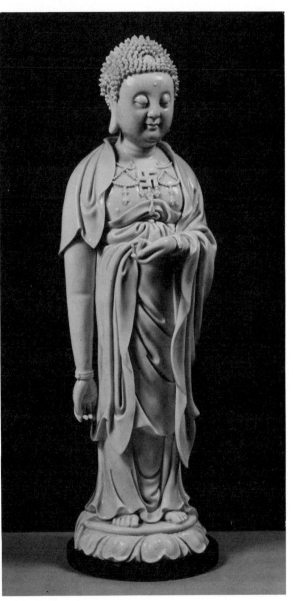

93. Ivory Arhat. Ming period. Singer collection, Summit, New Jersey.

94. Porcelain Avalokitesvara (Kuan Yin). Ming period. Morse collection, New York.

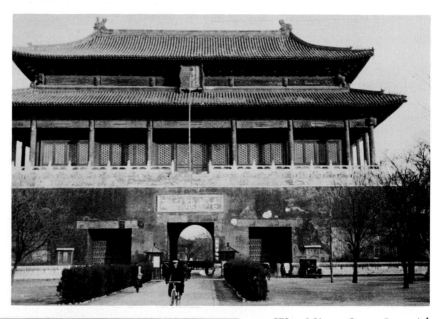

95. Wu Mêng Gate. Imperial Palace, Peking. Ming period.

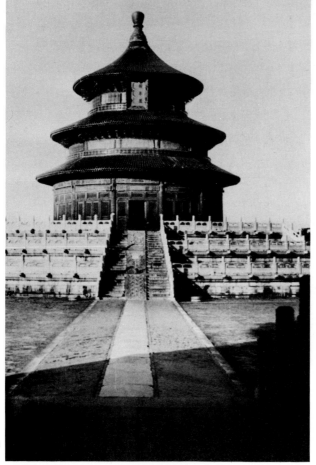

96. Hall of Annual Prayers, Temple of Heaven, Peking. Ming period.

97. Blue-and-white porcelain plate. Ming period. Falk collection, New York.

98. Porcelain box with dragon-and-bird design. Ming period. Fogg Museum of Art, Cambridge, Massachusetts.

99. Lacquer box with design of dragons, clouds, and lotus flowers. Ming period. Royal Ontario Museum, Toronto.

represent one of the great technical achievements of the Chinese craftsmen.

Ming blue-and-white wares were made in a great variety of shapes. Dishes, bowls, jars, plates, bottles, and containers of all types were most common, the forms generally going back to earlier models. The decorations were usually not done by the potters themselves but by other craftsmen. They were often pictorial in character, representing flowers, leaves, fruit, insects, birds, all kinds of animals, and sometimes even scenes from history or legend, mostly derived from the work of the Ming painters. Although some of the later designs tend to be overelaborate, the best of the Ming blue-and-whites, especially those from the reign of the emperor Hsüan-tê (1426–35), have beautiful designs that are perfectly adapted to the shape of the vessel. In fact the productions of this period were so much admired that both Chinese and Japanese potters of later times often put the characters Hsüan-tê on their own work as a sign of ultimate excellence.

A fine example of Ming blue-and-white ware is the large plate in the Falk collection (Plate 97) produced during the Hsüan-tê reign. On a pure white body, the artist has painted the graceful form of a blossoming lotus surrounded by a border of intertwining leaves and flowers. The design is beautifully composed in relation to the surface of the plate, the product of a close and successful collaboration between the potter and the painter. These blue-and-white porcelains were produced for centuries in both China and Japan and were imitated in Persia and Europe, but it is the output of the Ching-tê-chên kilns during the Ming period, especially the fifteenth-century works like the Falk plate, which have been universally regarded both in China and in the West as the culmination of this kind of ware.

A second type of porcelain produced during the Ming period was the polychrome ware decorated in bright enamel colors over the glaze. Both T'ang and Sung potters had used color in their decorations, but they were restricted to a very limited palette, usually green and yellowish brown in T'ang times and red and green in the Tz'u-chou wares of Sung. The Ming potters used multicolored decorations, a new development which took place largely during the reign of the emperor Ch'êng-hua, 1467 to 1487. A great variety of colors was used in addition to the red and green of Sung wares—yellow, purple, violet, blue, turquoise, white, tomato red, brown, and black—and gold leaf was sometimes applied. These wares

are usually referred to as five-colored, or *wu-ts'ai,* but actually two, three, four, five, and even more colors were used, depending on the particular design and the taste of the painter. The finest of these porcelains are gay and colorful, but they can also be overornate and gaudy. The material splendor and the love of display that mark so many phases of Ming art find their most characteristic expression in these works. An example is the circular box with the dragon-and-bird design in the Fogg Museum (Plate 98). The exuberant, brightly colored design is typical of the production of the reign of the emperor Wan Li (1573–1615) and shows the late Ming style at its very best.

In addition to the blue-and-white and the multicolored porcelains, the Ming potters not only continued to make monochromes but also greatly expanded the repertoire in this field. Among these traditional wares were the celadons, many of which are now attributed to the Sung period although they are actually the products of Yüan or Ming kilns. The most remarkable of the Ming monochromes are the pure white porcelains made at Ching-tê-chên as well as Tê-hua in Fukien. These wares were no doubt derived from the Ting-yao of the Sung period, but they had a purity and thinness which the Sung potters had not been able to achieve. Other outstanding Ming monochromes are the brilliant yellow porcelains, the lustrous blacks, the copper reds, and the deep blues. In all of them, the emphasis is on technical perfection and splendor, unlike the Sung works, which are marked by subtlety and elegance.

Pottery was less important than porcelain, although Tz'u-chou and Chün ware continued to be made. The most original development was the so-called three-color, or *san-ts'ai,* ware, which was stoneware of coarse, heavy porcelain and was decorated in bright colors applied directly to the body. Among the colors used, turquoise, aubergine purple, and white were particularly popular. The shapes are varied, but vases, jars, bowls, and garden seats were common. The designs are often pierced, incised or carved, as well as outlined with threads of clay, a device which was derived from cloisonné. The effect of the *san-ts'ai* ware can be quite strong, but it is often gaudy and vulgar.

Next to ceramics, the most important of the Ming decorative arts were the lacquers, a medium treasured during Chou and Han times but less common in the following centuries. Brilliant red lacquers with carved

designs were much in demand throughout the Ming period; their bright color and bold decoration appealed to the Ming taste. While the earlier lacquers had painted designs directly applied to the wooden base, the Ming lacquer workers preferred a technique which required many coats of lacquer into which the designs were carved. The finest of these were made for the imperial court at Peking, but lacquers were also made in other parts of the country. As in the case of the porcelains, the best work comes from the fifteenth century, especially from the reigns of Yung Lo and Hsüan-tê. An example of a fine Ming lacquer is the cylindrical box in the Royal Ontario Museum in Toronto (Plate 99), which has a dragon-and-cloud pattern interspersed with lotus flowers. Executed in low relief in an animated and vigorous style, it is typical of Ming taste.

Other Ming lacquer techniques were incising, inlay, and painting. The incised designs were often gilded, resulting in gorgeous if showy effects. The subjects were usually flowers or animals, especially dragons, which enjoyed great favor at the court because they were emblematic of the emperor. The painted lacquers were usually made in southern China, especially Fukien, and tended to be more provincial in style. Done in a free, colorful manner, they are often charming, although they lack the strength and technical skill of the carved lacquers made for the capital. Toward the end of the period, lacquer inlaid with mother-of-pearl became popular. The iridescent shell is used against a dark surface, either black or deep brown, resulting in designs of great delicacy and beauty.

Textiles, which had been highly developed as early as the Chou period and continued to play an important role during Han, T'ang, Sung, and Yüan times, flourished greatly during the Ming period. Outstanding among these textiles are the elaborate court robes worn by the nobles and officials. Gorgeous in color and brilliant in decoration, these robes used emblems which indicated the rank and court position of the wearer. The dragon associated with the Son of Heaven was particularly popular, but various other animals symbolizing the status of the courtier were also used in the designs. Another typical Ming textile was a tapestry of a very delicate kind called *k'o-ssu* which was used for the mandarin squares on the officials' garments as well as for all kinds of hangings, often reproducing contemporary paintings with great accuracy. Here again the love for the colorful and lavish is apparent.

The Ming period was also known for its outstanding cloisonné enamels. The Chou and Han turquoise and lacquer inlay was similar in technique, and some T'ang objects actually used genuine cloisonné, but it was only during the Ming period that this medium was used on a large scale. The source for this art may well have been in Byzantium, whose cloisonné had been developed to a very high degree, and it was then introduced into China during the Yüan period, when close trade relations existed between the Mongol empire and the West. The finest of the Ming cloisonnés show the Hsüan-tê reign mark and were products of the fifteenth century. Their colors were brilliant, and their decorative designs of great beauty. The later cloisonnés, although technically more perfect, tend to create a dead and mechanical impression. All of them, like most of the other decorative arts, show the great skill of the Ming craftsmen as well as the love of richness and display so characteristic of the period.

100. "Powder-blue" porcelain vase with gold decoration. Ch'ing period. Morse
collection, New York.

The Art of

the CH'ING DYNASTY

(1644–1912)

BY THE END of the sixteenth century, the Ming dynasty had begun to disintegrate because of various problems including poor administration and peasant uprisings. The weakened empire, facing rebellion at home and invasions from abroad, fell prey to the Manchu nomads, a barbaric tribe descended from the Jurchen, who in Sung times had already molested China. With the help of disaffected Chinese, the Manchus conquered the country after a bloody but relatively brief war, and in 1644 they established their own dynasty, which they called Ch'ing. This Manchu house ruled China for almost three centuries until it was replaced by the Chinese Republic in 1912.

Since the Manchus had no political or cultural traditions of their own, they took over the administrative and political philosophy of traditional China and became the most orthodox Confucianists. With the exception of high military offices, they opened up government positions to Chinese scholars, and in general behaved very much as a native Chinese dynasty would have done. Under their rule the country prospered. By 1741 China had no less than 143,000,000 inhabitants, almost three times as many as all of Western Europe. Its military strength, at least during the early centuries of Manchu rule, was also considerable, and China was strong and at peace until the nineteenth century, when Western aggression and internal decay undermined the foundation of the empire.

The Ch'ing period was not as creative culturally as the T'ang and Sung.

The prevailing trend was to preserve traditional institutions and ideas rather than to meet the challenges of the modern age, an attitude which proved fatal when China was confronted with the military invasions and cultural forces of the Western world. But in the eighteenth century, leading Western philosophers like Voltaire thought that Chinese society was the most humane and rational ever evolved, and the fashion for Chinese things, known as chinoiserie, became a veritable craze in the artistic capitals of Europe.

Several of the Ch'ing rulers were outstanding patrons of the arts, notably K'ang Hsi (reigned 1662–1722) and Ch'ien Lung (reigned 1736–95), who was also a great collector of paintings and antiquities. Under their sponsorship, all the arts were encouraged, especially the manufacture of porcelains at the imperial kilns at Ching-tê-chên. While Buddhist art declined even further, the decorative arts flourished—in fact, many collectors consider the Ch'ing products among the finest of the Chinese crafts. Not all of the arts depended upon the patronage of the court, for many of the outstanding painters, especially during the early years of Manchu rule, lived far from the capital, usually as hermits, in order to avoid serving the hated foreigners.

Painting continued to be the dominant art form during the Ch'ing period. Most of the paintings surviving today were undoubtedly produced during the three centuries of Manchu rule, although many of these works have signatures and seals attributing them to masters of Sung, Yüan, or Ming times. Thousands of gifted painters were at work in China during these years, and it would be impossible in a brief account such as this to attempt even a survey of the many schools and painters. The critical evaluation of their work has fluctuated greatly. The older generation of Western critics, influenced by Japanese scholars who felt that all Chinese painting after the Southern Sung period represented a steady decline, thought that hardly any Ch'ing painting deserved serious attention. More recent criticism has tended to upgrade Ch'ing painting and has been enthusiastic about the so-called Eccentrics, seeing them as men of originality and genius, working in a style akin to modern Western art. The Chinese themselves have always had a high regard for the best of the Ch'ing painters, especially those of the seventeenth century, and have felt that all periods of Chinese art have made valid contributions, although readily

granting that the bulk of extant painting, particularly that of the eighteenth and nineteenth centuries, is dull and eclectic.

The dominant school in the eyes of Chinese critics continued to be the Southern school of gentlemen painters who carried on the traditions of masters like Tung Yüan, Chü-jan, Ni Tsan, Huang Kung-wang, and Shên Chou. Outstanding among these artists were the Four Wangs, of whom Wang Hui (1632–1717) is generally regarded as the most accomplished. A prolific painter, he is considered to be the author of a large number of extant works, many of which are no doubt by his hand. In earlier periods it is extremely difficult, and sometimes quite impossible, to form a clear idea of the style and development of the major painters, but with the Ming period, and even more so with the Ch'ing, it becomes possible to establish an oeuvre for each of the famous artists and to follow his career through a study of dated works. A typical example of a Ch'ing painting which can be dated with accuracy and placed within the development of the artist is the Wang Hui mountain landscape in the Morse collection, which comes from the artist's old age, for it is dated 1710 (Plate 102). Called *Landscape after Ni Tsan*, it shows the great admiration Wang Hui had for the masters of the Yüan period. Yet this picture could never be taken for a fourteenth-century work, since Wang Hui, although influenced by Ni Tsan, paints in a manner reflecting both his own style and that of the Ch'ing period. The theme is a traditional one—there is the towering mountain and, in the lower right corner, the miniature figure of a scholar in his hut. The dry yet vigorous brushwork and the emphasis on the massiveness of the mountain are typical of Ch'ing literati painting at its very best.

The artists of the Northern school, who followed T'ang masters like Li Ssu-hsün and his son Li Chao-tao as well as the Ming decorative painters, were less highly regarded by Chinese critics, yet many of the finest Ch'ing pictures can be attributed to this school, and it was the work of these artists which Europeans admired so extravagantly when they first discovered Chinese painting during the eighteenth century. Since these men were professional painters rather than amateurs, they were not particularly admired by the Confucian scholars who dominated Chinese art criticism, but much of their work, if considered on its own merit, is very attractive. A good example of a picture painted in the style of the North-

ern school is the Ch'ing hand scroll in the Freer Gallery (Plate 103), which for many years was actually attributed to Li Ssu-hsün. Executed in bright greens, blues, and reds, with delicate gold outlines, it is typical of the Northern school in contrast to the Southern school, which preferred a monochrome ink style. Its emphasis is upon the narrative and decorative, with its picturesque landscape and elaborate palaces, which incidentally give a fine picture of the commodious and graceful architecture of the time. Other works portray scenes from court life, showing the willowy beauties admired during the period. In fact all the traditional genres continued to flourish—portraits, bird-and-flower pictures, horse paintings, and, above all, landscapes of every type. And under the influence of European copper engravings, which Jesuit missionaries had introduced into China, even paintings using Western perspective and chiaroscuro were produced at the Chinese court.

Far more interesting and certainly much more original than any of the artists of the Southern or Northern school are the eccentric painters of the early years of the Ch'ing dynasty. Although they were men of culture—in fact, the two most famous, Shih-t'ao and Pa-ta Shan-jên, were descendants of the founder of the Ming dynasty—they became hermits and monks to show their disapproval of the foreign rulers. Inspired by Ch'an Buddhism and even more by Taoism, they spent their life far from the court in Peking and the circles of the literati, a life of wandering through the mountains, drinking wine, painting pictures and composing poetry. Although their protest was primarily directed at the Manchu dynasty, they represented that substratum of Chinese thought which had always rebelled against the conformity of orthodox Confucianism.

The most famous of these artists was Shih-t'ao, also known by his monk's name Tao-chi, who lived from 1630 to 1717. Although he became a Buddhist monk, he apparently did not take his obligations too seriously, but roamed about the mountains of China. A writer and philosopher as well as a painter, Shih-t'ao was the kind of artist the Chinese have always admired, and the best of his paintings were treasured by his contemporaries and are much admired today both in the Far East and in the West. A good example of his work is the lake scene in a private collection in China (Plate 104). Employing vigorous brush strokes and simplified forms, Shih-t'ao renders the landscape much as a modern abstract painter might,

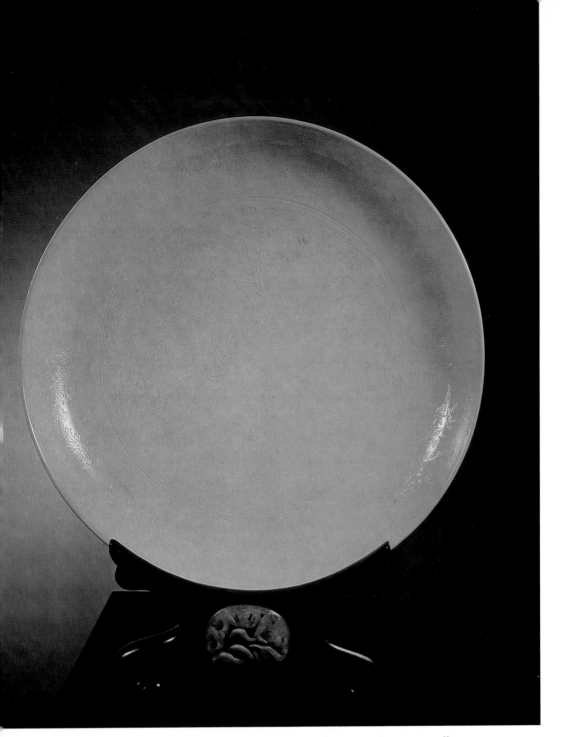

101. Yellow porcelain dish with dragon design. Ch'ing period. Morse collec-
tion, New York.

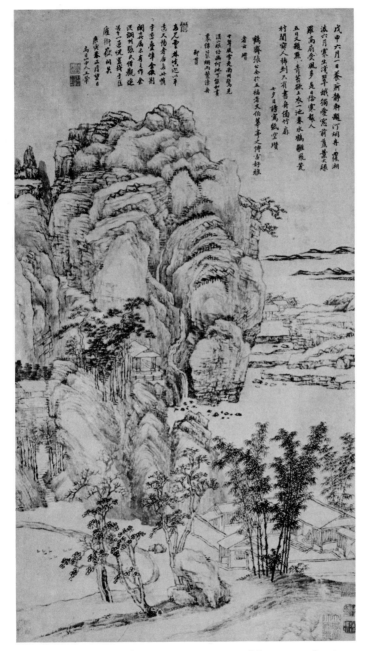

102. Wang Hui: *Landscape After Ni Tsan*. Ch'ing period. Morse
collection, New York.

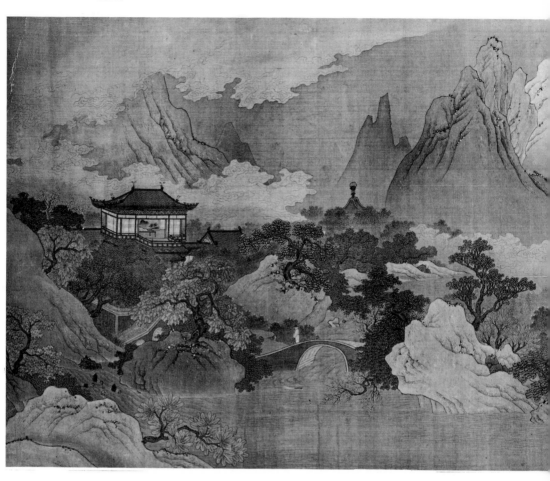

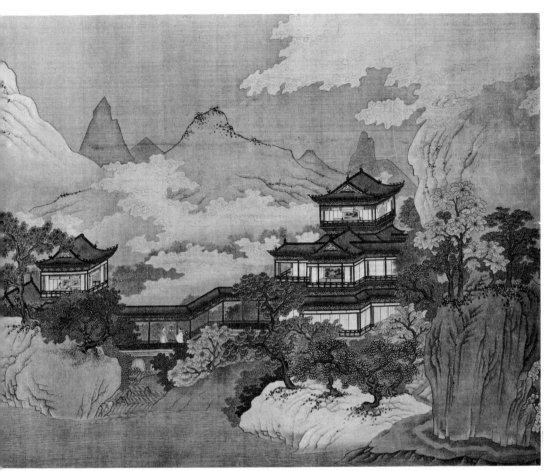

103. *Sages in a Landscape* (section of scroll). Ch'ing period. Freer Gallery of Art, Washington.

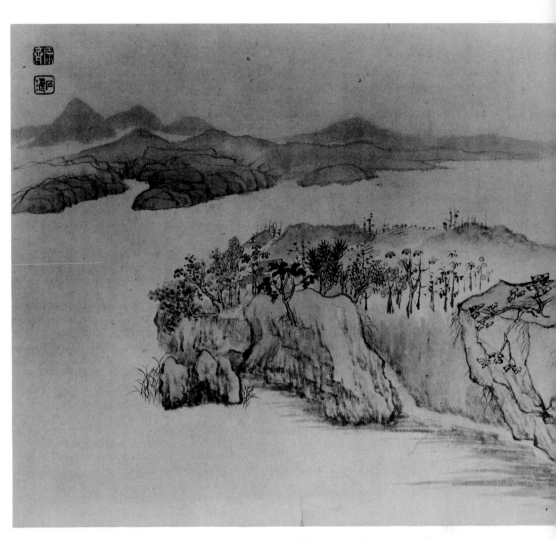

104. Shih-t'ao: *Landscape*. Ch'ing period. Private collection, China.

106. Chi Pai-shih: *Frogs and Tadpoles*. Period of the Republic. Morse collection, New York.

107. Chi Pai-shih: *Cottages in a Cypress Grove*. Period of the Republic. Morse collection, New York.

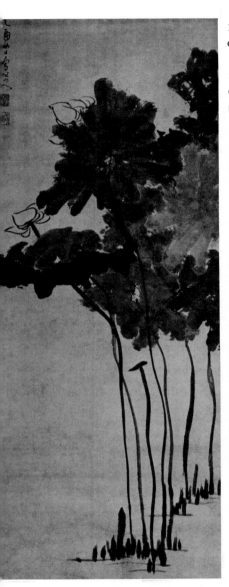

105. Chu Ta (Pa-ta Shan-jên): *Lotuses*. Ch'ing period. Mi Chou Gallery, New York.

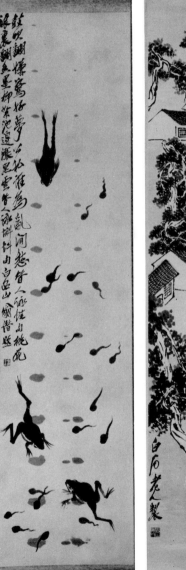
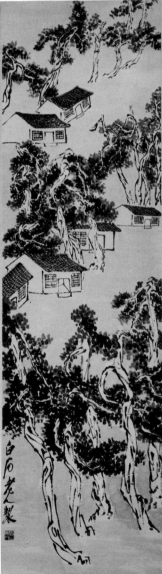

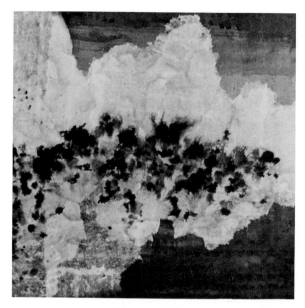

108. Tseng Yu-ho: *Sung Landscape.* Twentieth century (1958). Collection of the artist, Honolulu.

109. Walasse Ting: *Two Eagles.* Twentieth century (1965). Lefebre Gallery, New York.

110. Woodcuts of birds from the *Mustard Seed Garden Manual of Painting.*
Ch'ing period. New York Public Library (Spencer collection).

111. Woodblock folk print of tiger. Ch'ing period. Meltzer collection, New
York.

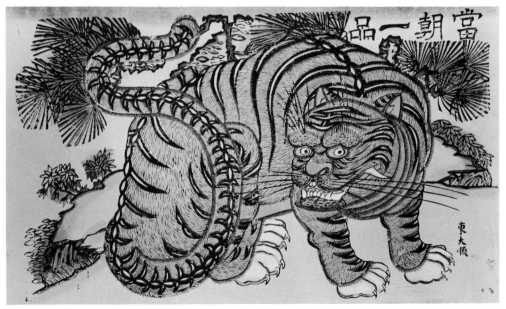

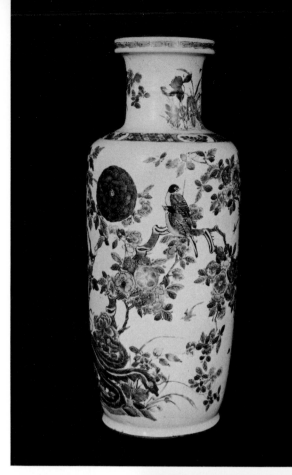

112. Famille verte porcelain vase. Ch'ing period. White House collection, Washington.

113. Jade incense burner. Chi'ing period. Morse collection, New York.

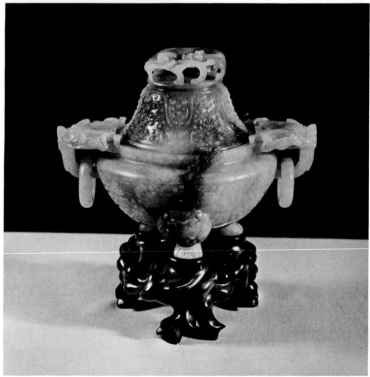

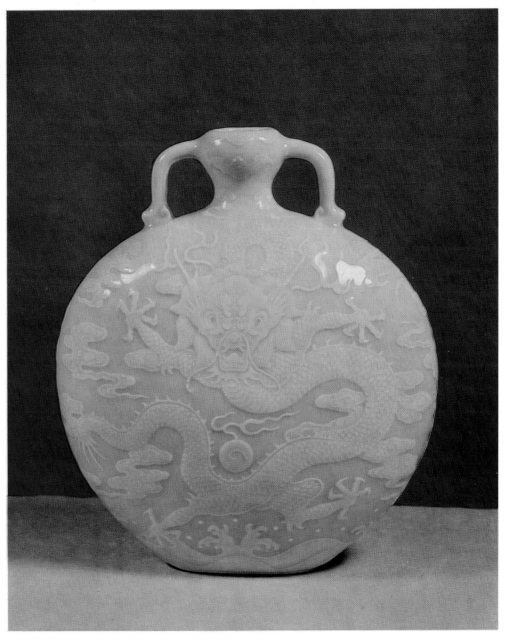

114. Porcelain pilgrim bottle with molded dragon design. Ch'ing period. Morse collection, New York.

stressing the formal structure and the bold brushwork rather than the poetic spirit or the realistic detail.

Even more individualistic was Shi-t'ao's friend and fellow monk Chu Ta, who called himself Pa-ta Shan-jên. Born around 1626, he was a young man when the Manchus came to power, and he showed his disapproval by retiring from the world and entering a monastery. Numerous stories about his eccentric and wild behavior are told in Chinese art literature. There can be little doubt that he suffered from fits of madness, and, according to his son, he became dumb at the time of the downfall of the Ming dynasty. It is said that he did his best work when he was drunk and that people would give him wine in the hope of persuading him to paint, but he refused to have any dealings with people who wished to buy his paintings, for he looked upon his art as a purely personal means of expression which had nothing to do with monetary reward. His style was extremely personal, quite different from that of any other Chinese painter but often having marked affinities with modern Western painting of the expressionist school. Using bold, heavy brush strokes and simple yet forceful forms, he achieved works of great power and originality. A typical example is the painting of lotuses in the collection of the Mi Chou Gallery in New York (Plate 105), in which the traditional Buddhist symbol is rendered in a very expressive manner.

Although a great variety of paintings continued to be produced on a large scale throughout the eighteenth and nineteenth centuries, little that was new or outstanding was created. The eclectic and mannered qualities which were already evident in much of the work of the academic painters of the early Ch'ing period became even more pronounced during the second half of the Manchu reign, and no really outstanding artists emerged during these years. It is not until modern times that new and interesting developments appeared in Chinese painting. The greatest modern artist was no doubt Chi Pai-shih, who was born in 1863, in the late Ch'ing dynasty, and died in 1957 after the Communists had seized control of the country. Strongly influenced by Pa-ta Shan-jên, he developed a very original style in which he painted birds and flowers as well as fish, frogs, insects, and fruit. A charming example is the scroll of frogs and tadpoles in the Morse collection in New York (Plate 106). In the same collection there is a painting of cottages in a cypress grove which is

believed to be from his late period around 1930 (Plate 107). The almost abstract treatment of the cottages and picturesque tree shapes forms a bold and interesting design.

While the older-generation artists like Chi Pai-shih worked wholly in the Chinese tradition, younger artists have attempted to fuse the native tradition with modern Western art, whose impact has been increasingly marked in China as in the rest of Asia. Typical of this new synthesis is the work of the Chinese-born painter Tseng Yu-ho, who now lives in Honolulu and whose work combines elements recalling Sung and Yüan painting with ones reminiscent of Paul Klee. A characteristic example of her work is the *Sung Landscape* of 1958 (Plate 108), which is Chinese in its use of water color and in its brushwork and yet shows an emphasis upon abstract design and expression derived from contemporary European art. Another good example of the attempt to create an art which is modern yet Chinese is the ink painting of Walasse Ting, a young Chinese-born painter who now lives in New York. At one time an abstract expressionist, he now combines the vigorous style of action painting with the Chinese eccentric tradition of Chu Ta and Shih-t'ao. An example of his work is the *Two Eagles* of 1965 (Plate 109), a painting of great beauty and power.

Along with painting, the graphic arts continued to thrive during the Ch'ing period. The most important work was the *Chieh Tzu Yüan Hua Chuan,* or *Mustard Seed Garden Manual of Painting,* which was first published between 1679 and 1701 during the reign of the emperor K'ang Hsi but has been reprinted many times both in China and in Japan and has also been translated into French and English. Discussing artistic principles and methods and illustrating the way various subjects should be treated, it became the most popular manual of painting ever published in the Far East. The woodcuts are often attractive works of art in their own right as well as good examples of how certain themes were treated by Chinese painters. A good illustration is the page from the *Mustard Seed Garden Manual* in the Spencer collection of the New York Public Library which shows different kinds of birds (Plate 110). The woodcut medium is effectively used to simulate brush strokes, and the birds are rendered in a few spirited lines.

A very different kind of print which has enjoyed a certain popularity, especially in modern times, is the folk print produced by ordinary crafts-

men for the use of the common people. Representing figures and scenes from popular religion and folk tales, these prints give a revealing picture of the beliefs and superstitions of the peasants of modern China. Stylistically, they are usually crude, strong works with colors that are bright and garish in contrast to the subtle tonalities used by the more artful wood engravers. A typical example is the tiger in the collection of Doris Meltzer in New York (Plate 111). Although the drawing is untutored and the colors are applied by hand, the total effect is very impressive, giving forceful expression to the traditional Chinese image of the tiger, which ever since Shang times has been looked upon as a powerful protector.

The most remarkable achievement of the Ch'ing age was not so much in painting or prints but in the production of porcelains, especially those made during the reign of the second Ch'ing emperor, K'ang Hsi. Critics have differed in their evaluation of Ch'ing ceramics as compared to these of Sung and Ming. Some think that they represent the finest achievement of the Chinese potter, while others feel that they show a marked decline, having lost the vitality and inner life of the earlier wares. However, no one has doubted that the best of the Ch'ing porcelains are technically the finest the world has ever produced. The purity of the white paste, the brilliance of their color, and the sophistication and technical mastery of their painted designs represent the ultimate in skill, and even today, when the great vogue for Ch'ing porcelains has spent itself, K'ang Hsi wares are eagerly sought after by collectors and museums and fetch higher prices than any other Chinese ceramics.

The center of manufacture, where no less than eighty percent of the Ch'ing wares were made, was Ching-tê-chên, which, according to the Jesuit priest d'Entrecolle, had three thousand kilns, twenty of which produced work for the imperial court. It was a city of almost a million inhabitants, most of whom were active in one way or another in the manufacture of porcelains. The golden age was the first half of the eighteenth century, when the porcelain industry enjoyed imperial patronage, first under K'ang Hsi, who was responsible for reviving the industry after years of neglect, and then under his successors Yung Chêng and Ch'ien Lung. It was this ware which, when first exported to Europe, excited such great admiration for Chinese porcelains and was widely imitated by European porcelain manufacturers.

The Ch'ing porcelain production was not only of the highest quality but also huge in quantity. Literary accounts tell of orders from the court for many thousands of pieces, and of entire shiploads of porcelains comprising tens of thousands of vessels and dishes of all types made for the export market. Although the quality of these wares naturally differed, the best porcelains being made for imperial use, the characteristic that marked all this production was that of elegance and refinement. Compared to the shapes of Ming wares, those of Ch'ing porcelains were more slender and graceful, lacking the strength and boldness that many of the best Ming wares had possessed. The most striking difference between Sung and Ch'ing wares is the ornamental designs covering the surfaces of the vessels, for the Sung potters preferred monochromes, while many of the Ch'ing porcelains are painted in bright enamel colors by craftsmen other than the potters who made them. In fact, Ch'ing porcelains were usually the product of a highly developed industrial system in which the end product was the result of the collaboration of a number of craftsmen, each a specialist in one phase of the manufacture.

Among the K'ang Hsi porcelains, the ones which have been most highly valued both by Western and Chinese collectors are the imperial vases, usually decorated with bird-and-flower designs painted in enamel colors over the glaze, as in the vase in the collection of the White House (Plate 112). European critics have grouped these wares according to their dominant colors, calling them famille verte, famille jaune, and famille noire after the greens, yellows, and blacks used in their decoration. These polychrome designs are painted with great care in a very elegant style reflecting the sophistication of the Ch'ing court, and it is not surprising that the rococo period found these wares particularly attractive and tried to imitate their designs, as did the Japanese in their Kakiemon and Imari porcelains.

While the polychromes were basically derived from the Ming five-colored wares, other Ch'ing porcelains go back to the blue-and-white ceramics of the Ming potters. Here again the perfection of the workmanship was remarkable, for the purity of the porcelain body and the brilliance of the deep cobalt blue equaled and often surpassed the finest of the Ming works. Among the many different shapes and designs used by the Ch'ing potters, the most celebrated are the so-called hawthorn jars, the

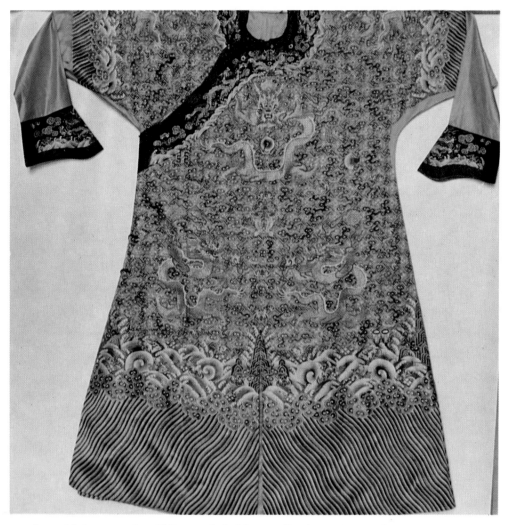

115. Imperial dragon robe. Ch'ing period. Morse collection, New York.

decoration of which actually represents the prunus, considered a symbol of winter (the peony symbolized spring; the lotus, summer; and the chrysanthemum, autumn). A fine specimen of a K'ang Hsi blue-and-white jar with a prunus design is the covered one in the Morse collection (Frontispiece). The pronounced shape of the body is balanced by the lid, which looks like an inverted dish with a knob at the top. Equally strong is the design with the overall pattern of the white blossoms standing out against the deep cobalt blue.

The third major category of K'ang Hsi porcelains was the monochromes. Usually small in size and exquisite in make, they are regarded by many critics as the most beautiful of all Ch'ing wares. They too are derived from earlier models, but they have far greater variety of shape and color than their Ming prototypes. A deep red, known as ox blood, is particularly famous. Other colors used are a reddish pink called peach blossom, an apple green, a brilliant yellow, a lustrous black, a moon white, a sky blue, and a pale lavender called clair de lune. The Ch'ing monochromes are more exquisite than those of the Sung period, but they lack some of the strength and life which the Sung wares possessed. However, their colors are of extraordinary beauty, and this gives them a very real aesthetic appeal. Closely related to the monochromes are the "powder-blue" wares, so called because the color applied to their surface was a blue powder which was either blown or sprayed onto the vessels. These porcelains often had gold decorations over the glaze, as in the "powder-blue" vase in the Morse collection (Plate 100). Here the taste for the lavish that marked so much of the late Ch'ing production is already apparent, but the gold design of lions, flowers, landscape elements, and the four Shou characters around the neck is still restrained and makes a handsome pattern against the deep blue of the glaze.

Although Chinese porcelain began to decline during the reigns of K'ang Hsi's successors, much of the ceramic output of the Yung Chêng and Ch'ien Lung periods was of a very high order. Both these emperors were enthusiastic patrons of the arts, and the great porcelain factories at Ching-tê-chên continued to flourish. The two most important innovations during Yung Chêng's rule were the introduction of famille rose porcelains, in which pink was the dominant color, and the development of a fine white porcelain decorated with charming scenes showing the

slender beauties of the day or the familiar bird-and-flower motifs. Al-
though technically superb, both these types show a tendency toward
over-refinement that is typical of this period. But the best of the Yung
Chêng wares are among the finest of Chinese porcelains, as is well illus-
trated by the large yellow dish in the Morse collection (Plate 101), which
combines beauty of color with a delicately incised pattern of dragons and
flowers.

The Ch'ien Lung period, which lasted some sixty years, almost to the
end of the eighteenth century, is usually regarded as the last major period
of Chinese porcelain production. The best of the Ch'ien Lung works are
still very fine, although they tend to imitate the masterpieces of the past
rather than to develop any new designs or techniques. All kinds of ceram-
ics, the imperial wares of Sung, the blue-and-white of Ming, and the
most outstanding porcelains of the K'ang Hsi period, were now repro-
duced at the request of the court and other well-to-do patrons. The
reproductions were often of high quality, but they never quite equaled the
finest of the older wares. An outstanding example of a Ch'ien Lung
porcelain is the pilgrim bottle with a molded dragon design in low relief
made for the imperial court and now in the Morse collection (Plate 114).
A product of the Ching-tê-chên kilns, it shows the technical mastery of
the Ch'ien Lung potters as well as the somewhat ornate design typical of
the period.

Porcelain was undoubtedly the major art form of the Ch'ing period,
but other crafts, such as textiles, lacquer, cloisonné, jade, and ivory also
flourished. It is only from this period that any number of Chinese costumes
have come down to us, for prior to Ch'ing we have largely fragments
and archaeological material. There were three main types of robes: the
garments which were worn for state ceremonies; the so-called dragon
robes, which were worn for official or festive occasions; and the garments
worn in daily life. Very few of the first type have survived, but there are
numerous dragon robes in both Chinese and Western collections. Worn
by the officials and nobles of the Manchu court, the dragon robe was a
gown of a very simple cut with straight lines, a narrow opening for the
neck, and tightly fitting sleeves. Its surface was almost completely covered
with gorgeous designs in bright colors. These garments are magnificent,
although somewhat gaudy, reflecting the grandeur of the Ch'ing court.

The designs were carefully prescribed and varied according to the status of the wearer. A garment believed to have been worn by the emperor Ch'ien Lung is the dragon robe in the Morse collection (Plate 115), which shows the twelve emblems and the yellow color associated with the emperor. Made of yellow satin and embroidered in five colors, with blue predominating, the garment has a richly textured, crowded design, over-ornate in our eyes but of real magnificence.

Although monumental sculpture was no longer important, miniature works of jade, ivory, coral, and crystal were very popular. The finest are the jade carvings. Although often overelaborate and fussy, they are extraordinary works from a technical point of view, and the best are aesthetically pleasing as well. A good example of a late-Ch'ing jade is the incense burner in the Morse collection (Plate 113), which combines technical virtuosity with beauty of color and material. The animal motifs are the familiar ones of the dragon, the t'ao t'ieh masks, and the cloud patterns, but they are merely decorative, without any of their original meaning. A product of the nineteenth century, this work shows the late phase of Chinese culture. Such technical competence was rare during the last years of the Ch'ing dynasty, and it has disappeared altogether in our own times, when, with the exception of painting, China has not produced any outstanding art.

Bibliography

GENERAL BOOKS ON CHINESE ART

Bachhofer, L.: *A Short History of Chinese Art,* New York, 1946

Burling, J. and A.: *Chinese Art,* London, 1954

Carter, D.: *Four Thousand Years of Chinese Art,* New York, 1948

Fry, R., editor: *Chinese Art,* London, 1925

Grousset, R.: *Chinese Art and Culture,* New York, 1959

Lion-Goldschmidt, D., Jenyns, S., Watson, W. et al.: *Chinese Art,* London, 1960–65

Munsterberg, H.: *A Short History of Chinese Art,* New York, 1949

Sickman, L. and Soper, A.: *The Art and Architecture of China,* London, 1956

Sirén, O.: *Kinas Konst Under Tre Artusenden,* Stockholm, 1942

Speiser, W.: *China,* New York, 1960

Sullivan, M.: *An Introduction to Chinese Art,* Berkeley, 1961

Willetts, W.: *Chinese Art,* London, 1958

PREHISTORIC POTTERY

Andersson, J. G.: *Children of the Yellow Earth,* London, 1934

——: "Researches into the Prehistory of the Chinese," *Bulletin of the Museum of Far Eastern Antiquities,* vol. 15, Stockholm, 1943

Chêng Tê-k'un: *Archaeology in China,* vol. 1, Cambridge, 1959

Li Chi: *The Beginnings of Chinese Civilization,* Seattle, 1957

Wu, G. D.: *Prehistoric Pottery in China,* London, 1938

ANCIENT BRONZES AND JADES

Chêng Tê-k'un: *Archaeology in China,* vols. 2 and 3, Cambridge, 1960, 1963

Hentze, C.: *Frühchinesische Bronzen und Kultdarstellungen*, Antwerp, 1937
———: *Frühchinesische Sakralbronzen und Ihre Bedeutung in den Frühchinesischen Kulturen*, Antwerp, 1941
Karlgren, B.: "Huai and Han," *Bulletin of the Museum of Far Eastern Antiquities*, vol. 13, Stockholm, 1941
———: "New Studies in Chinese Bronzes," *Bulletin of the Museum of Far Eastern Antiquities*, vol. 9, Stockholm, 1937
———: "Yin and Chou in Chinese Bronzes," *Bulletin of the Museum of Far Eastern Antiquities*, vol. 8, Stockholm, 1936
Laufer, B.: *Jade*, Chicago, 1912
Loehr, M.: *Chinese Bronze Age Weapons*, Ann Arbor, 1956
———: *Relics of Ancient China*, New York, 1965
Mizuno, S.: *Bronzes and Jades of Ancient China*, Kyoto, 1959
Salmony, A.: *Archaic Chinese Jades*, Chicago, 1952
Waterbury, F.: *Early Chinese Symbols and Literature*, New York, 1942
Watson, W.: *Ancient Chinese Bronzes*, Rutland, Vermont, 1962

PAINTING AND CALLIGRAPHY
Cahill, J.: *Chinese Painting*, New York, 1960
Chiang Yee: *Chinese Calligraphy*, London, 1938
Cohn, W.: *Chinese Painting*, London, 1957
Gray, B. and Vincent, J. B.: *Buddhist Cave Paintings at Tun Huang*, London, 1959
van Gulik, R. H.: *Chinese Pictorial Art*, Rome, 1958
Kuo Hsi: *An Essay on Landscape Painting*, London, 1936
Lee, S.: *Chinese Landscape Painting*, Cleveland, 1954
Munsterberg, H.: *The Landscape Painting of China and Japan*, Rutland, Vermont & Tokyo, Japan, 1955
Sirén, O.: *The Chinese on the Art of Painting*, Peking, 1936
———: *Chinese Painting: Leading Masters and Principles*, 7 vols., London, 1956–58
Sullivan, M.: *Chinese Art in the Twentieth Century*, London, 1959
Swann, P.: *Chinese Painting*, Paris, 1958
Waley, A.: *An Introduction to Chinese Painting*, London, 1923

SCULPTURE
Ashton, L.: *Introduction to the Study of Chinese Sculpture*, London, 1924
Chavannes, E.: *Mission Archéologique dans la Chine Septentrionale*, Paris, 1909–15
Fischer, O.: *Chinesische Plastik*, Munich, 1948
Mizuno, S.: *Chinese Stone Sculpture*, Tokyo, 1950
———: *Yün Kang*, 15 vols., Kyoto, 1952

Munsterberg. H.: *The Art of the Chinese Sculptor,* Rutland, Vermont & Tokyo, Japan, 1960

Sirén, O.: *Chinese Sculpture,* 4 vols., London, 1925

Soper, A.: *Literary Evidence for Early Buddhist Art in China,* Ascona, 1959

ARCHITECTURE

Boerschmann, E.: *Chinesische Architektur,* Berlin, 1925

———: *Pagoden,* Berlin, 1931

Boyd, A.: *Chinese Architecture,* London, 1962

Prip-Møller, J.: *Chinese Buddhist Monasteries,* Copenhagen, 1937

Sirén, O.: *Chinese Architecture,* vol. 4 in *History of Chinese Art,* London, 1929

———: *Gardens of China,* New York, 1949

———: *Imperial Palaces of Peking,* Paris, 1926

———: *Walls and Gates of Peking,* London, 1924

CERAMICS

Garner, H.: *Oriental Blue and White,* London, 1954

Gompertz, G. St. G. M.: *Chinese Celadon Wares,* London, 1958

Gray, B.: *Early Chinese Pottery and Porcelain,* London, 1953

Hobson, R. L.: *Chinese Pottery and Porcelain,* London, 1915

———: *Chinese Pottery and Porcelain in the David Collection,* London, 1934

———: *Later Ceramic Wares of China,* London, 1925

———: *The Wares of the Ming Dynasty,* London, 1923 (reissued, 1962)

Honey, W. B.: *The Ceramic Art of China and Other Countries of the Far East,* London, 1945

Jenyns, S.: *Later Chinese Porcelain,* London, 1959

———: *Ming Pottery and Porcelain,* London, 1953

Pope, J. A.: *Chinese Porcelains from the Ardebil Shrine,* Washington, 1956

———: *Fourteenth Century Blue and White,* Washington, 1953

Index